Selected Works from
The Detroit Institute of Arts

1979

Frontispiece:

Female Mask, North American Indian, Tlingit, 1800/1900
Wood, sinew, haliotis shell, human hair; h. 28 cm. (11 in.)
Founders Society Purchase, New Endowment Fund (78.40)
See S. Phelps, *Art and Artefacts of the Pacific, Africa, and the Americas, the James Hooper Collection,* London, 1976: no. 1479.

Cover:

PAUL CEZANNE, French (1839-1906)
Portrait of Madame Cézanne, 1892
Oil on canvas; 101 x 81.3 cm. (39¾ x 32 in.)
Bequest of Robert H. Tannahill (70.160)
See DIA *Handbook,* 1971: 160.

Copyright © 1979 The Detroit Institute of Arts
All rights reserved
ISBN 0-89558-076-4
Designed by Malcolm Grear Designers, Inc.
Typeset by Dumar Typesetting, Inc.
in Jan Tschichold's Sabon
Printed by the Meriden Gravure Company
on 80 lb. Lustro Offset Enamel Dull
Color printing by Princeton Polychrome Press

All photographs in this book were taken by the Photography Department, The Detroit Institute of Arts, except pls. XV, XVIII; and nos. 99, 100, 103, courtesy of Bullaty-Lomeo, New York.

Library of Congress Cataloging in Publication Data

Detroit. Institute of Arts.
 Selected works from the Detroit Institute of Arts.

 Includes index.
 1. Art—Michigan—Detroit—Catalogs.
 2. Detroit. Institute of Arts—Catalogs.
N560.A7 708'.73'34 79-15904
ISBN 0-89558-076-4 pbk.

Editor's Notes:

The works of art included here have been listed chronologically within most departments. The European department's holdings, however, have been grouped according to country, listed alphabetically, and within this, are in chronological order based on the date of the work. The African pieces have been arranged alphabetically by culture.

We have listed one bibliographical reference for each work wherever possible to provide the reader with additional information. We have tried to include the most important or recent publication, listing Detroit Institute of Arts' publications where relevant.

Abbreviations include:
DIA *Bull.*: *Bulletin of The Detroit Institute of Arts*
DIA *Handbook*: *The Detroit Institute of Arts Illustrated Handbook*

TABLE OF CONTENTS

Frederick J. Cummings, Director

Selected Works from The Detroit Institute of Arts is the first published survey of the museum's collections to appear in 13 years. While many of the 300 works of art reproduced here are masterpieces that came into the collections at various points in our nearly 100 years of existence, 118 have been acquired during the past ten years and, as such, focus our attention on a decade of enormous growth, new directions, and significant change for The Detroit Institute of Arts.

Since 1950 the museum's collections have doubled, its space tripled, and its staff quadrupled. While such rapid growth is typical of many American museums in the 1970s, the story of the Institute's recent growth is particularly fascinating and unique. In the following pages I would like to discuss the major developments that have occurred since 1969 as I have observed them, first as Assistant Director (1966-1973) and then as Director (1973 on).

The last ten years were among the most dramatic in the history of the Institute. They include the loss of valued and dedicated leaders, the enrichment of the collections through several large and important bequests, the development of a significant new group of patrons, the actual shutdown of the building during the City of Detroit's greatest economic crisis since the Depression, and the emergence of the State of Michigan as a major supporter of the arts—second only to New York State in this regard. This period has also seen the growth of new or re-activated curatorial departments, as well as the creation and expansion of various service departments that provide increased programs and services for our ever-widening museum audience.

* * *

The paramount consideration for any growing museum is the building of its collections. In augmenting ours, we have not taken the view that art is embodied in the works of only a few well-known heroes but rather in a multiplicity and breadth of forms, individual expressions, and cultures. Thus, the vision of the Institute's first great director, William R. Valentiner, who believed an American art museum should provide a comprehensive expression of human life and history by containing fine examples of art from diverse world cultures and historical periods, is consciously being continued today in our expanding collections and programs.

Perusal of the objects reproduced in this book, as well as the essays introducing each section of the museum's holdings, reveals that the museum has been the recipient of several major collections during the past decade. The bequests of Robert H. Tannahill, Anna Thomson Dodge, and Eleanor Clay Ford strengthened the museum's holdings in many critical areas. The Tannahill gift, received in 1970, created the nucleus of a fine survey of French art from Impressionism through the School of Paris, as well as contributing significantly to our collections of modern European and American graphic arts and African sculpture. The Dodge bequest of 1971 of 18th-century European art included furniture by some of France's greatest cabinetmakers, an important collection of Sèvres porcelain, decorative objects and sculptures, and a small but distinguished group of 18th-century English portraits. And, finally, in 1977, Eleanor Clay Ford, the museum's longest-standing and most generous patron, bequeathed to the museum, among other things, an important group of Italian Renaissance paintings and English portraits. While there can be no replacement for patrons of such devotion, energy, and taste, their spirits will continue to be felt by the presence of their legacies in the Institute's galleries.

Since 1970, an enthusiastic group of new patrons and leaders has emerged to help build the collections and support the museum's activities. Since the contributions of these individuals are discussed in the various departmental essays that follow, they will not be specifically mentioned here. Suffice it to say that we would not have been able to pursue any of the new directions detailed below without their vision, commitment, and generosity.

Selected Works highlights several areas that are receiving new or renewed attention. After many years of relative inactivity and little or no curatorial guidance, the Department of Asian Art

has emerged with great vitality, acquiring in many fields, particularly Chinese painting. Totally new is the Department of African, Oceanic, and New World Cultures, formed in 1976 with a fund given anonymously by Eleanor Clay Ford to create one of America's most important collections of African art (it was named the Eleanor Ford Fund for African Art after her death). In just a few years, the department has been able to re-examine the museum's holdings and has already acquired an impressive group of works for the collections.

New directions can also be discerned in pre-existing departments. In the European field, particularly notable additions have been made of 17th- and 18th-century Italian art and 18th- and 19th-century French painting and sculpture. The Department of Modern Art has made significant acquisitions of contemporary American sculpture, as well as supporting, through purchases and special exhibitions, the work of a dynamic group of young Michigan artists. Over the past few years, the Department of Graphic Arts has been able to form an important collection of photography.

Another important development of the last decade is in the area of conservation. Founded in 1971, the Conservation Services Laboratory now features a large and highly trained staff specializing in paintings, drawings, three-dimensional objects, and textiles. Aided by sophisticated equipment and techniques, the department conserves the collection, supervises the installation and dismantling of special exhibitions, and serves as a regional center for the conservation of the holdings of State and other near-by museums.

A major area of Institute activity over the last ten years has been building extension and renovation. The opening of the North Wing in October 1971 permitted a more rational arrangement of the collections than had been possible previously, enabling us to place on view numerous works of art, even entire collections, that had never been shown or had been in storage for some time. The art of the Ancient World, including the civilizations of Egypt, Greece, and Rome, was installed in the Main Building in the galleries around the Rivera Court, forming at the literal center of the museum complex the physical and intellectual fountainhead for the branching developments of all other Western European arts. Equally important was the reinstallation of the collections representing the civilizations of China, Japan, India, and Islam in a series of five galleries on the ground floor of the North Wing. The Tannahill Collection of Impressionists, Post-Impressionists, and works from the School of Paris was placed on permanent view for the first time on the second floor of the North Wing. The installation of the contemporary collections in adjacent galleries has made possible a survey of the development of 20th-century art beginning with Fauvism.

In the South Wing (renamed the Eleanor and Edsel Ford Wing in 1977 after the death of Mrs. Ford), the Mr. and Mrs. Horace E. Dodge Memorial Collection was installed on the main floor, surrounded by European decorative arts and 17th- and 18th-century French painting. Dutch art of the 17th century was reorganized and extended to the third-floor balcony of this wing, permitting the exhibition of some 40 paintings from storage. Also rehung was the collection of British paintings.

The arrangement of the collections established in 1971—by cultural groups or national schools— has been respected in subsequent reinstallations. In 1977, the Italian galleries in the Main Building were redesigned and extended. In 1978, the Kanzler Room, an 18th-century French panelled period room, was moved from its original setting in the Main Building and totally refurbished in a gallery adjacent to the Dodge Collection. Also in 1978, the Textile Galleries were installed at the top level of the Main Building, enabling us to exhibit portions of our outstanding textile collection, which has been in storage for many years. In progress, thanks to various public and private sources—including the City of Detroit, the National Endowment for the Arts, the Kresge Foundation, the Ferry Trustee Corporation, the Ina M. Clark Bequest, and Mrs. Allan Shelden—are a

series of ethnographic galleries around the court of the North Wing; a Graphic Arts Center on the lower level of the Main Building that will include exhibition galleries, offices, study room, and study storage; the complete renovation of the Kresge Court dining and theatre facilities as well as the Performing Arts complex; and the redesign and renovation of the museum grounds, including the Elizabeth and Allan Shelden Sculpture Garden to be installed on the southwest side of the museum.

The responsibility of the museum to select, preserve, and exhibit works of art is integrally tied to the necessity of functioning as a public service by providing our various audiences with an increased understanding of the visual arts. Toward this end, over the past decade we have greatly increased our emphasis on education and other museum services.

In 1969, the Department of Education included five full-time staff and about one hundred volunteers who lectured to children and adults in the museum, as well as in metropolitan Detroit schools. Today, this department is staffed by over a dozen professional members and several hundred volunteers performing in a multitude of areas in the museum, in the metropolitan Detroit area, and across the State. The Publications Department, created in 1972, publishes the quarterly *Bulletin* with scholarly articles on museum accessions, the *Annual Report*, special exhibition catalogues and checklists, and a variety of publications on the permanent collections. The ambitious programs of both the Education and Publications Departments are supported in part by a fund created in 1972 by Mrs. Ford: the Edsel B. and Eleanor C. Ford Education and Communications Fund. The Performing Arts Department has also experienced great expansion over this period. Its numerous highly successful film, music, and children's theatre programs, held both at the museum and throughout the State, reinforce our critical position as a State resource for the performing as well as the visual arts.

While the special exhibitions the museum has sponsored over the last ten years do not relate directly to this book, they have been a critical focus of our energies during this time and require mention here. Major national and international loan exhibitions have received traditional emphasis since the 1920s, when Valentiner undertook them to expose Detroiters to the work of the honored Old Masters, to contribute to art historical scholarship through published catalogues, and to encourage collecting both on the part of the museum and individual patrons whose private collections he cultivated. This tradition was continued into the 1960s with the great "Flanders in the Fifteenth Century" exhibition (1960), "Art in Italy 1600-1700" (1965), and "Romantic Art in Britain" (1968). Such major international loan shows would not have been possible in the 1970s, with rising shipping and insurance costs, without the help of the Edsel and Eleanor Ford Fund, established by Mrs. Ford in 1968. Her extraordinary farsightedness and generosity, combined with increased corporate and federal support of our efforts, have permitted us to organize or co-organize such important and innovative exhibitions as "Akhenaten and Nefertiti: Art from the Age of Egypt's Sun King" (1973), "The Twilight of the Medici: Late Baroque Art in Florence" (1974), "The Age of Revolution: French Painting 1774-1830" (1975), "Henri Matisse Paper Cut-Outs" (1977), and "The Second Empire: Art in France under Napoleon III" (1978-79)—all of which made significant contributions to their respective fields, especially through their scholarly catalogues. In addition, nearly every one of these exhibitions has prompted a major acquisition or group of acquisitions to augment the museum's permanent collections.

* * *

Like a work of art, a museum has its own special character and qualities which, to a great extent, reflect the concerns and complexion of the people who participate in its activities and support its functions. Since 1919, The Detroit Institute of Arts has occupied a rather unique

position among major American museums. In that year it became a public, municipal institution owned by the City of Detroit and administered by the City's Arts Commission. From that time on, all important works of art have been acquired in the public trust and are considered unique treasures and resources of the people of Detroit and Michigan.

Financially, our museum has always been deeply affected by the automobile-based and, therefore, highly volatile economy of Michigan. During the past decade, the City's tax base severely shrunk, causing the level of its funding to the Institute to dwindle considerably. It was during this period, under the expert and wise guidance of President Lee Hills, that the Arts Commission encouraged efforts to enlarge the financial base of the museum.

One of the most visible new sources of support during this turbulent period was the Founders Society, the museum's private support group. This organization, which originally ran the private Detroit Museum of Art before it became a public institution in 1919, had been for years a relatively small group of interested individuals and patrons who provided various kinds of aid to the Institute while the museum's principal source of income was the City of Detroit. During the 1960s, under the leadership of museum Director Willis F. Woods and President and Chairman of the Board William A. Day, the Founders Society began to take on new energy and character. The upgrading of Founders Society policies and procedures—including the expansion of the Board to include wider representation of the total community, increased public relations, and encouragement of the involvement of Detroit's corporate sector—resulted in greatly expanded membership and funding. Thus, in 1962, the Founders budget was only $194,400 and its membership 4,532. By 1969, the membership had grown to 9,815 and the budget to $398,800. Today, the Society's membership has reached over 16,000, and its total budget is $4,474,000.

In the 1970s, the Founders Society has been directed by an outstanding board under the leadership of Stanford C. Stoddard, Chairman, and Norman B. Weston, President. The Society has developed into a highly complex parent institution with numerous sub-groups that support special interests and activities. These include the African Art Gallery Committee, the Antiquaries, the Associates of the American Wing, the Drawing and Print Club, the Friends of Asian Art, and the Friends of Modern Art, as well as other committees that assist in myriad ways—the Activities Committee, the Joint Museum Collections Committee, the Junior Council, the Museum Shops Advisory Committee, the Volunteer Committee, the Women's Committee, and others.

Thus, an active, dynamic Founders Society, supporting nearly all aspects of the museum's programs with funds, volunteered time, and gifts, was able to supply nearly half the Institute's required budget when we faced the recession of 1974-75. The City of Detroit was forced to withdraw funding from all but the most essential public services, creating the most severe crisis at the Institute since the Depression (when the museum had to lay off its entire professional staff). A significant cut in financial support from the City resulted in the lay-off of 58 City employees and the closing of the building. When, after several weeks, we were able to re-open the museum, it was only possible to have public hours five days a week (as opposed to the normal six) and approximately twenty-five percent of the galleries open at one time.

Discussions early in 1975 with Detroit Mayor Coleman A. Young resulted in a joint effort with the Founders Society to seek funding from the State Legislature. Our initial proposal, to maintain current services, present statewide programs, and improve the museum's building and grounds, was met with particular sympathy by the legislators. A statewide appeal, consisting of a campaign of letters and personal contacts, was organized by the museum's corps of 400 volunteers. Substantial bi-partisan support was obtained to enable the museum to win a recommended appropriation of $680,000 from the State Legislature that subsequently was approved by Governor William G. Milliken. This established the historic principle that the State of Michigan recognized the Institute's unique role as a State institution. The current State stipend to the Institute

of $7,100,000, together with the support given to other arts organizations and institutions, makes the State of Michigan one of the leaders in America in public funding of the arts.

In discussing the expansion of the financial base of the museum in the 1970s, it is important to mention the increased support during this period of the arts by the federal government, principally through the National Endowments for the Arts and Humanities, as well as several other agencies. In the private sector, corporations also began to show a growing interest in funding cultural activities. To increase our ability to tap these funding sources, a Department of Development was created within the Founders Society in 1973. The museum has received recently challenge grants from both national endowments, along with numerous other public and private grants.

Thus, during a period in which we experienced the closing of the galleries and a serious curtailment of our activities, we have also participated in a startling revitalization of the museum. We have established for the first time a staff and programs capable of responding to the needs of our region as well as assuring our continuing national and international importance. The diversification of funding sources has enabled the museum, on the one hand, to enlarge the concept of public ownership of its resources that had been so integral to our special identity over the years, and, on the other, to open up new potentials for our activities and growth.

The decade of the 1980s is upon us, and with it, the centennial celebration of the founding of the Detroit museum (1885-1985). As we approach this significant moment in our history, we hope to make the art collections the finest possible in a broad range of fields, to catalogue the collections and publish our research, to complete the renovation of the museum building in order to fully utilize all parts of the existing structure and grounds, to extend our service programs throughout the State of Michigan, and to continue to develop our staff and equipment in order to effectively carry out these plans.

It is intriguing to speculate upon the response of the 19th- and early 20th-century founders of the Detroit Museum to The Detroit Institute of Arts of 1985. While our size and advanced technology would obviously astound them, certainly they would grasp the continuation of several traditions they themselves established. The first is a pursuit of excellence, as we try to bring to Detroit and Michigan what, in our opinion, constitute the most important and beautiful examples of human achievement in the arts, so that objects from distant times and disparate places become part of the texture of life here and now, and hopefully transform the meaning and quality of our existence. The second is the special partnership of government, museum staff, generous individuals, and corporations, whose commitment to the quality and vitality of artistic life of our community has assured the continuation of our role as a vital cultural resource in the present and into the future.

Therefore, it is with great pleasure and pride in our accomplishments and confidence in our ability to achieve our future goals that I invite you to enjoy 300 works from the Institute's collections. *Selected Works from The Detroit Institute of Arts* was produced in conjunction with the curatorial staff by our Publications Department by Susan Panitz Fillion, Assistant Editor, and Susan F. Rossen, Senior Editor and Coordinator of Publications. The photography was done largely by Robert Hensleigh of the museum's Photography Department, under the supervision of Nemo Warr. I am grateful to each of these individuals for their dedication and hard work.

COLOR PLATES ASIAN AND ANCIENT ART

I

CH'IEN HSUAN (attrib.), Chinese, c. 1235-
after 1300

Early Autumn (detail)

Handscroll; ink and colors on paper; 26.7 x
120 cm. (10½ x 47¼ in.)

Founders Society Purchase (29.1)

See R. Edwards, "Ch'ien Hsuan and 'Early
Autumn,' " *Archives of the Chinese Art Society
of America* VII (1953): 71-83.

11

Writing Box (*Suzuribako*), Japanese, late 19th
century

Lacquer with gold, silver, and other metals;
27.3 x 24.8 x 5.1 cm. (10¾ x 9¾ x 2 in.)

Gift of Dr. and Mrs. Leo S. Figiel and
Dr. and Mrs. Steven J. Figiel (69.508)

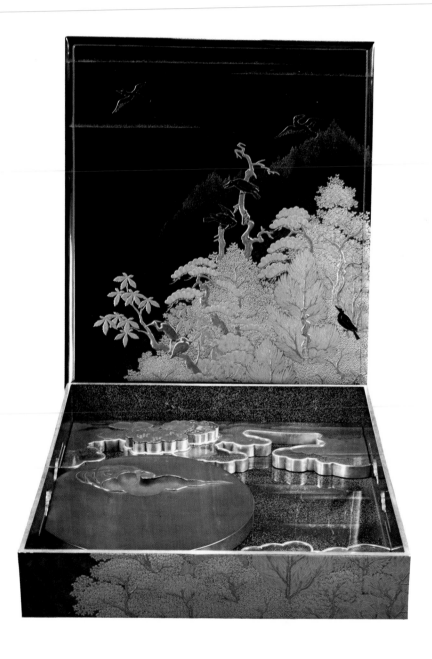

III
Lovers Reclining on a Couch, Central India,
Malwā School, Rājasthāni Style, c. 1650
Gouache and gold on paper; 21.6 x 15.2 cm.
(8½ x 6 in.)
Gift of Dr. and Mrs. Leo S. Figiel and
Dr. and Mrs. Steven J. Figiel (71.310)

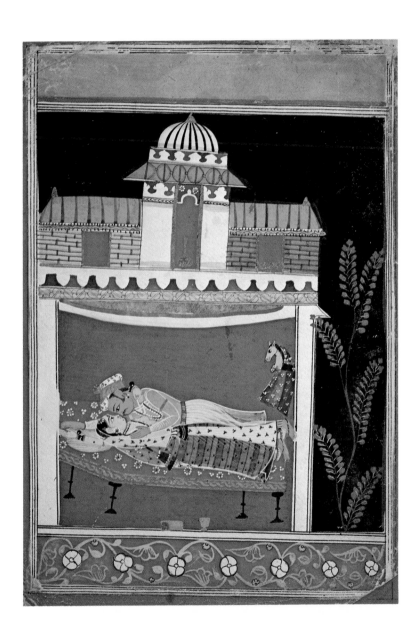

IV
Portrait of a Woman, Egyptian, Roman Period,
100/300
Encaustic on wood; 44.8 x 24.8 cm. (17⅝ x
9¾ in.)
Gift of Julius H. Haass (25.2)
See W. H. Peck, *Mummy Portraits from Roman
Egypt,* exh. cat., DIA, 1967: no. 10.

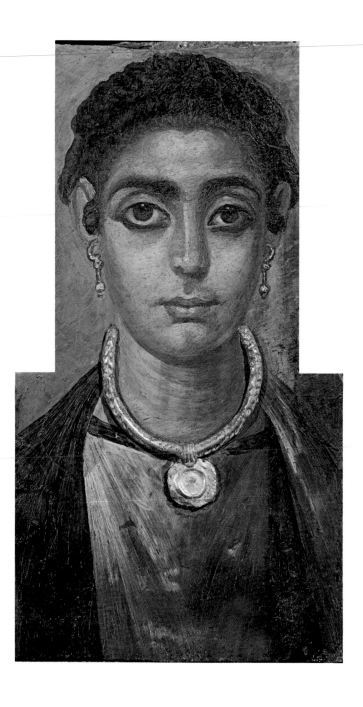

V
Relief Representing the Snake-Dragon,
Symbol of the God Marduk, Mesopotamian,
The Ishtar Gate of King Nebuchadnezzar II,
Babylon, Neo-Babylonian, 604/562 B.C.
Molded, glazed terracotta bricks; 115.6 x 167
cm. (45½ x 65¾ in.)
Founders Society Purchase (31.25)
See W. R. Valentiner, "A Dragon Relief of the
Time of Nebuchadnezzar," DIA *Bull.* 12, 7
(1931): 78-81.

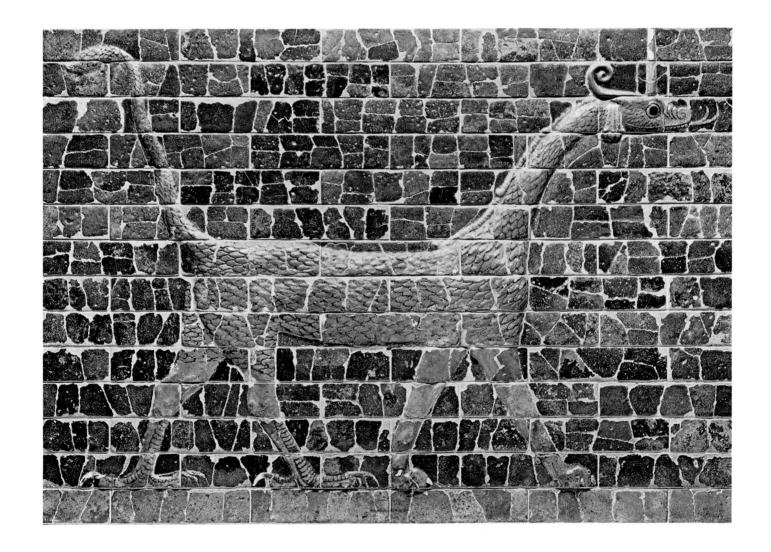

VI

Irish Prehistoric Jewelry, early to late Irish
Bronze Age, c. 1800/300 B.C. (four from group
of twelve)

Gold; diam. ranging from 22 to 3.1 cm. (8⅝ to
1¼ in.)

Founders Society Purchase, William H. Murphy
Fund (53.268, 53.274, 54.241); Gift of Mr. and
Mrs. Lawrence A. Fleischman (54.35)

See T. A. Motz, "Irish Gold in Detroit," DIA
Bull. 57, 2: (forthcoming).

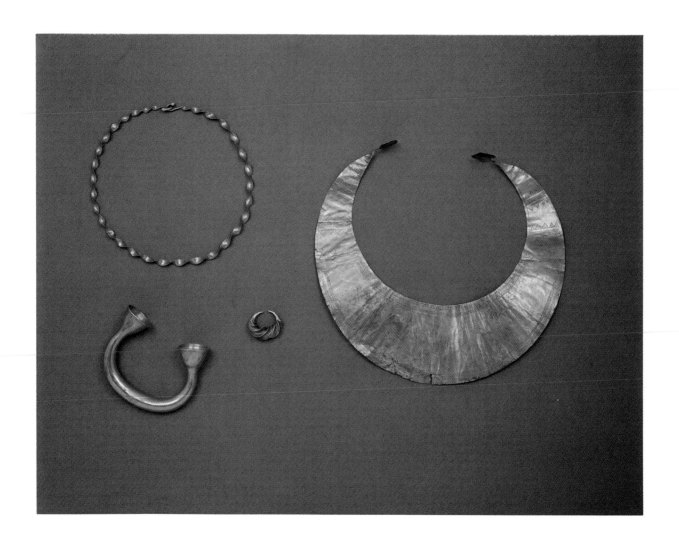

VII
Panathenaic Amphora, Greek, Attic,
c. 375/350 B.C.
Black-figured ceramic; h. (with cover) 85.1 cm.
(33½ in.)
Founders Society Purchase (50.193)
See J. D. Beazley, *Attic Black-Figure Vase
Painters,* Oxford, 1956: 412.

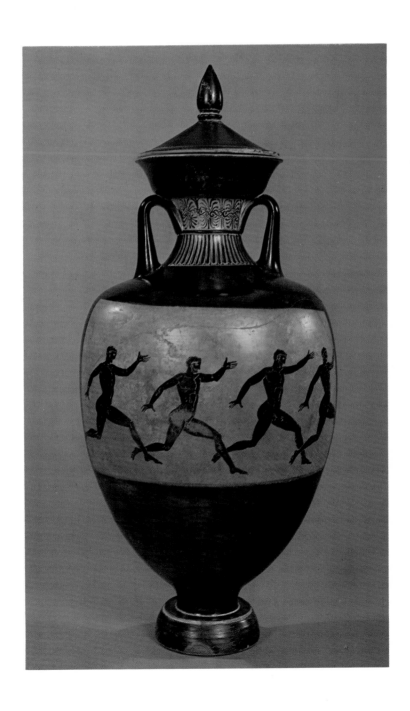

VIII

*Combat Between Ardeshir and Ardawan for the
Throne of Persia* (Page from the "Demotte"
Shah Nameh), Persian, Tabriz, Mongol Dynasty,
c. 1350
Ink and tempera on paper; 59.1 x 38.7 cm.
(23¼ x 15¼ in.)
Founders Society Purchase, Edsel B. Ford Fund
(35.54)
See E. J. Grube, *Muslim Miniature Paintings
from the XIII to XIX Century,* exh. cat., Asia
House Gallery, New York, 1962: 13-17.

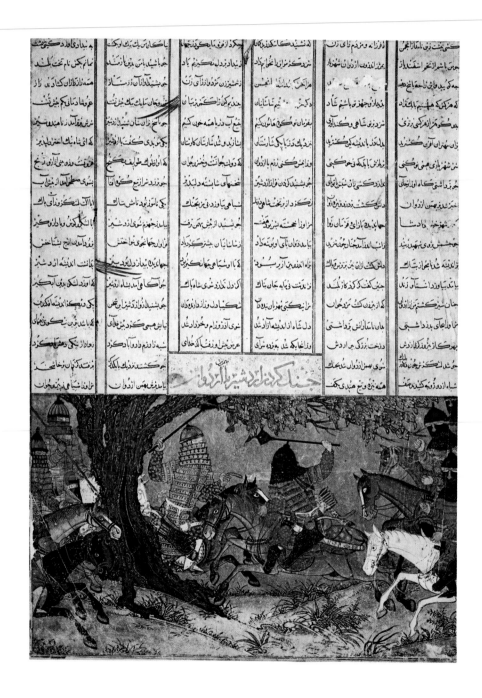

Suzanne W. Mitchell, Associate Curator

Within the Asian department are the arts of India, Southeast Asia, Indonesia, China, Korea, and Japan, spanning the centuries from prehistory to modern times. The collection includes paintings, sculptures, ceramics, lacquer, textiles, and glyptic arts.

In 1919, a Chinese and a Japanese gallery were opened at the museum with a nucleus of works from the Frederick Stearns collection of oriental art objects. A few acquisitions were made in the years following, but it was not until 1927, with the appointment of Benjamin March as Curator of Asiatic Art, that collecting became systematic. Two years later the first exhibition of Chinese art was presented at the Institute; also in 1929 every issue of the museum's *Bulletin* contained an article on Asian art, and important acquisitions were made which today stand as masterworks in the Chinese collection. Among these are the exquisite handscroll entitled *Early Autumn*, attributed to Ch'ien Hsuan; the Yuan period wood sculpture of *Sakyamuni as an Ascetic;* and the Ming period bronze *Buddha* (pl. 1, nos. 2, 4). By the early 1930s, Benjamin March had succeeded in making Asian art a vital and necessary part of a developing collection of world art in Detroit. However, as a result of March's untimely death in 1934, the fledgling department, left without a curator, nearly faded into obscurity as the decade progressed.

The period of the early 1940s can be characterized as one of renewed activity within the department not unlike that of the early 1930s. In 1941, Sherman Lee was appointed to the staff as Curator of Far Eastern Art. In the following year he organized an important loan exhibition of Buddhist art. During Dr. Lee's tenure, notable acquisitions were made in Indian and Chinese art, including the Indian bronze *Parvati* (no. 16). With the resignation of Sherman Lee in 1947, the department remained without a curator for the next 30 years. While growth of the collection did not match that of other departments during this period, acquisitions were made by Paul A. Grigaut, assistant to the Director from 1947 to 1961 and Acting Director from 1961 to 1962, and Willis F. Woods, Director of the Institute from 1962 to 1973, who also installed the collection in the present galleries. When Frederick J. Cummings became Director in 1973, a program to acquire fine Chinese paintings from the Ming and Ch'ing periods began with the purchase of *The Red Cliff* by the Ming master Wen Cheng-ming (no. 6). The search was fruitful; the acquisition of a number of other paintings followed, including an outstanding example of calligraphy by Tung Ch'i-ch'ang, entitled *Freehand Copy of Chang Hsü's [Writing of the] "Stone Record"* (no. 7). In 1978, with the appointment of Suzanne Mitchell as Associate Curator, the Department of Asian Art once again became an independent department within the Institute.

Throughout the museum's history, donors have been particularly important in the formation of the Asian collection. A fine Northern Wei *Maitreya* dated 520, and an outstanding *tz'u-chou* ware bowl were added to the Chinese collection through the generosity of Mr. and Mrs. Edsel B. Ford (no. 3). Similarly, the bronze *P'ou* and *Ode to the Pomegranate and Melon Vine*, a collaborative work of painting and calligraphy by Shen Chou and Wang Ao, were acquired as gifts from Mr. Allan Gerdau and Mr. and Mrs. Edgar B. Whitcomb, respectively (nos. 1, 5). During the directorship of Willis Woods, Justice and Mrs. G. Mennen Williams presented a large collection of Chinese and Southeast Asian ceramics to the Institute. In the same years, Dr. and Mrs. Leo S. Figiel and Dr. and Mrs. Steven J. Figiel significantly enriched the holdings of Indian paintings and Japanese lacquers (pls. II-III). The Friends of Asian Art, an auxiliary group within the Founders Society, dedicated to supporting the department and aiding the growth of the collection, was organized in 1977. To mark the founding of this organization, Mrs. Howard J. Stoddard and Mr. and Mrs. Stanford C. Stoddard established a fund for the acquisition of Asian art.

By building and exhibiting a significant collection of Asian art, it is our goal to introduce the visual delights of an imagery so different from our Western, Greco-Roman tradition, as a means for a deeper understanding of Eastern cultures.

1
Bronze Bowl (P'ou)
Chinese, Shang Dynasty, 1523/1028 B.C.
Bronze; diam. 21.6 cm. (8½ in.)
Gift of Mr. Allan Gerdau (51.300)
See M. Loehr, *Ritual Vessels of Bronze Age
China,* New York, 1968: no. 19.

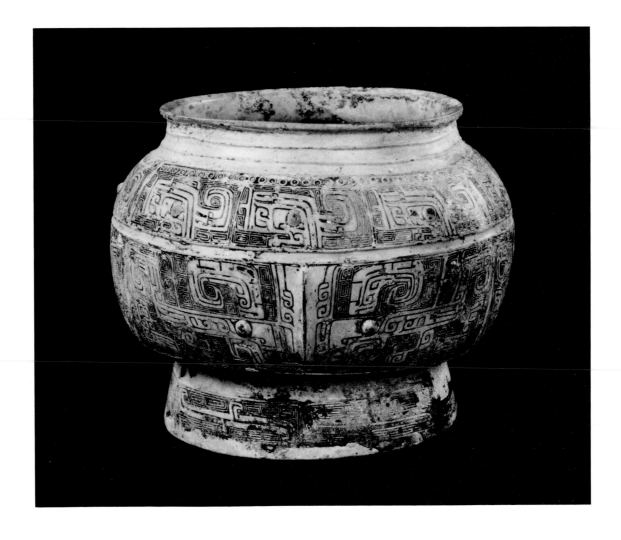

2

Sakyamuni as an Ascetic, Chinese, Yüan Dynasty, 1279/1368

Lacquered wood with traces of color and gold; h. 29.8 cm. (11¾ in.)

City Purchase (29.172)

See S. E. Lee and W-k. Ho, *Chinese Art Under the Mongols: The Yüan Dynasty (1279-1368),* exh. cat., Cleveland Museum of Art, 1968: no. 20.

3

Bowl, Chinese, Yüan Dynasty, 1279/1368

Tz'u-chou ware, buff stoneware with wash of white slip and cream glaze; diam. 23.5 cm. (9¼ in.)

Gift of Mrs. Edsel B. Ford (50.195)

See S. E. Lee and W-k. Ho, *Chinese Art Under the Mongols: The Yüan Dynasty (1279-1368),* exh. cat., Cleveland Museum of Art, 1968: no. 53.

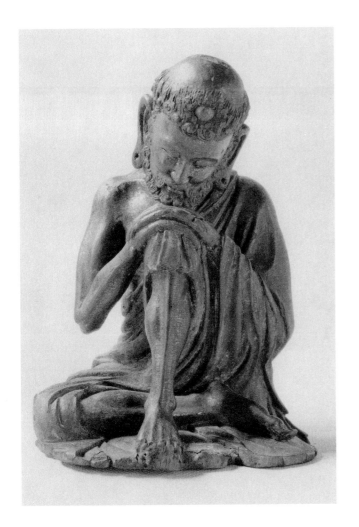

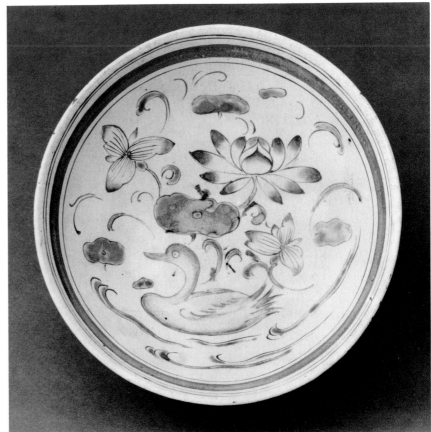

4
Buddha, Chinese, Ming Dynasty, 1368/1644
Bronze with traces of gilt; h. 116.2 cm. (45¾ in.)
City Purchase (29.245)
See B. Rowland, *The Evolution of the Buddha Image,* exh. cat., Asia House, New York, 1963: no. 49.

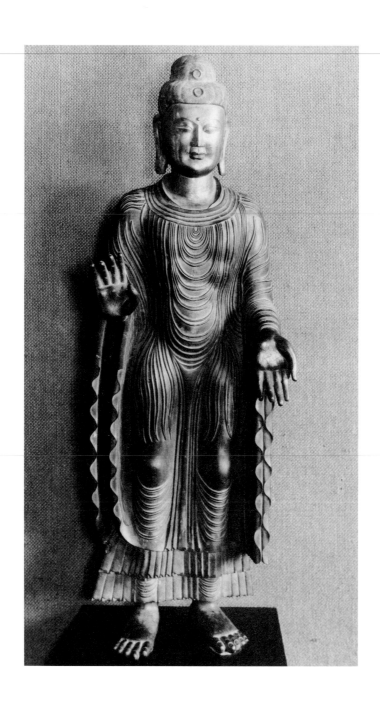

5

SHEN CHOU, Chinese (1427-1509) and WANG AO
(calligraphy), Chinese (1450-1524)
Ode to the Pomegranate and Melon Vine
Hanging scroll; ink and colors on paper;
148.9 x 75.6 cm. (58⅛ x 29¾ in.)
Gift of Mr. and Mrs. Edgar B. Whitcomb
(40.161)
See R. Edwards, *The Field of Stones,* Washington, D.C., 1962: 75, 99 (46A).

6

WEN CHENG-MING, Chinese (1470-1559)
The Red Cliff, 1558
Hanging scroll; ink on paper; 140.7 x 33 cm.
(55⅜ x 13 in.)
Founders Society Purchase, Robert H. Tannahill Foundation Fund (76.3)
See *The Art of Wen Cheng-ming,* exh. cat.,
University of Michigan Museum of Art, Ann
Arbor, and Asia House, New York, 1976: 209-12.

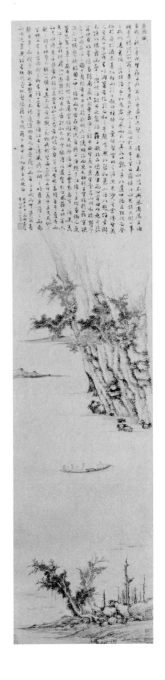

7

TUNG CH'I-CH'ANG, Chinese (1555-1636)

Freehand Copy of Chang Hsü's [Writing of the]
"Stone Record" (detail)

Handscroll; ink on satin; 27.1 x 328.9 cm.
(10⅔ x 129½ in.)

Founders Society Purchase, Henry Ford II Fund
(77.63)

See E. J. Laing, "Two-in-One: Introducing Five
Recent Acquisitions of Chinese Calligraphy and
Painting," DIA *Bull.* 56, 3 (1978): 177, 184.

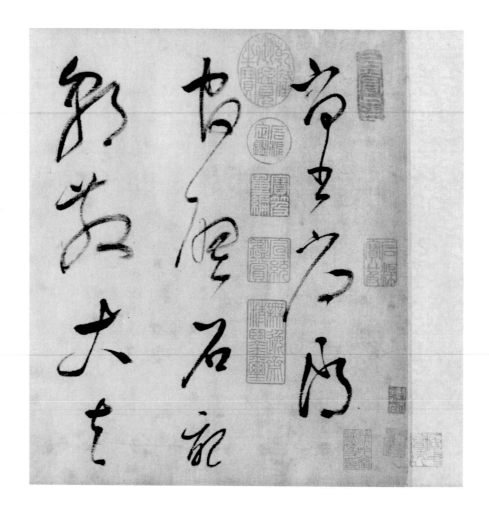

8
WANG CHIEN, Chinese (1598-1677)
Landscape in the Style of Chu-jan
Hanging scroll; ink and slight color on paper;
124.5 x 60.7 cm. (49 x 23⅞ in.)
Founders Society Purchase, Ralph H. Booth
Bequest Fund (77.91)

9
MEI CH'ING, Chinese (1623-1697)
*Mountain Stream, Large Pines, and Projecting
Cliffs,* 1691
Hanging scroll; ink and slight color on paper;
194.9 x 50.2 cm. (76¾ x 19¾ in.)
Founders Society Purchase (71.35)
See O. Sirén, *Chinese Painting: Leading Masters
and Principles,* New York, 1956, 5: 119-21.

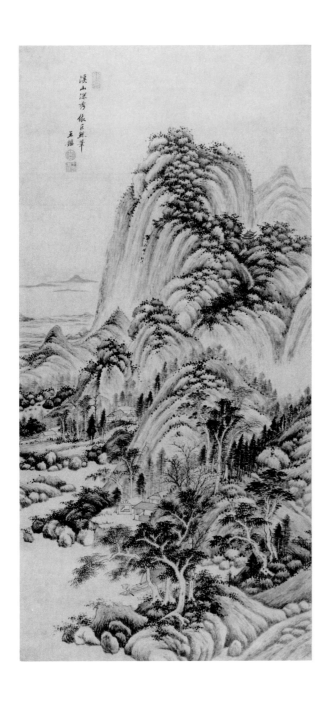

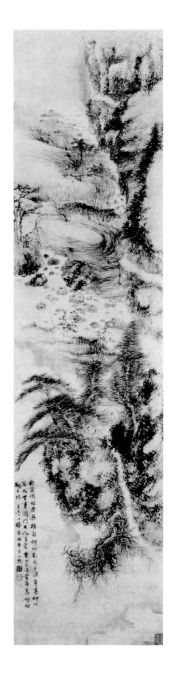

10

Jizō Bosatsu as Priest, Japanese, Kamakura
Period, 1185/1333
Wood with traces of polychrome; h. (incl. base)
83.2 cm. (32¾ in.)
Gift of K. T. Keller (61.269)
See E. J. Laing, *East of Mandalay,* exh. cat., The
Midland Art Center, Michigan, 1971: no. 41.

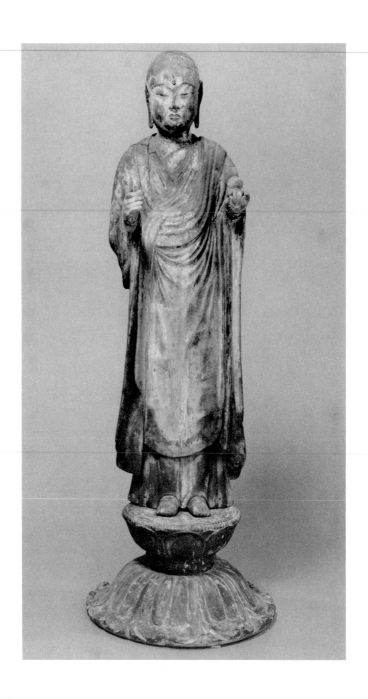

11
Lionlike Dog (Koma-inu), Japanese Momoyama
Period, c. 1600
Seto ware, glazed and gilded ceramic; h. 17.8 cm.
(7 in.)
Founders Society Purchase, Laura H. Murphy
Fund (53.348)
See H. P. Stern, *Birds, Beasts, Blossoms and Bugs:
The Nature of Japan,* New York, 1976: no. 19.

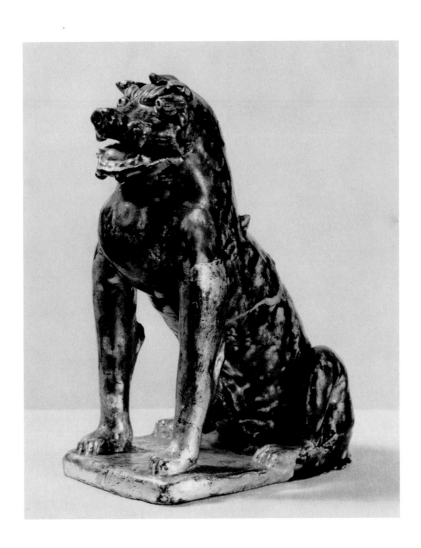

12

TAKETSUGU, Japanese (active mid-17th century)
Illustrations from the Genji Monogatari
Panels, probably from a screen, mounted as three
hanging scrolls; ink, colors, and gold on paper;
64.151: 101 x 48.3 cm. (39¾ x 19 in.); 64.152:
91.4 x 38.7 cm. (36 x 15¼ in.); 64.153: 100 x 48
cm. (39⅜ x 18⅞ in.)
Founders Society Purchase, the John and Rhoda
Lord Fund (64.151-53)
See J. Hillier, *Catalogue of the Japanese Paint-
ings and Prints in the Collection of Mr. and Mrs.
Richard P. Gale*, London, 1970, I: 19.

13

WATANABE SHIKO, Japanese (1683-1755)
Owl with Red Leaves
Panel, probably from four-fold screen mounted
as a hanging scroll; ink and color on paper;
181 x 43 cm. (71¼ x 16⅞ in.)
Founders Society Purchase, Mary Martin
Semmes Fund (59.405)
See H. P. Stern, *Birds, Beasts, Blossoms and Bugs:
The Nature of Japan,* New York, 1976: no. 41
(color ill.).

14

SOGA SHOHAKU, Japanese (1730-1783)
Lion
Hanging scroll; ink on paper; 114.3 x 49.4 cm.
(45 x 19⁷⁄₁₆ in.)
Founders Society Purchase (74.47)

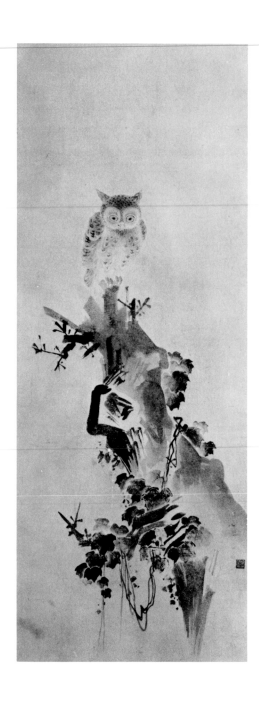

15
Chamunda, South Indian, Chola Period, c. 850/
1150
Stone; h. 111.8 cm. (44 in.)
Founders Society Purchase, L. A. Young Fund
(57.88)

16
Parvati, South Indian, Vijayanagar Period, 1300/
1400
Bronze; h. (incl. base) 103.8 cm. (40⅞ in.)
Founders Society Purchase, Sarah Bacon Hill
Memorial Fund (41.81)
See *Master Bronzes of India*, exh. cat., The Art
Institute of Chicago, etc., 1965: no. 56.

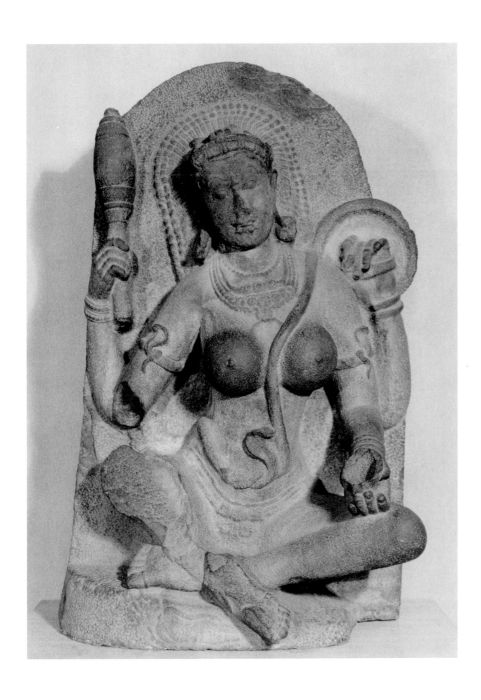

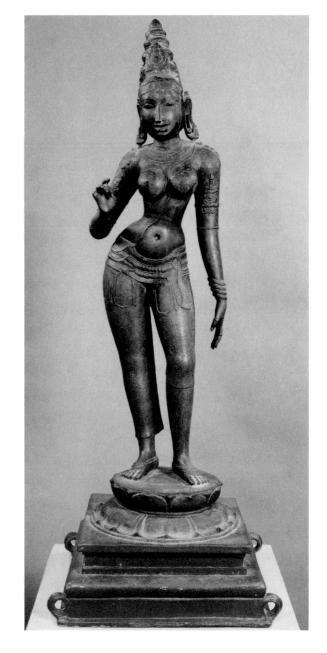

William H. Peck, Curator
Elsie H. Peck, Research Associate

The Department of Ancient Art has as its responsibility all of the cultures of the Mediterranean area, the Ancient Near East, and the Islamic Near East. This includes Egypt, Mesopotamia, and ancient Iran, as well as Greece, Etruria, and Rome. The holdings of the department are diverse, ranging from sculpture and ceramics to bronze, glass, textiles, and painting. The collections had their beginnings in the old Detroit Museum of Art with the gift of a large number of objects from Frederick Stearns. Like most late 19th-century accumulations of antiquities, the Stearns collection was diverse, including art and craft objects from the Middle East and the Orient, and ranging in size from a pair of full-scale Japanese wrestlers in lacquer to tiny seal stones, but it reflected an interest in "curiosities" rather than works of art.

The real beginning of the serious collection of ancient art came under Director Dr. William R. Valentiner in the 1920s, when he set out to find objects of quality. Valentiner provided, through careful purchase, the nucleus of a representative survey of classical, Egyptian, and Near Eastern art, including the first Egyptian relief to enter the collection, Greek ceramics, Luristan bronzes, and Roman portrait heads (pls. IV-V). The Depression years saw little added to the department and it was not until the mid-1940s that an attempt was made to fill gaps by the acquisition of small but important works such as the relief of Ka-aper, and the Etruscan bronze rider (nos. 18, 31). The Department of Ancient Art was created in 1968 with a separate curator, William H. Peck. Before this appointment, the ancient art in the museum had been under the care of Francis W. Robinson, Curator of Ancient and Medieval Art, who held this position from 1955. Prior to that date the holdings of ancient art were not large enough to be considered a full-scale department. In 1970, with the addition of the North Wing, the exhibition space for the department was expanded to the present ten galleries.

The historical survey of ancient art begins with a selection of Pre-historic stone-age tools and an important collection of gold objects from the Bronze Age in Ireland (pl. VI). From the Ancient Near East, Mesopotamia is represented by important Assyrian wall reliefs and a glazed tile relief from Babylon (pl. V, no. 23). Persian art includes relief carvings from Persepolis and a Sasanian silver bowl (nos. 24-25). The Egyptian collection is especially rich in Old Kingdom tomb reliefs, sculpture from various periods, and a survey of the decorative arts. Marble sculpture and Attic vase painting highlight the Greek collection, while the Etruscans are represented by bronze sculpture, ceramics, and stone cinerary urns. The Roman collection includes a fine survey of Roman portraiture as well as pottery, glass, fresco painting and mosaics.

A number of famous names in the history of archaeology are associated with objects in the collection. Pottery excavated by Schliemann at Troy can be seen in the Mesopotamian gallery, as well as the relief of Tiglath Pileser III, which was found by Austin Henry Layard at Nimrud (no. 23). The Egyptian relief of cattle and fishermen was acquired for the museum by Howard Carter, the discoverer of the tomb of Tutankhamum, and the Chapel Wall of Merynesut was excavated near the Great Pyramid at Giza by G. A. Reisner. Many other objects have come over the years as gifts and purchases which have been in the hands of important collectors such as Murch, MacGregor, Hilton-Price, Spencer-Churchill, and William Nelson, Admiral Nelson's brother. The museum has been the recipient of material from excavations carried out by the Egypt Exploration Fund, Princeton University, the Etruscan Foundation, and other institutions.

The collection of Islamic Near Eastern art, although small, comprises many excellent examples of the arts of painting, textiles, calligraphy, metalwork, ceramics, woodcarving, and glass. These objects span the period from the eighth century to modern times and were produced in Egypt, Syria, Turkey, Iraq, and Iran. Most strongly represented are early Persian ceramics and metalwork of the ninth to the thirteenth centuries and Safavid Persian seventeenth-century textiles and miniatures. The collection began to be formed in the 1920s and '30s under the guidance of Valentiner, who acquired fine examples of Seljuk bronze work, Persian ceramics, and Egyptian woodcarvings.

One of the most important purchases in any field by the museum was a miniature page from the "Demotte" *Shah Nameh,* a 14th-century Mongol painting, bought through the Edsel B. Ford Fund, from the most famous Persian manuscript in existence (pl. VIII). Representative pieces of early Egyptian, Persian, and Turkish textiles and Persian pottery entered the museum's collection in the mid-20th-century. At this time, a small group of Persian 17th-century miniature paintings by celebrated masters was also acquired. In the last eight years the collection has been increased by the addition of several pieces of Persian ceramics, metalwork, and glass.

What was begun as a collection of oddities and curiosities has developed, over the years, into an important segment of the museum's collections. The past 15 years have been a period of great growth for the ancient collections, which have taken their place as an important resource for the people of Detroit and Michigan.

17
Painted Jar, Egyptian, Pre-Dynastic, 3600/3200
B.C.
Ceramic; h. 18.4 cm. (7¼ in.)
Gift of the J. M. Pincus Foundation (70.656)

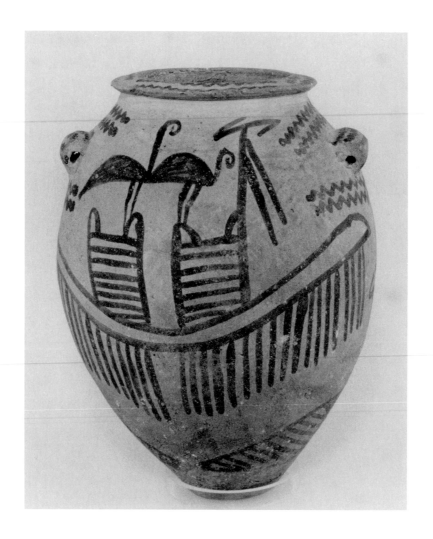

18

Ka-aper with Offerings, Egyptian, Old Kingdom, early 5th Dynasty, c. 2565 B.C.

Painted limestone; 50.5 x 62 cm. (19⅞ x 24⅜ in.)

Founders Society Purchase, Sarah Bacon Hill Memorial Fund (57.58)

See H. G. Fisher, "A Scribe in the Army in a Saqqara Mastaba of the Early Fifth Dynasty," *Journal of Near Eastern Studies* 18, 4 (1959): 233-72.

19

Standing Figure of Sebek-em-hat, Egyptian, Middle Kingdom, late 12th- early 13th Dynasty, c. 1900/1700 B.C.

Limestone; h. 48.3 cm. (19 in.)

Founders Society Purchase, Sarah Bacon Hill Memorial Fund (51.276)

See W. K. Simpson, "A Statuette of a Devotee of Seth," *Journal of Egyptian Archaeology* 62 (1976): 41-44.

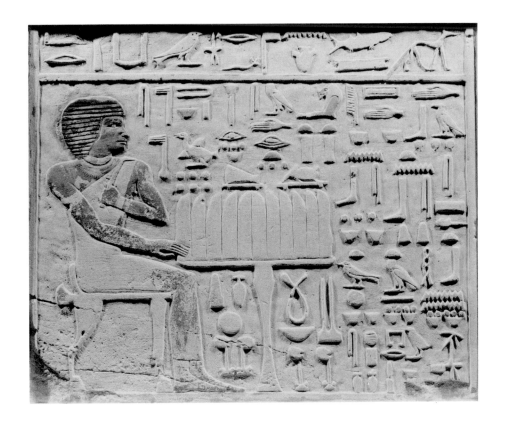

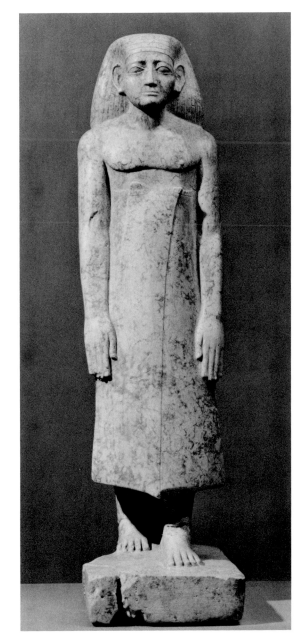

20
Seated Scribe, Egyptian, New Kingdom, 18th Dynasty, 1570/1342 B.C.
Basalt; h. 6.4 cm. (2½ in.)
Gift of Mrs. Lillian Henkel Haass and Miss Constance Haass (31.70)
See W. H. Peck, "Two Seated Scribes of Dynasty Eighteen," *Journal of Egyptian Archaeology* 64 (1978): 72-75.

21
Head of a Man, Egyptian, Ptolemaic Period, c. 250 B.C.
Black diorite; h. 19.7 cm. (7¾ in.)
City Purchase (40.47)
See B. V. Bothmer, *Egyptian Sculpture of the Late Period*, exh. cat., Brooklyn Museum, New York, 1960: no. 104.

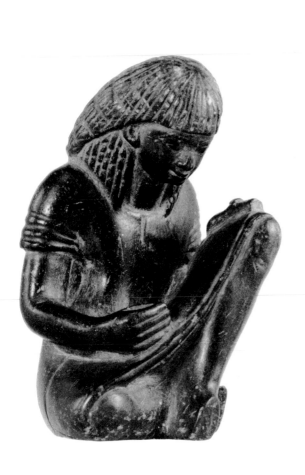

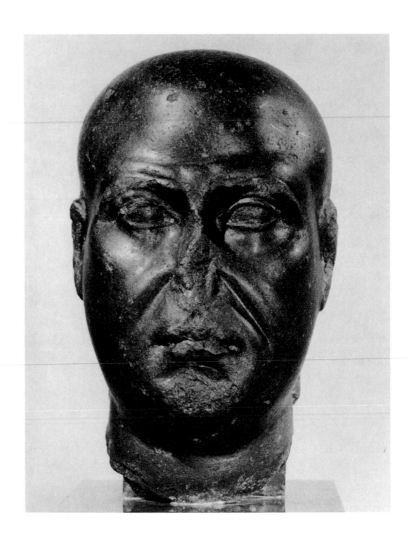

22
Whetstone with Socket in the Form of an Ibex,
Iranian, Luristan, c. 850/650 B.C.
Bronze and stone; l. 22.9 cm. (9 in.)
Founders Society Purchase, Activities Committee
Fund (67.163)
See W. H. Peck, "Luristan Bronzes in the Collection of The Detroit Institute of Arts," DIA *Bull.*
47, 2 (1968): 32, 34.

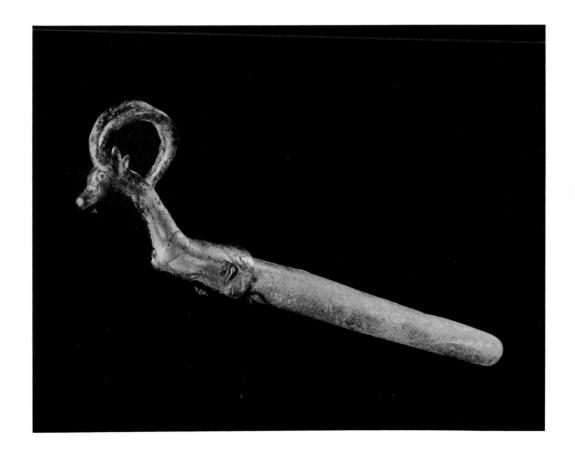

23
Relief Representing the Assyrian King Tiglath-Pileser III Receiving Homage from a Conquered Enemy, Mesopotamian, Southwest Palace, Nimrud (Kalah), Neo-Assyrian, 744/727 B.C.

Alabaster; 122 x 238.8 cm. (48 x 94 in.)

Founders Society Purchase, Ralph H. Booth Bequest Fund (50.32)

See F. W. Robinson, "An Assyrian Relief of Tiglath-Pileser III," DIA *Bull.* 29, 4 (1949-50): 86-89.

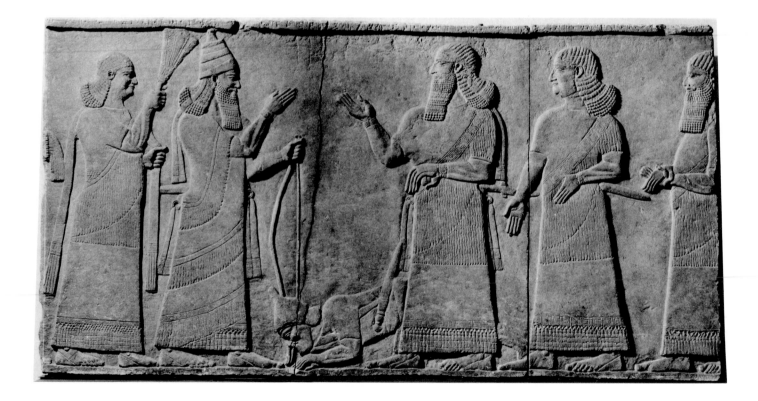

24
Relief Fragment Representing a Persian Court Servant Carrying a Covered Tray, Iranian, Persepolis, Achaemenid Dynasty, 500/400 B.C.
Limestone; 54.6 x 29.2 cm. (21½ x 11½ in.)
Gift of Mrs. Lillian Henkel Haass (31.340)

25
Bowl with Carved and Chased Decoration of Animals and Birds Amid Grape Vines, Iranian, Sasanian Dynasty, 500/600
Silver, gilt; diam. 13.7 cm. (5⅜ in.)
Founders Society Purchase, Sarah Bacon Hill Memorial Fund (62.266)
See E. H. Peck, "A Sasanian Silver Bowl," DIA *Bull.* 47, 2 (1968): 23-28.

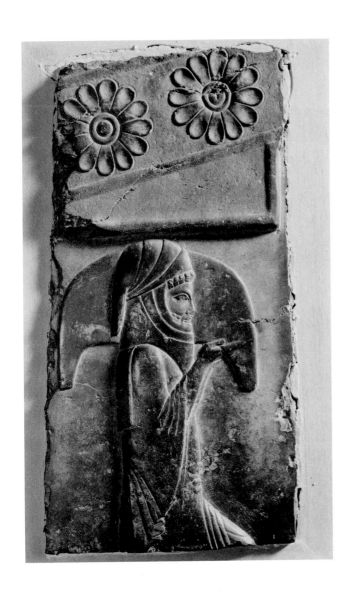

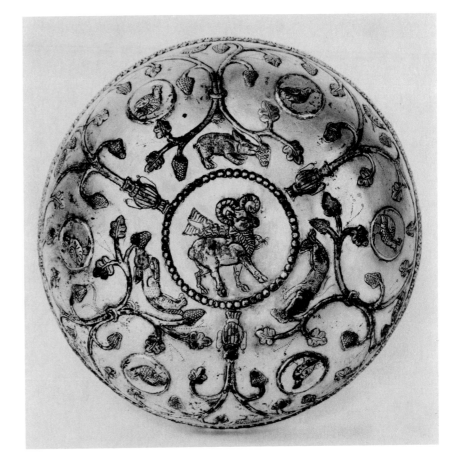

26

Ceremonial Helmet, Thraco-Getian, Iron Gates
region of the Danube, c. 400 B.C.
Chased silver; h. 24.1 cm. (9½ in.)
Founders Society Purchase, Sarah Bacon Hill
Memorial Fund (56.18)
See B. Goldman, "A Scythian Helmet from the
Danube," DIA *Bull.* 42, 4 (1963): 63-72.

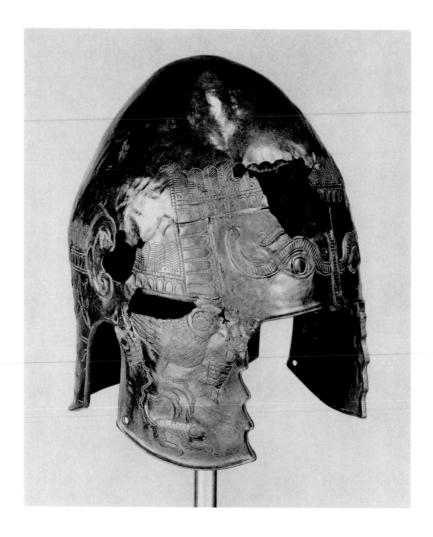

27
Man Playing Syrinx, Cycladic, Early Bronze Age,
2600/2000 B.C.
Marble; h. 26 cm. (10¼ in.)
Founders Society Purchase, Dr. Lester W. Cameron Bequest Fund (65.80)
See *Early Art in Greece,* exh. cat., André Emmerich Gallery, New York, 1965: no. 28.

28
Head of a Bearded Man, Cypriot, 600/500 B.C.
Limestone; h. 31.8 cm. (12½ in.)
City Purchase (24.105)

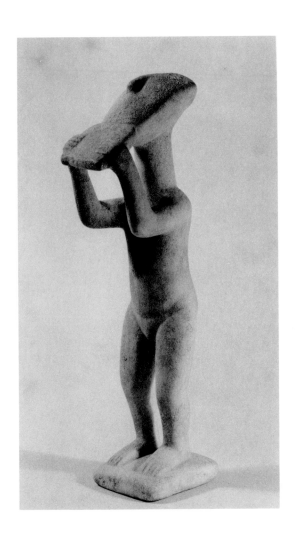

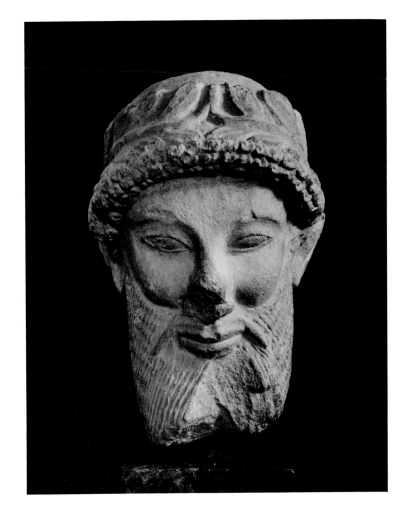

29
Torso of Apollo, Roman, 1st century A.D., copy
of early 5th-century B.C. Greek original
Marble; h. 148.6 cm. (58½ in.)
City Purchase (26.122)

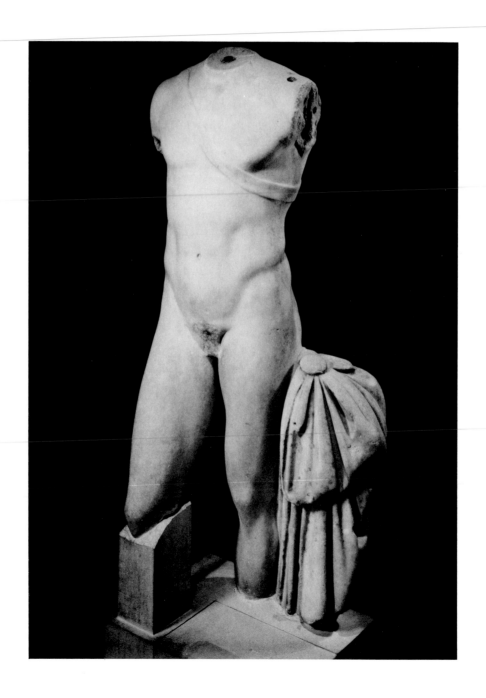

30
Torso of Aphrodite (Venus Genetrix type), Roman, 1st century A.D., copy of late 5th-century B.C. Greek original
Marble; h. 168.9 cm. (66½ in.)
Gift of Mr. and Mrs. Henry Ford II (74.53)
See W. H. Peck, "A New Aphrodite in Detroit," DIA *Bull.* 54, 3 (1976): 124- 32.

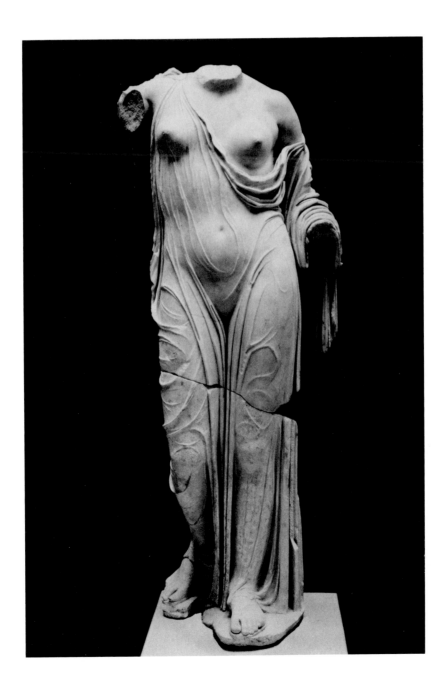

31
Rider, Etruscan, c. 430 B.C.
Bronze; h. 26.7 cm. (10½ in.)
City Purchase (46.260)
See DIA *Bull.* 31, 3-4 (1951-52): 67.

32
Bull, Roman, late 1st century B.C./early 1st century A.D.
Bronze; h. 15.9 cm. (6¼ in.)
City Purchase (45.120)
See *Master Bronzes from the Classical World,* exh. cat., Fogg Art Museum, Cambridge, Mass., 1968: no. 283.

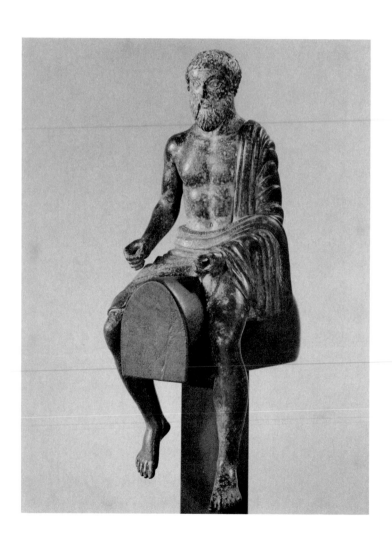

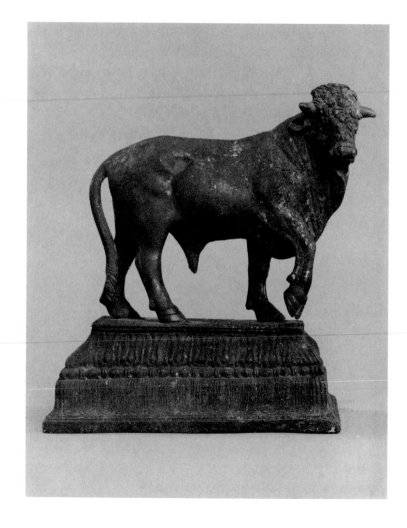

33
Togate Statue of a Youth (possibly Nero), Roman, Julio-Claudian Period, c. 52
Marble; h. 139.7 cm. (55 in.)
Founders Society Purchase, Various Funds (69.218)
See W. H. Peck, "A Youthful Nero," DIA *Bull.* 50, 3 (1971): 52-58.

34
Torso of an Emperor in Armor, Roman, 100/300
Marble; h. 114.3 cm. (45 in.)
Founders Society Purchase, Matilda R. Wilson Fund (72.273)

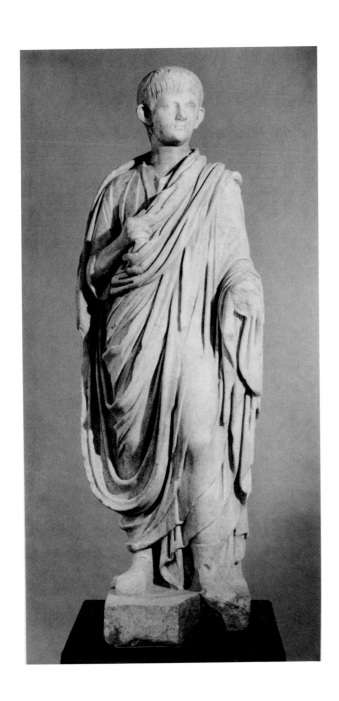

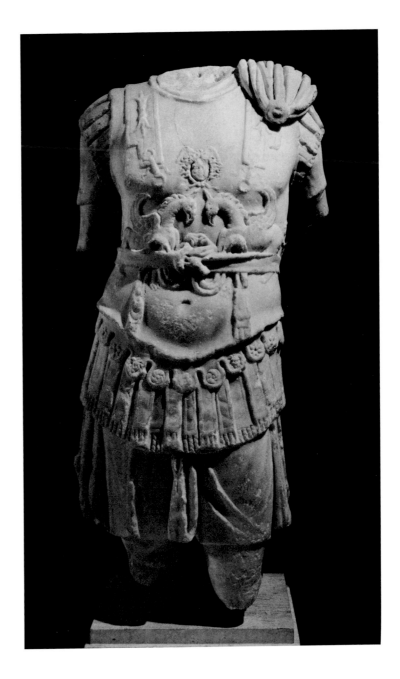

35
Gladiator's Parade Helmet, Roman, 1st/3rd century
Bronze; h. 35.3 cm. (13 ⅞ in.)
Gift of Mr. and Mrs. Edgar B. Whitcomb (48.214)
See DIA *Bull.* 31, 3-4 (1951-52): 68.

36
Illuminated Page from a Koran in Kufic Script, Mesopotamian, Abbasid Dynasty, 800/900
Ink and color on parchment; 54.6 x 62.2 cm. (21½ x 24½ in.)
City Purchase (30.317)

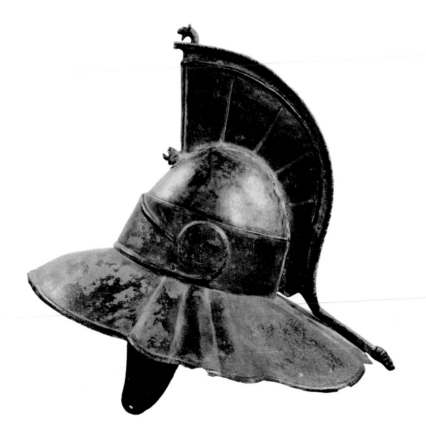

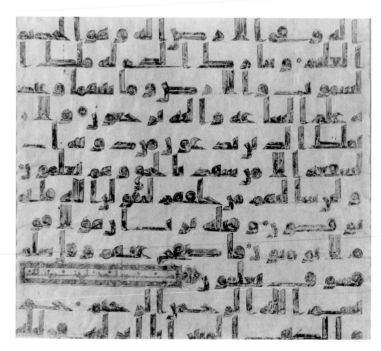

37
Bracelet (with inscription translating: "Sovereignty Belongs to God"), Egyptian or Syrian, Novorrossijsk, Fatimid Dynasty, 1000/1100
Gold; diam. 7 cm. (2¾ in.)
Gift of Mrs. Roscoe B. Jackson (26.15)
See A. C. Eastman, "An Islamic Gold Bracelet," DIA *Bull.* 7, 6 (1926): 69-70.

38
Stand or Candlestick with Openwork Design of Sphinxes and Harpies, Persian, Seljuk Dynasty, 1100/1300
Bronze; h. 48.3 cm. (19 in.)
City Purchase (29.362)
See M. Aga-Oglu, "A Bronze Candlestick of the Thirteenth Century," DIA *Bull.* 11, 6 (1930): 84-86.

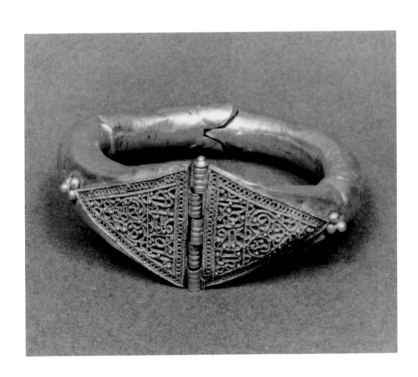

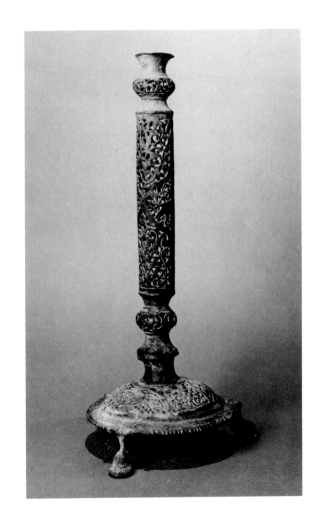

39
*'Minai' Bowl with Scene from the Shah Nameh
Representing the Victorious Sasanian King Fer-
idun and the Hero Khaveh with the Dethroned
King Zohak Maran*, Persian, Central Iran, Seljuk
Dynasty, early 13th century
Glazed earthenware; diam. 21 cm. (8¼ in.)
City Purchase (30.421)
See M. Aga-Oglu, "A Rhages Bowl with a Repre-
sentation of an Historical Legend," DIA *Bull*. 12,
3 (1930): 31-32.

40
Double Cloth Representing Scene with Boats,
Persian, Isfahan, Safavid Dynasty, c. 1600
Double-sided woven silk; 22.9 x 13.3 cm.
(9 x 5¼ in.)
City Purchase (47.2)
See A. Welch, *Shah 'Abbas and the Arts of Isfa-
han*, exh. cat., Asia House Gallery, New York and
Fogg Art Museum, Cambridge, Mass., 1973-74:
no. 19 and end papers (color ill.)

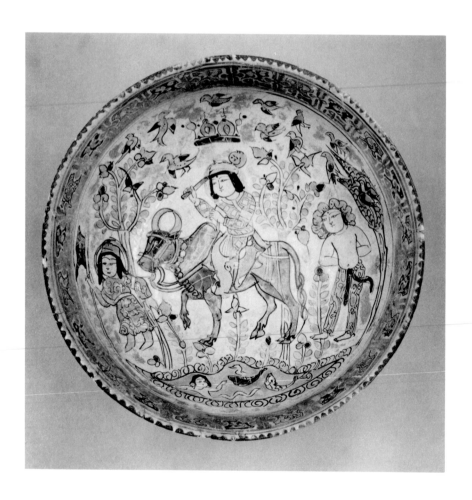

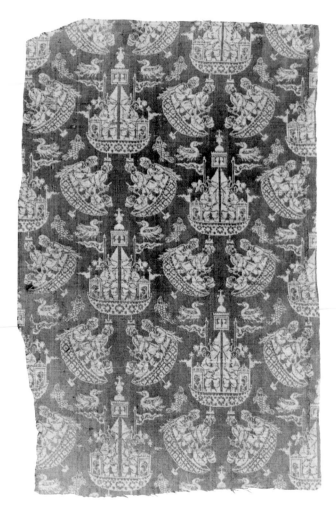

COLOR PLATES EUROPEAN ART

IX
JAN BAPTIST WEENIX, Dutch (1621-1660)
Italian Peasants and Ruins, c. 1649
Oil on canvas; 66.7 x 80 cm. (26¼ x 31½ in.)
Gift of Mrs. John A. Bryant in memory of her
husband (41.57)
See W. Stechow, "Jan Baptist Weenix," *Art
Quarterly* 11, 3 (1948): 188.

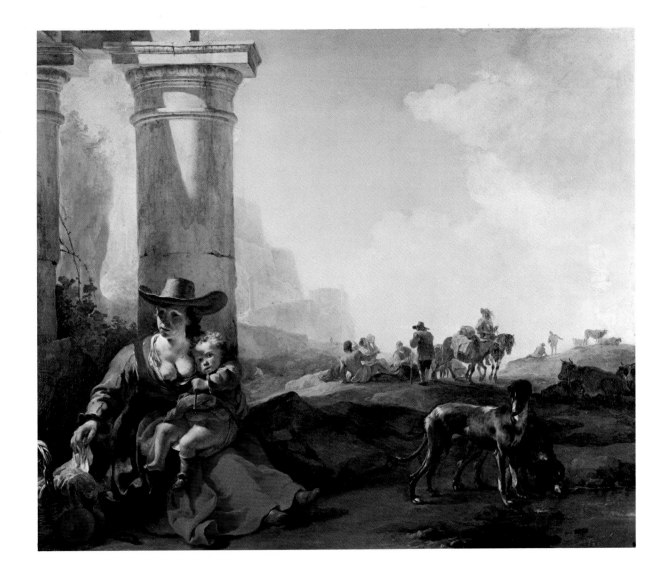

X
JOSHUA REYNOLDS, English (1723-1792)
Mrs Richard Paul Jodrell, 1774/76
Oil on canvas; 76.2 x 63.5 cm. (30 x 25 in.)
Bequest of Eleanor Clay Ford (77.7)
See E. Waterhouse, "Three British Portraits,"
DIA *Bull.* 57, 1 (1979): 41ff.

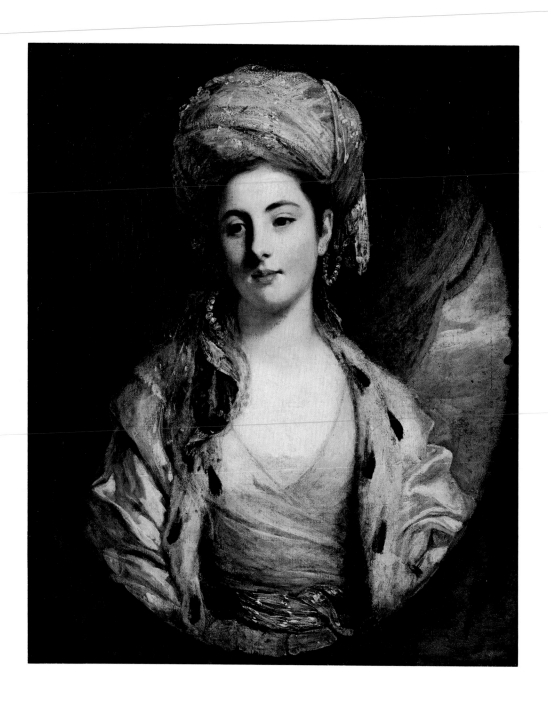

XI
JAN VAN EYCK, Flemish (c. 1390-1441)
St. Jerome in His Study, 1430/31
Panel; 20 x 12.7 cm. (7⅞ x 5 in.)
City Purchase (25.4)
See E. C. Hall, "Cardinal Albergati, St. Jerome
and the Detroit Van Eyck," *Art Quarterly* 31, 1
(1968): 2-34.

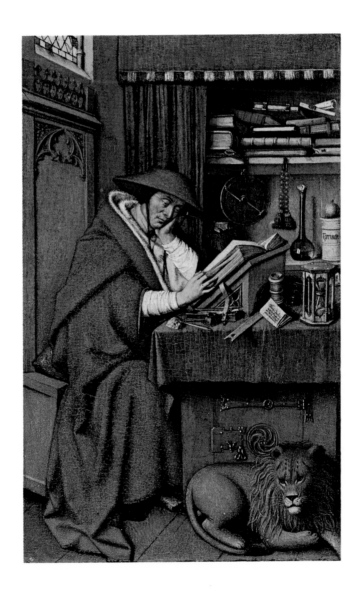

XII

HANS HOLBEIN THE YOUNGER, German (1497/98-1543)

Portrait of a Woman, 1532/35

Oil and tempera on panel; 23.4 x 19.1 cm.
(9⅛ x 7½ in.)

Bequest of Eleanor Clay Ford through the generosity of Benson and Edith Ford, Benson Ford, Jr., and Lynn Ford Alandt (77.81)

See K. Baetjer, "A Portrait by Holbein the Younger," DIA *Bull.* 57, 1 (1979): 25-29.

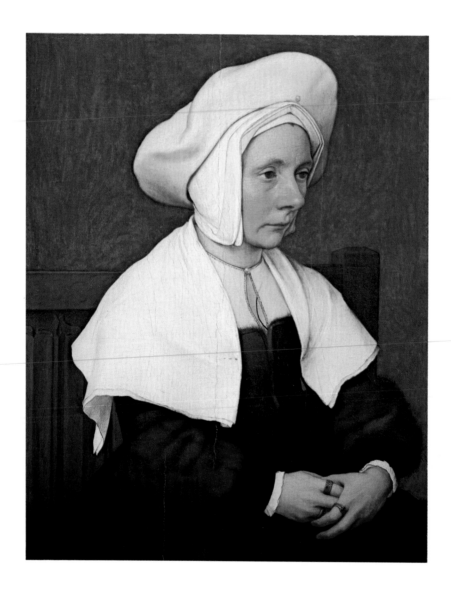

XIII
PIETER BRUEGEL THE ELDER, Flemish
(1525/30-1569)
The Wedding Dance, 1566
Tempera on panel; 119.4 x 157.5 cm. (47 x 62 in.)
City Purchase (30.374)
See E. Scheyer, "*The Wedding Dance* by Pieter
Bruegel the Elder in The Detroit Institute of Arts:
Its Relations and Derivations," *Art Quarterly*
28, 3 (1965): 167-93.

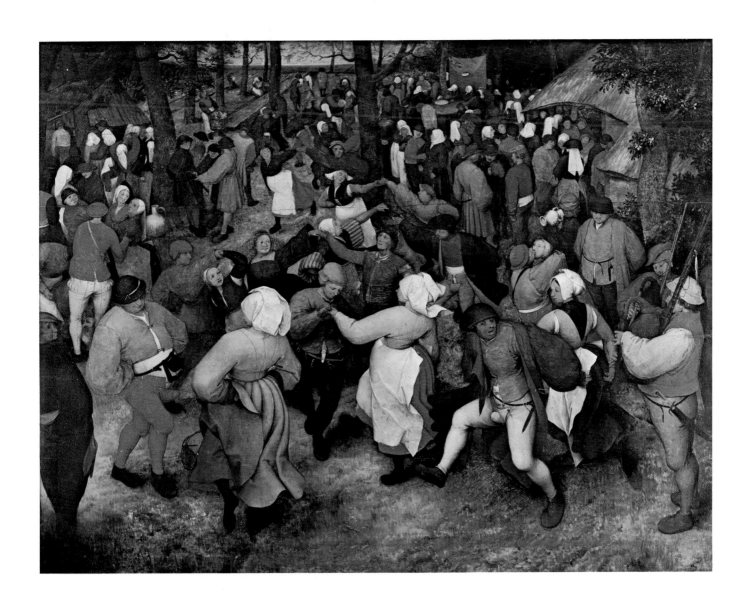

XIV
J. P. MELCHIOR (attrib.), German
The Chinese Emperor, c. 1770
Porcelain; h. 40.3 cm. (15 ⅞ in.)
Gift of James S. Holden in memory of his
mother, Mrs. E. G. Holden (51.59)
See P. L. Grigaut in DIA *Bull.* 30, 3-4 (1951): 73ff.

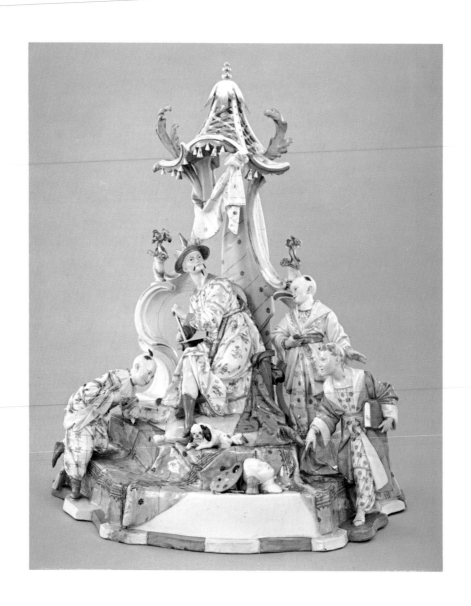

XV

JEAN-HONORE FRAGONARD, French (1732-1806)
Scenes of Country Life: The Shepherdess, 1753
Oil on canvas; 143.5 x 90.2 cm. (56½ x 35½ in.)
Founders Society Purchase, Mr. and Mrs.
Horace E. Dodge Memorial Fund (71.390)
See *Paris-New York,* exh. cat., Wildenstein
Gallery, New York, 1977: no. 37.

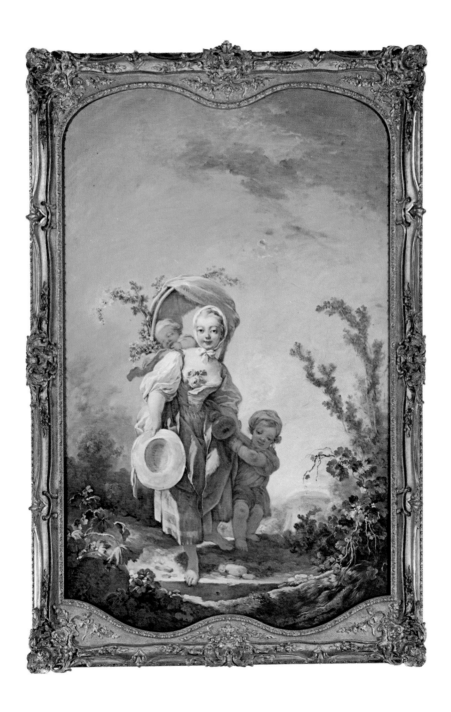

XVI

GEORGES SEURAT, French (1859-1891)
View of Le Crotoy, From Upstream, 1889
Oil on canvas; 70.5 x 86.7 cm. (27¾ x 34⅛ in.)
Bequest of Robert H. Tannahill (70.183)
See J. S. Newberry, "The Age of Impressionism
and Realism," *Art News* 38, 8 (1940): 13, 16.

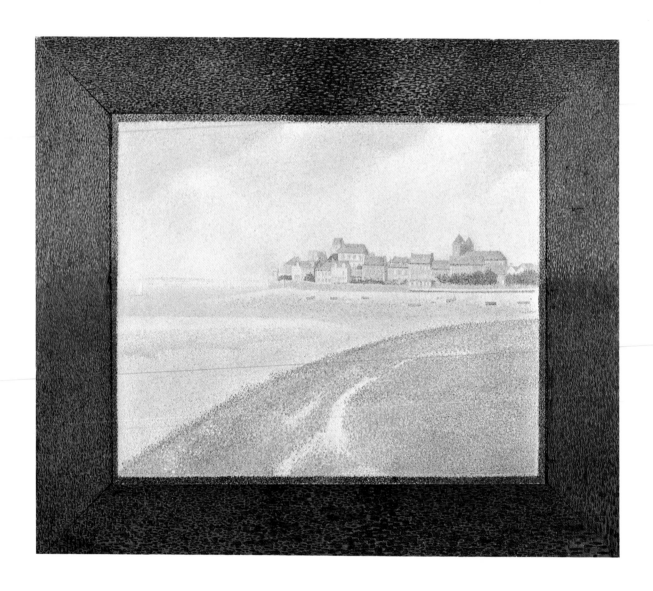

XVII
PAUL GAUGUIN, French (1848-1903)
Self Portrait, c. 1890
Oil on canvas; 46.2 x 38.1 cm. (18³⁄₁₆ x 15 in.)
Gift of Robert H. Tannahill (69.306)
See K. Mittelstädt, *Paul Gauguin Self-Portraits,*
Oxford, 1968: 64.

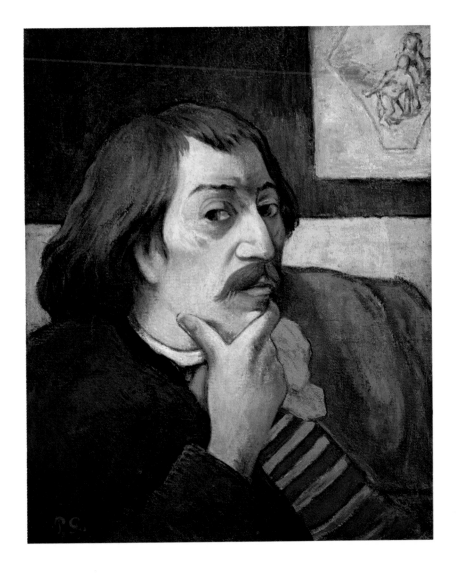

XVIII

MARTIN CARLIN, French (d. 1785)
Jewel Cabinet, Louis XV/XVI transitional style,
c. 1774
Tulipwood, Sèvres plaques, ormolu mounts;
h. 90.1 cm. (35½ in.)
Bequest of Mrs. Horace E. Dodge in memory of
her husband (71.196)
See R. L. Winokur, "The Mr. and Mrs. Horace E.
Dodge Memorial Collection," DIA *Bull.*
50, 7 (1971): 45.

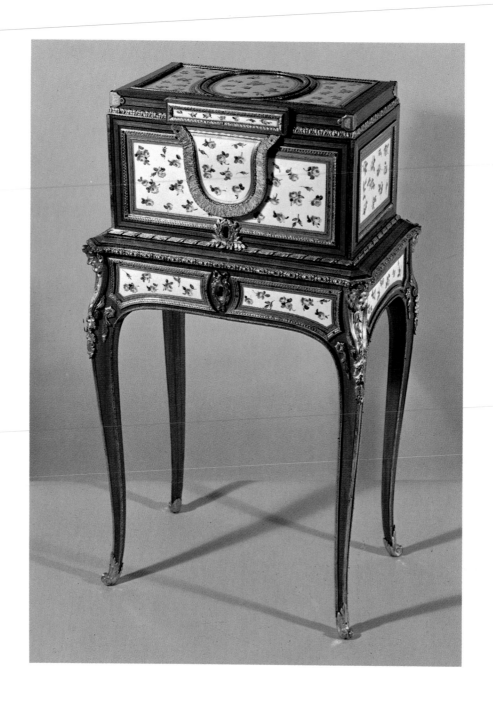

XIX
MASTER OF THE OSSERVANZA, Italian,
active c. 1430-1450
The Resurrection, c. 1435
Tempera and gold leaf on panel; 36.2 x 45.4 cm.
(14¼ x 17⅞ in.)
Gift of Mr. and Mrs. Henry Ford II (60.61)
See E. P. Richardson, *"The Resurrection* by the
Master of Osservanza," DIA *Bull.* 39, 3-4
(1959-60): 75-77.

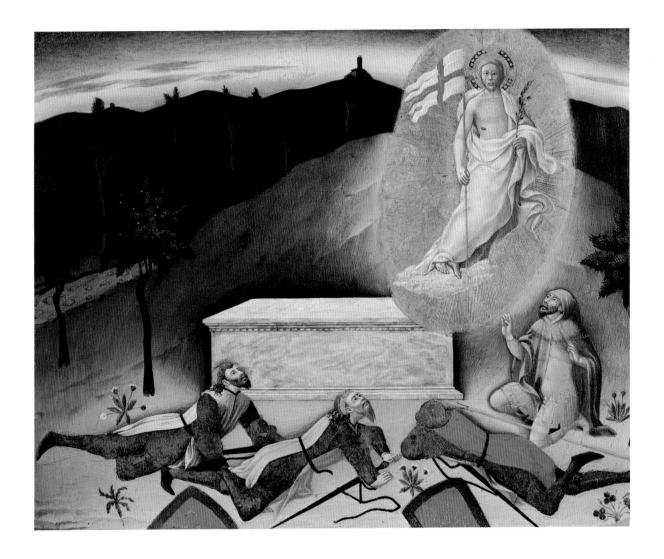

XX
FRA ANGELICO, Italian (c. 1400-1455)
Annunciatory Angel, 1450/55 (one of a pair—see no. 106)
Panel; 33 x 27 cm. (13 x 10⅝ in.)
Bequest of Eleanor Clay Ford (77.1.1)
See J. Pope-Hennessy, "The Ford Italian Paintings," DIA *Bull.* 57, 1 (1979): 15-18.

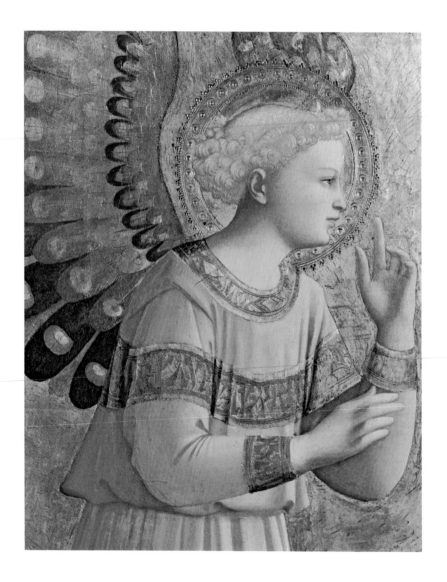

XXI
PIETRO PERUGINO, Italian (c. 1450-1523)
Madonna and Child, c. 1500
Panel; 80.6 x 64.8 cm. (31¾ x 25½ in.)
Bequest of Eleanor Clay Ford (77.3)
See J. Pope-Hennessy, "The Ford Italian Paint-
ings," DIA *Bull.* 57, 1 (1979): 20-22.

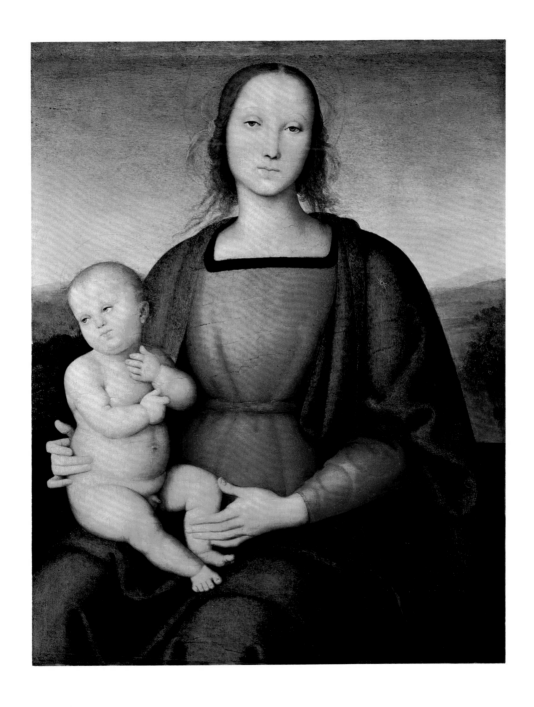

XXII

MICHELANGELO MERISI DA CARAVAGGIO, Italian
(1573-1610)

The Conversion of the Magdalen (The Alzaga Caravaggio), 1597/98

Oil on canvas; 97.8 x 132.7 cm. (38½ x 52¼ in.)

Gift of the Kresge Foundation and Mrs. Edsel B. Ford (73.268)

See *Burlington Magazine* 116 (1974): 559-616.

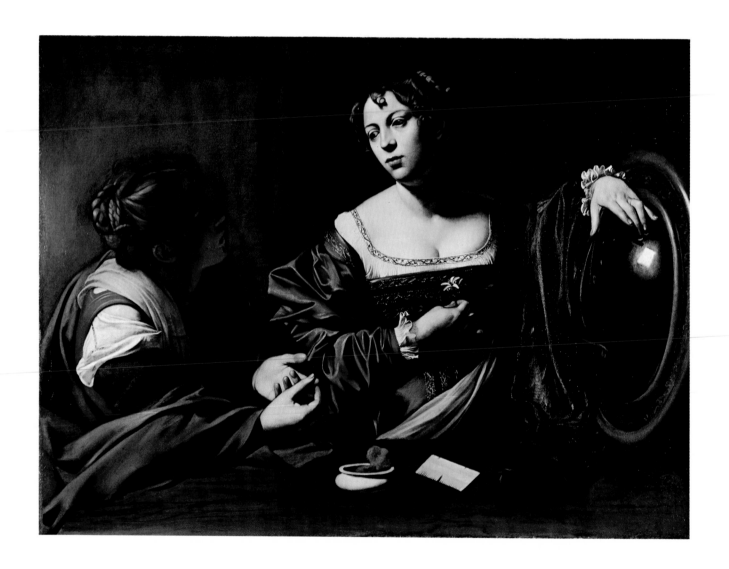

XXIII

BERNARDO BELLOTTO, Italian (1720-1780)
*View of the Tiber with Castel Sant'Angelo,
Rome*, c. 1740
Oil on canvas; 87.6 x 148.6 cm. (34½ x 58½ in.)
Gift of Mr. and Mrs. Edgar B. Whitcomb
(40.166)
See E. P. Richardson, "Bellotto's *View of the
Tiber with Castel S. Angelo, Rome*," DIA *Bull.*
20, 6 (1941): 60-62.

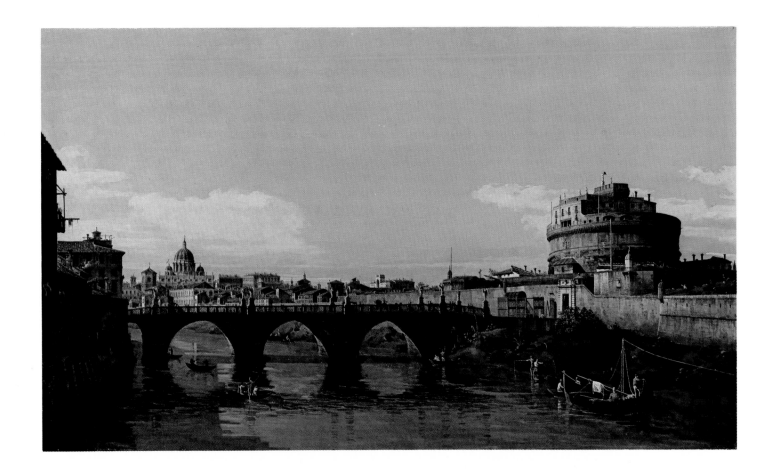

XXIV
BARTOLOME ESTEBAN MURILLO, Spanish
(1618-1682)
The Flight into Egypt, c. 1640/50
Oil on canvas; 209.6 x 166.4 cm. (82½ x 65½ in.)
Gift of Mr. and Mrs. K. T. Keller, Mr. and Mrs.
Leslie H. Green, and Mr. and Mrs. Robert N.
Green (48.96)
See E. P. Richardson, "Murillo's Flight into
Egypt," DIA *Bull.* 27, 4 (1948): 78-80.

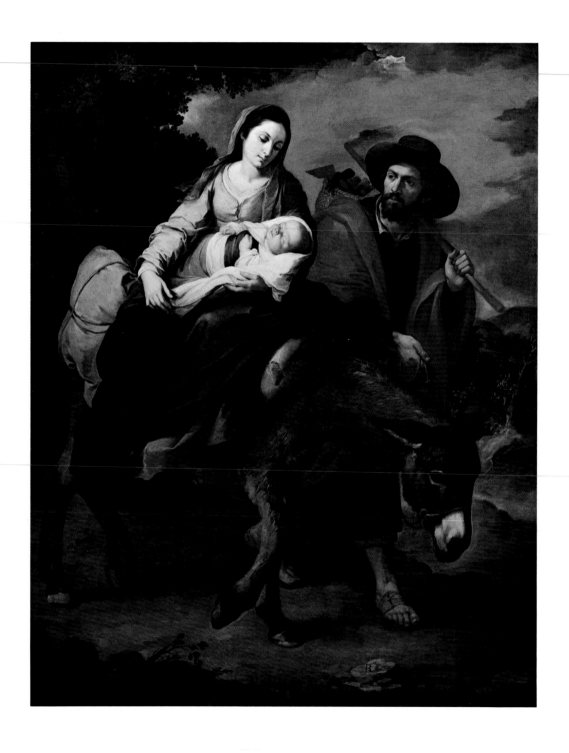

Dewey F. Mosby, Curator

Mary K. Grimes, Research Associate

The European art collections fill nearly half of the existing gallery space in the museum and include paintings, sculptures, stained glass, metal, decorative arts, and the Institute's extensive textile holdings. These works, numbering in the thousands, span the history of the art of the Western European countries from the medieval period through the end of the 19th century.

The foundation for the European collections was laid by several artistically enlightened, financially generous, and civic-minded patrons. The first important group of Old Master paintings came to the Detroit Museum of Art in 1889 from newspaperman James E. Scripps. This gift of 43 European paintings included Jan Provost's *Last Judgment* and Salomon van Ruisdael's *River Landscape* (nos. 66, 45). The Old Master paintings collection received its next major gift 20 years later from Scripps' widow, Harriet J. Scripps, who gave a group of important works, primarily Dutch and Flemish paintings.

During the 1920s, in the years before the Depression, the City of Detroit regularly appropriated funds for acquisitions, and the European department bought such important works as van Eyck's *St. Jerome,* Rembrandt's *Visitation,* Brueghel's *Wedding Dance,* and van Gogh's *Self Portrait* (pl. XI, no. 43, pl. XIII, no. 49). But it was the legendary dedication of Mr. and Mrs. Edsel B. Ford, beginning in the '20s and continuing until Mrs. Ford's death in 1976, that rounded out the paintings collection and added numerous masterpieces in other media as well. Assisted by Dr. William Valentiner, who became a non-resident staff member as Expert and Advisor to the recently renamed Detroit Institute of Arts in 1921 and Director in 1924, the Fords purchased such masterpieces as Andrea Pisano's *Madonna and Child,* two panels by Fra Angelico, Piazetta's *Madonna and Child with Adoring Figure,* Holbein's *Portrait of a Woman,* and Terborch's *A Lady at Her Toilet* (no. 124, pl. XX, nos. 106, 119, pl. XII, no. 47).

During the subsequent decades, such families as the Whitcombs, Booths, Kellers, Haasses, Fishers, Kanzlers, Dodges, and Sheldens, among others, have contributed works of art or acquisition funds, sometimes both, toward the growth of the European collections. Almost a century after James E. Scripps donated the nucleus of the Old Master paintings collection, the museum received the Robert H. Tannahill bequest, rich in important holdings in 19th-century French art, including Cézanne's *Mont Sainte-Victoire,* Seurat's *View of Le Crotoy,* and Renoir's *Seated Bather* (no. 89, pl. XVI, no. 90). The results of the generosity, perception, and vision of all these benefactors is reflected in the selection of masterpieces reproduced here.

The importance of the European collections is also due, of course, to the insight and dedication of the curatorial staff over the years. From 1921 to 1924, and again from 1934 to 1945, William Valentiner, while Advisor and then Director, headed the department. His encyclopedic interests and broad knowledge established a tradition of collecting, for he sought to bring the finest examples of European culture to Detroit, and thus set the tone for the department's activities in later years. Besides Valentiner, the department has been headed by a distinguished series of curators, including Walter Heil (1924-1934), Edgar P. Richardson (1945-1962), and Paul L. Grigaut (1960-1963). The museum's current Director, Frederick J. Cummings, served as curator from 1964 to 1974, when he was succeeded by the present curator, Dewey F. Mosby. While every curator has successfully impressed on the collection his own particular interests, each has demonstrated a broad range of expertise, and thus important examples of most schools or nationalities can be traced to their tenures.

The museum has developed one of America's finest collections of Italian art, housed in the Italian Wing, which was renovated and reinstalled in 1977. The rare collection of early Italian sculpture, assembled for the most part by Valentiner, is highlighted by Andrea Pisano's *Madonna and Child* (no. 124). It also includes the important bronze, *Judith,* by Pollaiuolo, and rare terracotta modellos by Lorenzo Bernini (nos. 127, 129). Among the finest examples of the outstanding painting collection are, from the 15th century, the *Resurrection* by the anonymous artist called the

Master of the Osservanza, Perugino's *Madonna and Child*, Giovanni Bellini's *Madonna and Child*; from the 16th century, several works by Titian, and *The Mystic Marriage of St. Catherine*, perhaps the best Correggio in this country; from the Baroque and Rococco periods, Caravaggio's *Conversion of the Magdalen* and several works by Tiepolo (pls. XIX, XXI, nos. 109, 114, 110, pl. XXII, no. 121). The collection includes such fine examples of furniture as Piffetti's *Secretary*, and a well-rounded selection of Majolica (nos. 133, 131).

The museum contains an especially strong collection of French art. The 17th-century selection includes Poussin's superb *Selene and Endymion* and Le Brun's *Purification of the Virgin* (nos. 73, 76). The 18th century, the period of France's emergence as the art capitol of Europe, is represented by master paintings by Pierre, Fragonard, and Chardin and includes sculptures by Clodion and Stouf (no. 79, pl. XV, nos. 77, 93, 94). The museum is particularly rich in 18th-century French decorative arts, having acquired in 1970 outstanding examples of furniture, porcelain, sculpture, and tapestry assembled by Mrs. Horace E. Dodge, with the guidance of the great art dealer Lord Joseph Duveen, for the Music Room of her Grosse Pointe, Michigan estate. In addition, the department has recently refurbished a mid-18th-century sitting room, the Kanzler Room, relocated next to the Dodge collection in the Ford Wing.

The 19th-century holdings are equally impressive and permit a thorough understanding of the period. The collection includes important works by Regnault, Gros, Dedreux, Bouguereau, and Degas, as well as outstanding examples of Impressionist and Post-Impressionist painting by Monet, Gauguin, Seurat, Cézanne, and Renoir, among others (nos. 80, 84, 88, pls. XVII, XVI, cover, nos. 89, 90). The sculpture, also encyclopedic in range, includes Rodin's *Eve* (no. 95).

The Flemish and Dutch collections, especially in the area of painting, are among the finest this side of the Atlantic. One can trace the development of Flemish painting from the time of the Renaissance master Jan van Eyck and Pieter Brueghel the Elder to Peter Paul Rubens, who is represented by no less than six fine works (pls. XI, XIII, nos. 67, 68). In addition, there is a masterful wooden sculpture from the circle of Rogier van der Weyden (no. 69). The Golden Age (the 17th century) of Flanders' northern neighbor, Holland, is highlighted in the collection by many masterpieces, including Rembrandt's *Visitation*, Terborch's *A Lady at Her Toilet*, and the chef d'oeuvre by Jacob van Ruisdael, *The Cemetery* (nos. 43, 47, 46).

The Spanish collection is small but choice; it includes Murillo's monumental *Flight into Egypt* and an engaging portrait by Goya (pl. XXIV, no. 136).

The strength of the German collection is primarily in the selection of wooden sculptures (no. 70). The collection also features several fine paintings, including a work by Hans Holbein the Younger (pl. XII). In addition, the museum contains important pieces of German (Meissen) porcelain (pl. XIV).

The collection of English painting is naturally strong in portraiture, with several works by Hogarth and Gainsborough (nos. 51, 53). But the galleries also feature important subject paintings by Reynolds and Fuseli, the monumental animal piece, *Chevy*, by Queen Victoria's favorite painter, Landseer, and landscapes by Wilson and Constable, among others (pl. X, nos. 54, 57, 56). The collection also contains fine examples of British ceramics, silver, and other decorative arts (nos. 58, 59, 60).

Over the years, the collections have become more encyclopedic, while always maintaining an emphasis on the artistic excellence of individual objects. As a result, the European holdings continue to rank among the most important European collections in America, providing a rich and varied experience for the museum's public.

41
MASTER OF THE TIBURTINE SIBYL, Dutch,
(late 15th century)
The Crucifixion, c. 1485
Tempera on panel; 143.5 x 102.6 cm. (56½ x
40⅜ in.)
Gift of Mr. and Mrs. Edgar B. Whitcomb
(41.126)
See *Flanders in the Fifteenth Century: Art and
Civilization*, exh. cat., DIA, 1960: no. 24.

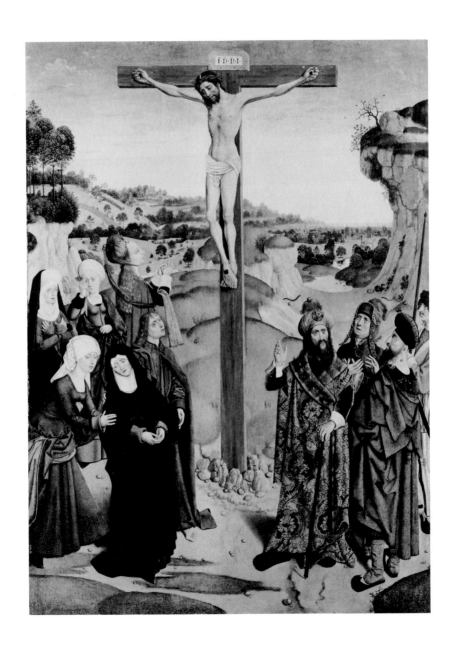

42

REMBRANDT VAN RIJN, Dutch (1606-1669)

Man Wearing a Plumed Beret and Gorget,
c. 1634

Oil on panel; 61 x 44.5 cm. (24 x 17½ in.)

Gift of the Matilda R. Wilson Fund (72.201)

See S. Slive, "Rembrandt's *Man Wearing a
Plumed Beret and Gorget,* A Recent Acquisition,"
DIA *Bull.* 54, 1 (1975): 5-13 (color cover).

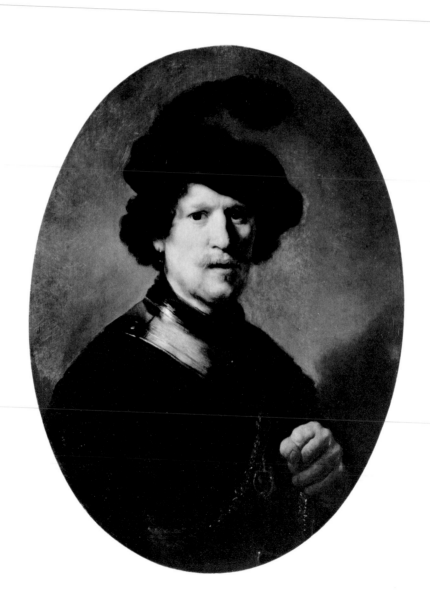

43
REMBRANDT VAN RIJN, Dutch (1606-1669)
The Visitation, 1640
Oil on panel; 56.5 x 48 cm. (22¼ x 18⅞ in.)
City Purchase (27.200)
See W. R. Valentiner, "*The Visitation* by Rembrandt," DIA *Bull.* 8, 8 (1927): 86-91.

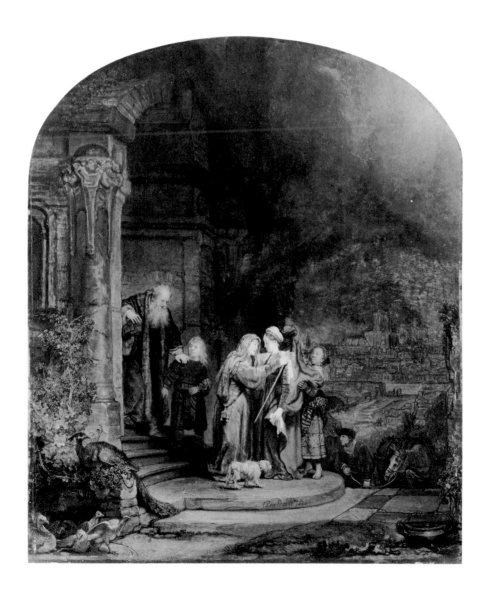

44
FRANS HALS, Dutch (c. 1580-1666)
Portrait of Hendrik Swalmius, 1639
Oil on panel; 27 x 20 cm. (10⅝ x 7⅞ in.)
City and Founders Society Joint Purchase
(49.347)
See S. Slive, *Frans Hals,* London, 1970, 3: no. 126.

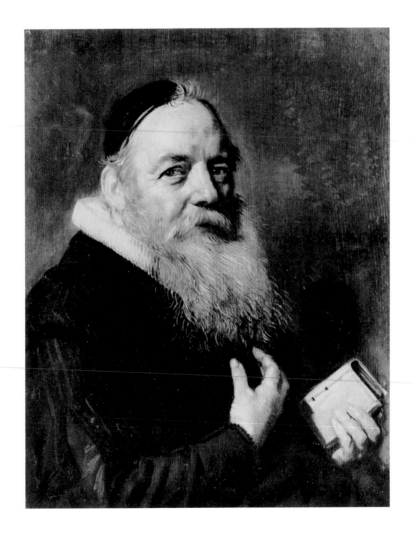

45
SALOMON VAN RUISDAEL, Dutch (1602-1670)
River Landscape, 1643
Oil on canvas; 99.1 x 136.5 cm. (39 x 53¾ in.)
Gift of James E. Scripps (89.43)
See E. P. Richardson, "From Old Bruegel to Van
Goyen," *Art Quarterly* 1, 3 (1938): 198ff.

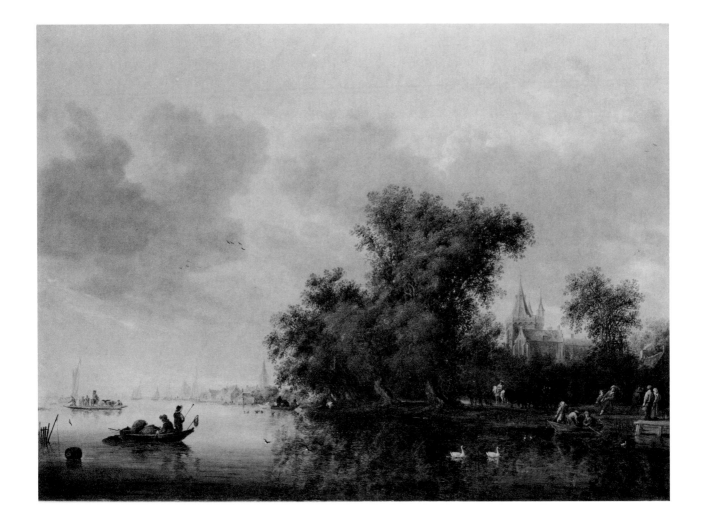

46
JACOB VAN RUISDAEL, Dutch (1628/29-1682)
The Cemetery, c. 1655/60
Oil on canvas; 142.2 x 189.2 cm. (56 x 74½ in.)
Gift of Julius H. Haass in memory of his brother
Dr. Ernest W. Haass (26.3)
See E. Scheyer, "The Iconography of Jacob van
Ruisdael's *Cemetery,*" DIA *Bull.* 55, 3 (1977):
133-46.

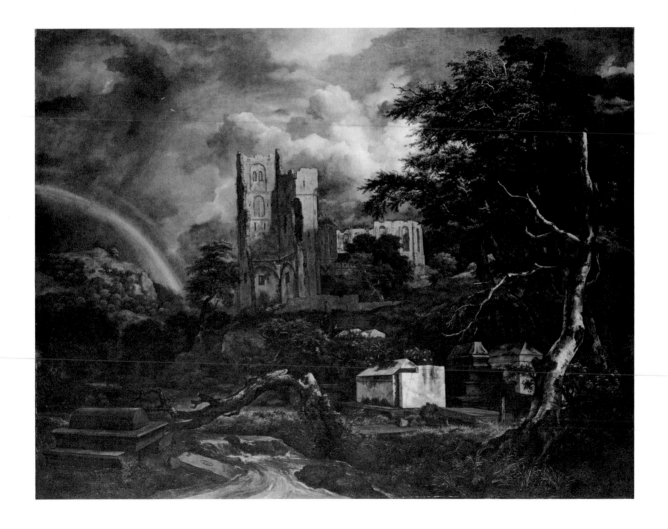

47
GERARD TERBORCH, Dutch (1617-1681)
A Lady at Her Toilet, c. 1660
Oil on canvas; 76.2 x 56.7 cm. (30 x 23½ in.)
Gift of Mrs. Edsel B. Ford and Founders Society
Funds (65.10)
See E. Haverkamp-Begemann, "Terborch's Lady
at Her Toilet," *Art News* 64, 8 (1965): 38-41
(color cover: detail).

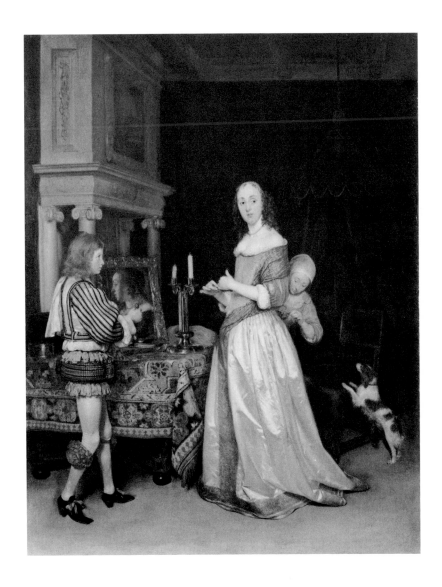

48

WILLEM KALF, Dutch (1622-1693)

Still Life with a Gold Cup, c. 1660/70

Oil on canvas; 52.7 x 48.9 cm. (22¾ x 19¼ in.)

Founders Society Purchase (26.43)

See C. J. Hope-Johnstone, "A Still Life by
Willem Kalf," DIA *Bull*. 8, 4 (1927): 45ff.

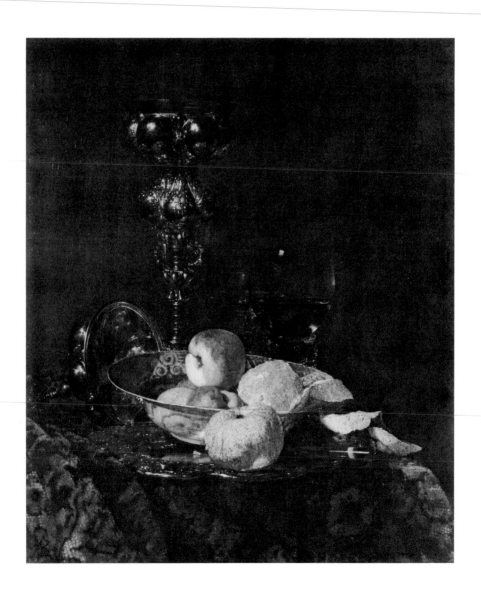

49
VINCENT VAN GOGH, Dutch (1853-1890)
Self Portrait, 1888/89
Oil on canvas; 34.9 x 26.7 cm. (13¾ x 10½ in.)
City Purchase (22.13)
See J. B. de la Faille, *The Works of Vincent Van Gogh*, Amsterdam, 1970: no. 526.

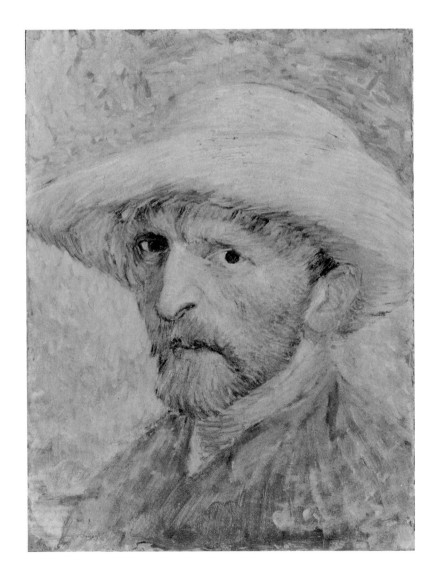

50
HUBERT GERHARD, Dutch (c. 1550-c. 1620)
Hebe, c. 1590
Bronze; h. (incl. base) 76.2 cm. (30 in.)
Gift of Mr. and Mrs. Henry Ford II (59.123)
See P. L. Grigaut, " 'Hebe, Goddess of Immortal
Youth,' by Adriaen de Vries," DIA *Bull.* 39, 1
(1959-60): 8-10.

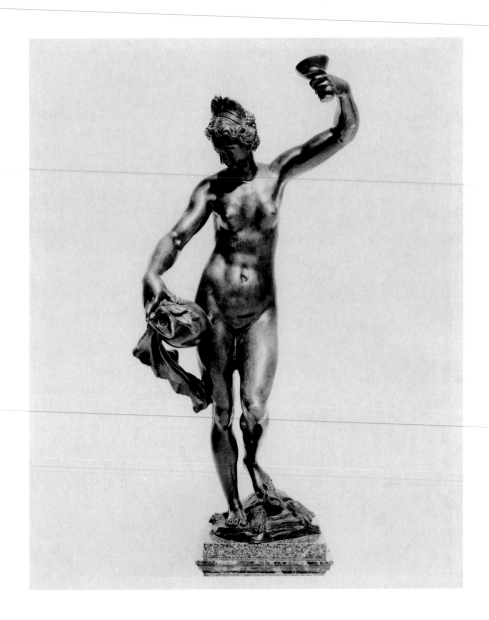

51
WILLIAM HOGARTH, English (1697-1764)
Portrait of a Lady, 1740/44
Oil on canvas; 75.6 x 64.1 cm. (29¾ x 25¼ in.)
Founders Society Purchase (27.11)
See J. Walther, "A Portrait by William Hogarth,"
DIA *Bull.* 8, 7 (1927): 75.

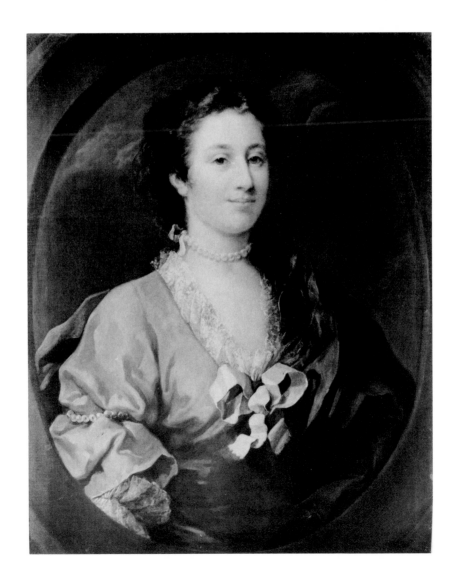

52
FRANCIS WHEATLEY, English (1747-1801)
The Wilkinson Family, 1776/78
Oil on canvas; 102.2 x 128 cm. (40¼ x 50⅜ in.)
Founders Society Purchase (46.133)
See *Romantic Art in Britain: Paintings and
Drawings 1760-1860,* exh. cat., DIA and the
Philadelphia Museum of Art, 1968: no. 75.

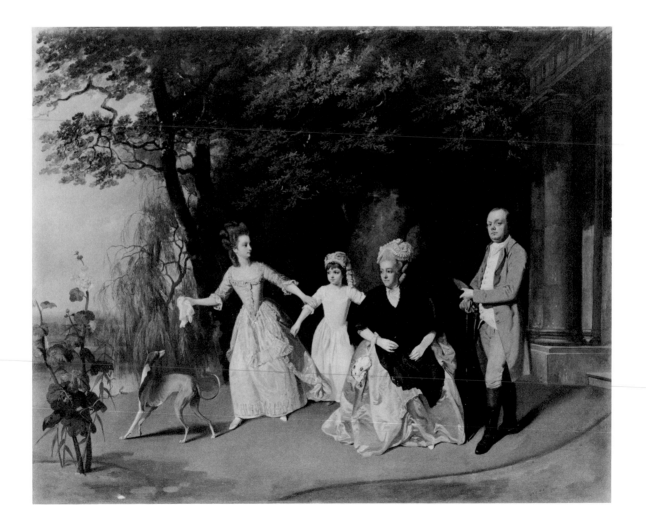

53
THOMAS GAINSBOROUGH, English (1727-1788)
*Lady Anne Hamilton (later Countess of
Donegal)*, c. 1778
Oil on canvas; 235 x 154 cm. (92½ x 60⅝ in.)
Bequest of Mrs. Horace E. Dodge in memory of
her husband (71.170)

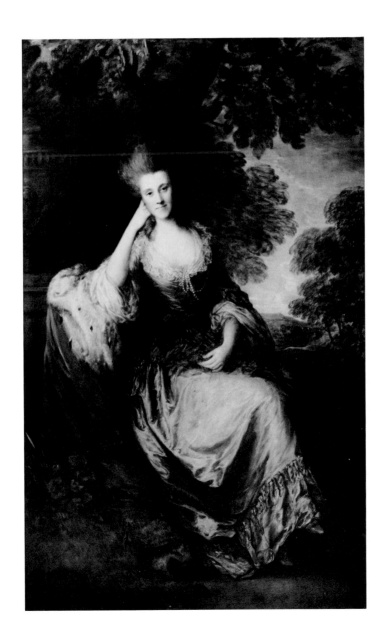

54
HENRY FUSELI, English (1741-1825)
The Nightmare, 1781
Oil on canvas; 101.6 x 127 cm. (40 x 50 in.)
Gift of Mr. and Mrs. Bert L. Smokler and
Mr. and Mrs. Lawrence A. Fleischman (55.5)
See E. P. Richardson, "*The Nightmare* by Henry
Fuseli, Swiss, 1741-1825," DIA *Bull.* 34, 1
(1954-55): 3.

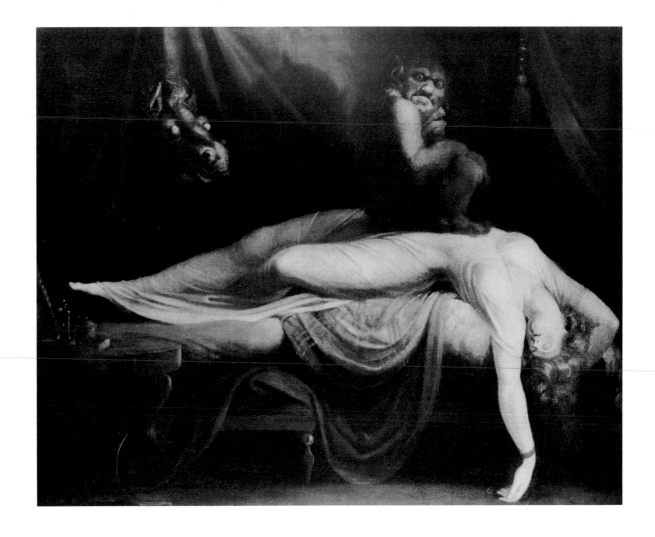

55
WILLIAM HAMILTON, English (1751-1801)
Celadon and Amelia, 1793
Oil on canvas; 154.3 x 123.2 cm. (60¾ x 48½ in.)
Founders Society Purchase (68.159)
See *English Revivalism: 1750-1870, The Aesthetic
of Nostalgia,* exh. cat., The University of Michigan, Ann Arbor, 1968: 7.

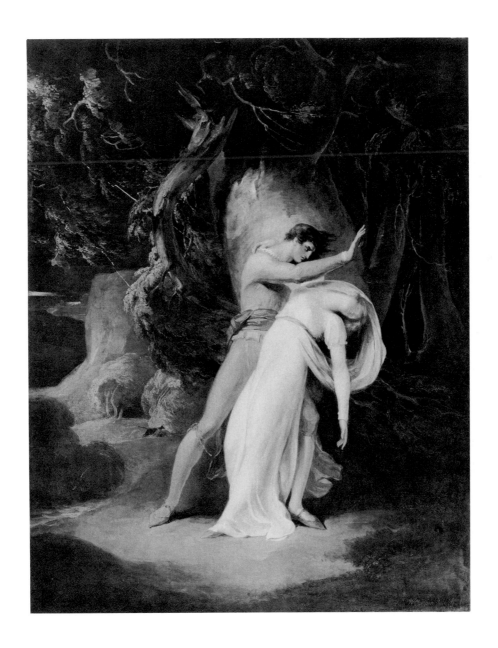

56
JOHN CONSTABLE, English (1776-1837)
Glebe Farm, Dedham, c. 1828
Oil on canvas; 46.4 x 59.7 cm. (18¼ x 23½ in.)
Gift of Mrs. Joseph B. Schlotman (64.117)
See D. F. Mosby, *Cinco siglos de obras maestras de la pintura en colecciones norteamericanas cedidas en préstamo a Costa Rica*, exh. cat., 1978: no. 27.

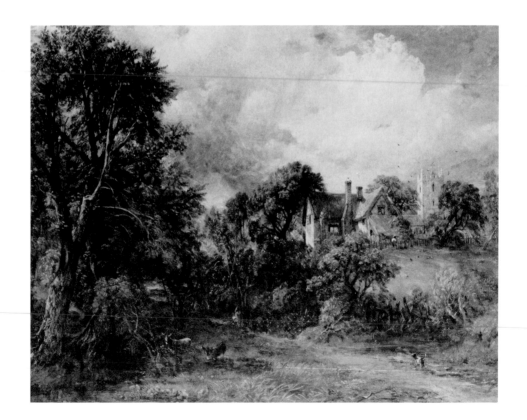

57
EDWIN LANDSEER, English (1802-1873)
*Chevy ("Weel, sir, if the deer got the ball, sure's
death Chevy will no leave him."), c.* 1868
Oil on canvas; 137.2 x 208.3 cm. (54 x 82 in.)
Founders Society Purchase, Alvan Macauley, Jr.
Fund (76.4)

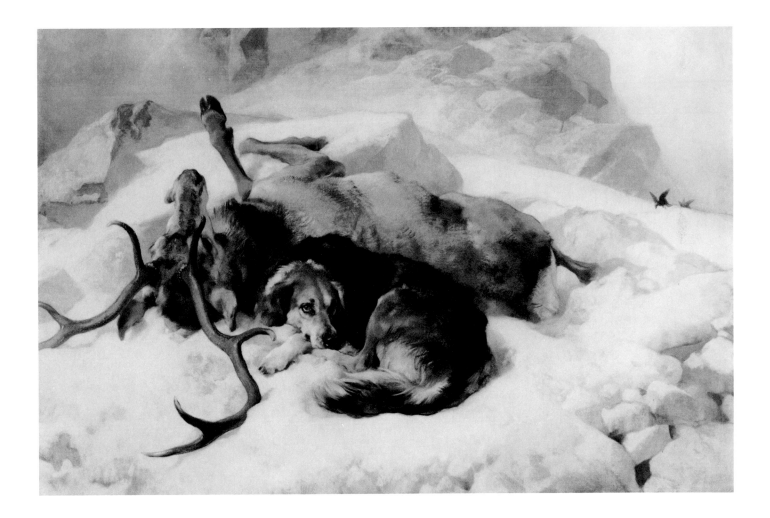

58
"Lighthouse" Caster (maker "M.G."), English,
1674
Silver; h. 12.1 cm. (4¾ in.)
Gift of Robert H. Tannahill (55.486)

59
BENJAMIN GODFREY, English
Two-Handled Presentation Cup with Cover,
1737
Silver gilt; h. 33.7 cm. (13¼ in.)
Founders Society Purchase, Edsel and Eleanor
Ford Fund (71.2)
See R. L. Winokur, "Recent Acquisitions of
English Silver," DIA *Bull.* 52, 2-3 (1973): 93-96.

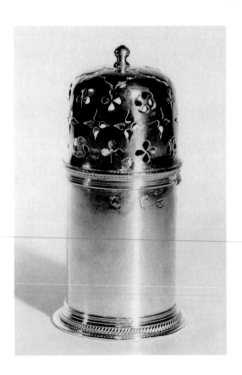

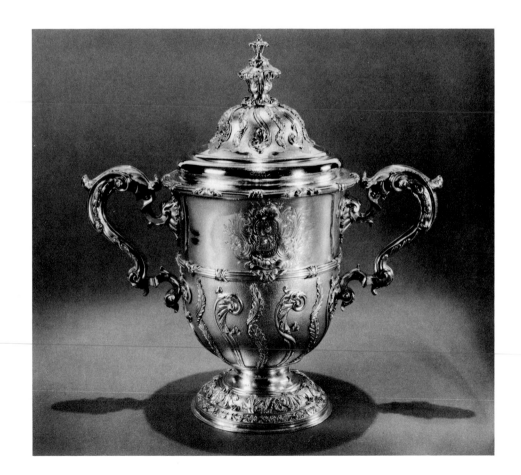

60
PAUL STORR, English (1771-1844)
Covered Vegetable Dish, 1816 (one of pair)
Silver; l. 36.5 cm. (14⅜ in.)
Gift of Dr. and Mrs. Arthur R. Bloom (71.298)
See R. L. Winokur, "Recent Acquisitions of
English Silver," DIA *Bull.* 52, 2-3 (1973): 93-96.

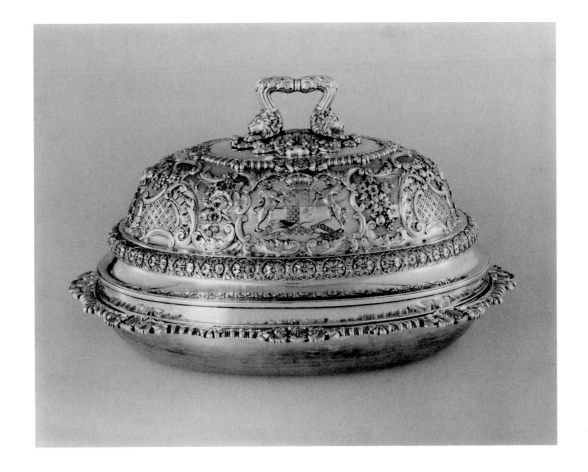

61

MASTER OF THE ST. LUCY LEGEND, Flemish
The Madonna in the Rose Garden (Mystic
Marriage of St. Catherine), 1475/80
Tempera on panel; 79.1 x 60 cm. (31⅛ x 23⅝ in.)
Founders Society Purchase (26.387)
See W. R. Valentiner, "The Madonna in the
Rose Garden, by the Master of the Lucia
Legend," DIA *Bull.* 8, 4 (1927): 38ff.

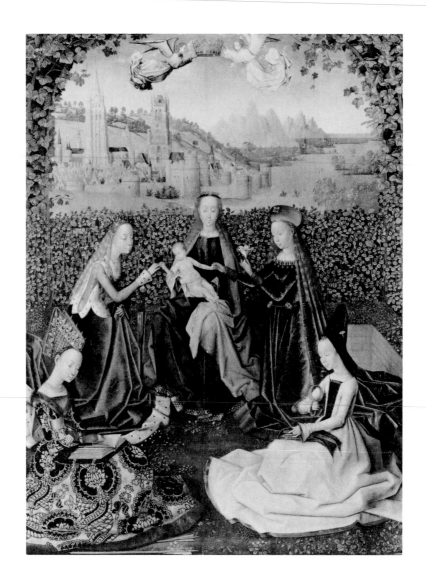

62
MICHAEL WOLGEMUT, German (1434-1519)
Portrait of a Young Man, 1486
Tempera on panel; 33.3 x 23.5 cm. (13⅛ x
9¼ in.)
Gift of Mr. and Mrs. Ernest Kanzler in memory
of Dr. and Mrs. Karl Kanzler (41.1)
See W. R. Valentiner in DIA *Bull.* 20, 6 (1941):
58-60.

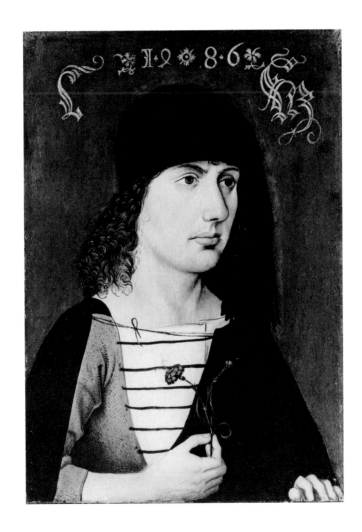

63
GERARD DAVID, Flemish (1450/60-1523)
The Annunciation, c. 1490
Tempera on panel; 31.8 x 22.9 cm. (12½ x 9 in.)
City Purchase (27.201)
See W. R. Valentiner, "The Annunciation by
Gerard David," DIA *Bull.* 8, 8 (1927): 92ff.

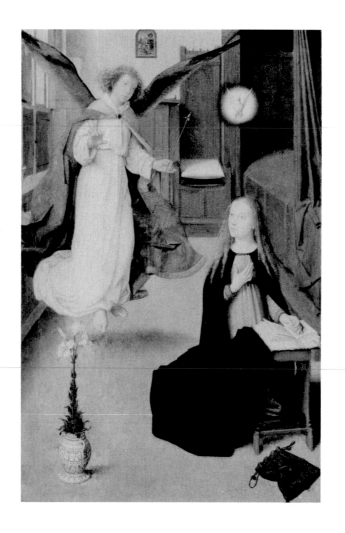

64

MASTER OF THE ST. URSULA LEGEND, Flemish
Triptych of the Nativity, c. 1495
Tempera on panel; overall (with frame) 74.7 x
133.4 cm. (29⅜ x 52½ in.)
Gift of the Metropolitan Opera Benefit
Committee (59.122)
See E. P. Richardson, "A Fifteenth Century
Altarpiece from Bruges," DIA *Bull*. 39, 1
(1959-60): 3-7.

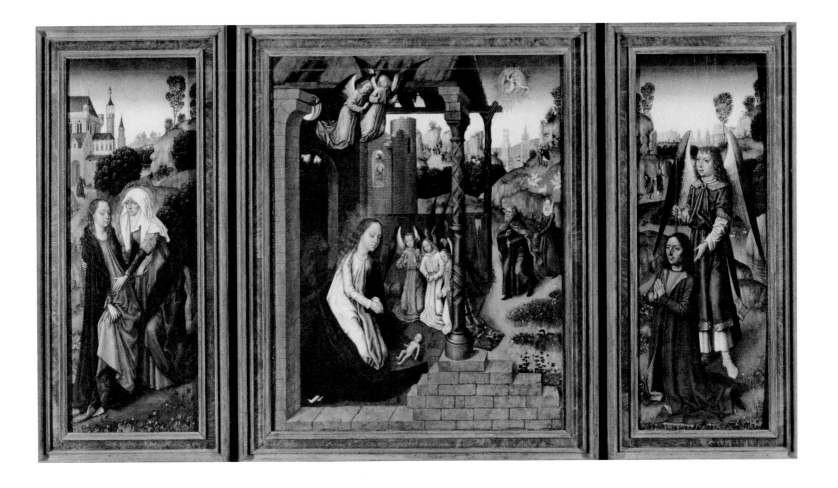

65
JOOS VAN CLEVE, Flemish (c.1485-1540/41)
The Adoration of the Magi, c. 1525
Tempera on panel; center, 89 x 64.8 cm. (35 x
25½ in.); each wing, 89 x 28 cm. (35 x 11 in.)
Gift of Mr. and Mrs. Edgar B. Whitcomb
(45.420)
See E. P. Richardson, "The Adoration of the
Magi," DIA *Bull.* 25, 1 (1946): 13-16.

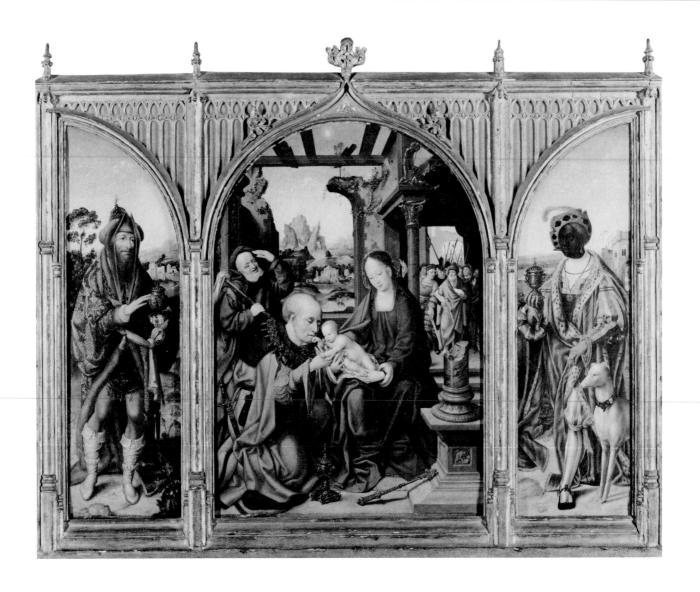

66
JAN PROVOST, Flemish (c. 1462/65-1529)
The Last Judgment, c. 1525
Tempera on panel; 57.8 x 60.7 cm. (22¾ x 23⅞ in.)
Gift of James E. Scripps (89.35)
See W. R. Valentiner in DIA *Bull.* 13, 4 (1932): 43ff.

67
PETER PAUL RUBENS, Flemish (1577-1640)
Portrait of the Artist's Brother, Philippe, 1608/11
Oil on panel; 68.6 x 54 cm. (27 x 21¼ in.)
Gift of William E. Scripps in memory of his son
James E. Scripps II (26.385)
See M. K. Grimes, *Homage to Rubens*, exh. cat.,
DIA, 1978: no. 1.

68
PETER PAUL RUBENS, Flemish (1577-1640)
Briseis Given Back to Achilles, 1625/27
Oil on panel; 45.1 x 67.3 cm. (17¾ x 26½ in.)
Bequest of Mr. and Mrs. Edgar B. Whitcomb
(53.356)
See M. K. Grimes, *Homage to Rubens*, exh. cat.,
DIA, 1978: no. 4.

69
CIRCLE OF ROGIER VAN DER WEYDEN, Flemish
The Lamentation, c. 1450/75
Oak; l. 139.7 cm. (55 in.)
Gift of Mrs. Edsel B. Ford (61.164)
See N. Verhaegen, "The Arenberg Lamenta-
tion," DIA *Bull.* 41, 4 (1962): 64-67.

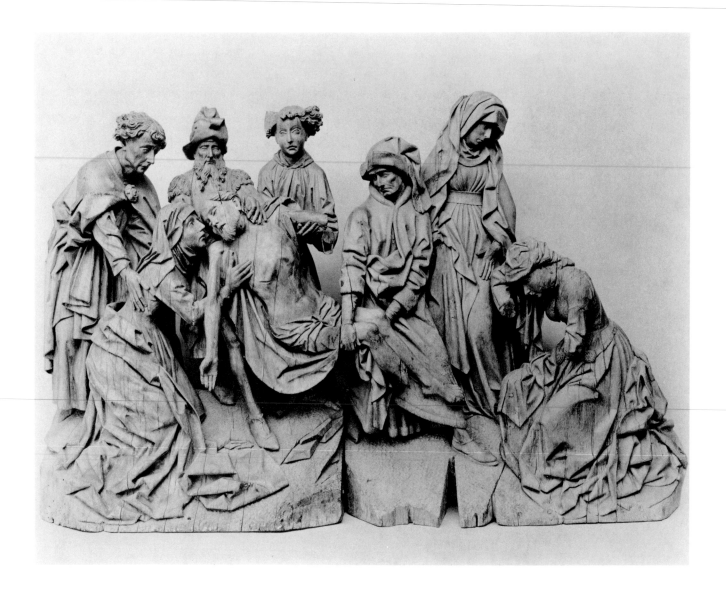

70
GREGOR ERHARDT, German (active c. 1500)
Madonna and Child
Wood; h. 162.6 cm. (64 in.)
Gift of Ralph H. Booth (22.3)
See W. R. Valentiner, "Late Gothic Sculpture
in Detroit," *Art Quarterly* 6, 4 (1943): 304.

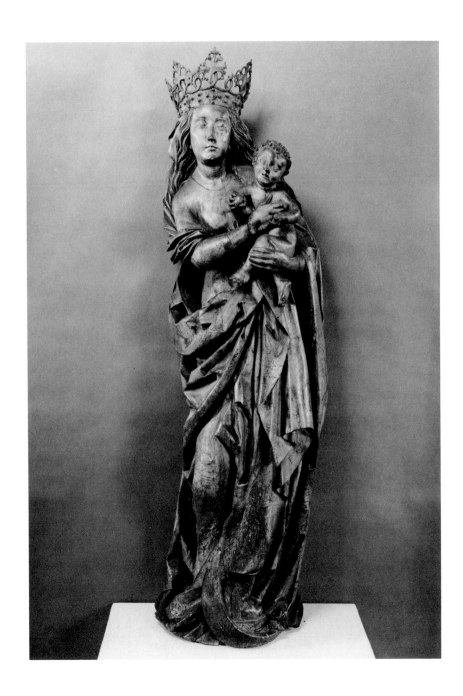

71
Suit of Tilting Armor (Maximilian style),
German, c. 1510
Steel; h. 177.8 cm. (70 in.)
Gift of Mr. and Mrs. Eugene H. Welker (56.123)

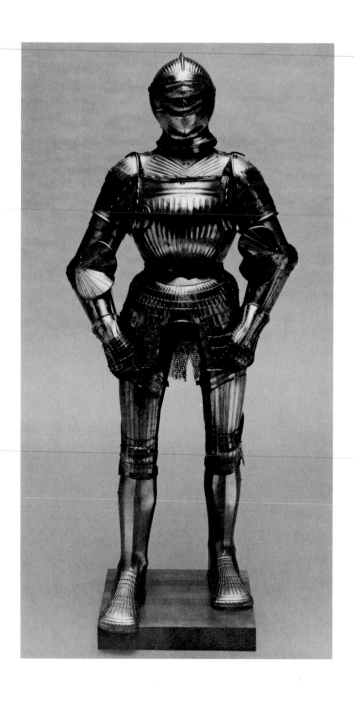

72
NICOLAS DIPRE, French (active 1495-1531/32)
The Crucifixion, c. 1500
Oil on panel; 29.2 x 44.3 cm. (11½ x 17 7/16 in.)
Founders Society Purchase (50.57)
See P. L. Grigaut, "A Crucifixion from
Provence," DIA *Bull.* 29, 4 (1949-50): 90-93.

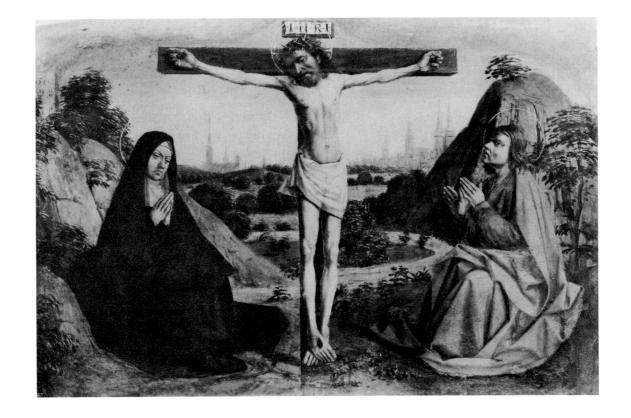

73
NICOLAS POUSSIN, French (1594-1665)
Selene and Endymion, c. 1630
Oil on canvas; 121.9 x 168.9 cm. (48 x 66½ in.)
Founders Society Purchase (36.11)
See W. R. Valentiner, "Selene and Endymion by
Poussin," DIA *Bull.* 15, 7 (1936): 96-99.

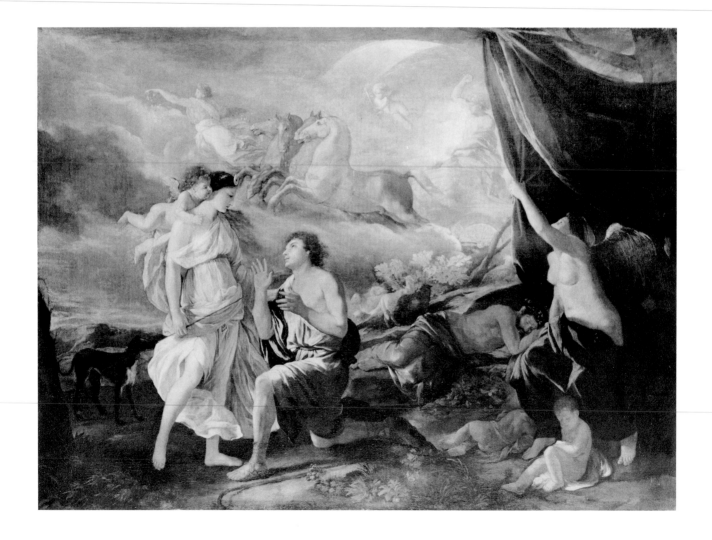

74
CLAUDE LORRAIN, French (1600-1682)
A Seaport at Sunset, 1643
Oil on copper; 40.8 x 52.4 cm. (16$\frac{1}{16}$ x 20$\frac{5}{8}$ in.)
Gift of Mr. and Mrs. Edgar B. Whitcomb
(42.127)
See E. P. Richardson, "A Seaport at Sunset by
Claude Lorrain," DIA *Bull.* 22, 7 (1943): 70-72.

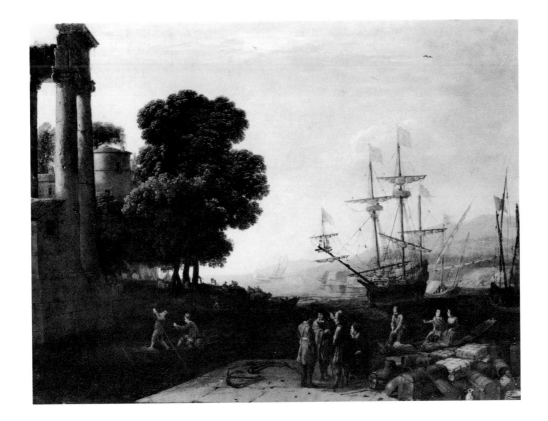

75
ANTOINE LE NAIN, French (c. 1588-1648)
The Village Piper, 1644
Oil on copper; 21.3 x 29.2 cm. (8⅜ x 11½ in.)
City Purchase (30.280)
See *Les Frères Le Nain,* exh. cat., Réunion des
musées nationaux, Paris, 1978: no. 20.

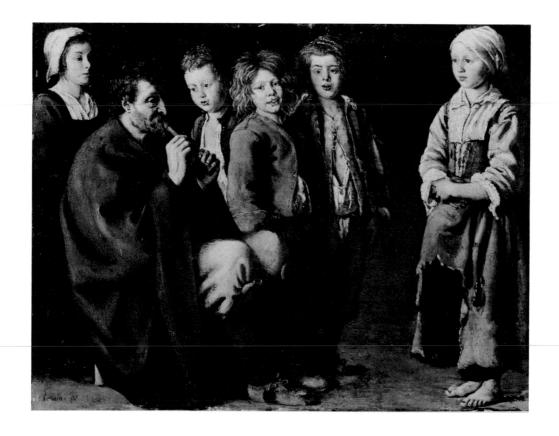

76
CHARLES LE BRUN, French (1619-1690)
Purification of the Virgin, 1645
Oil on canvas; 268.6 x 196.2 cm. (105¾ x
77¼ in.)
Gift of Mr. and Mrs. Allan Shelden III in
memory of Allan Shelden IV (73.1)
See G. Chomer, *"The Purification of the Virgin
by Charles Le Brun: A Few Notes,"* DIA *Bull.*
55, 4 (1977): 183-89.

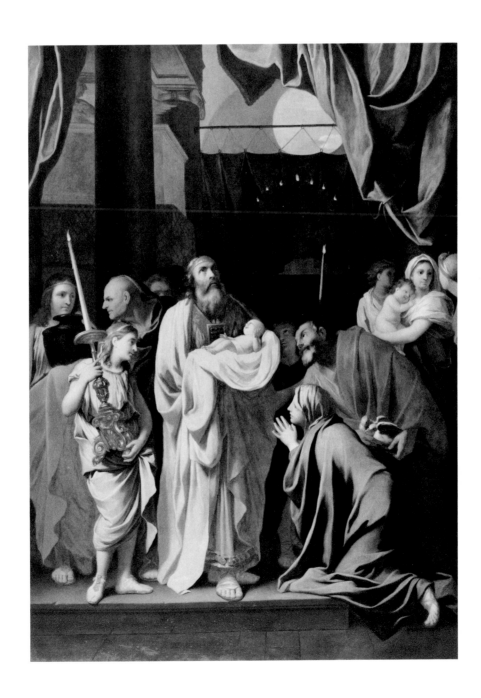

77
JEAN-BAPTISTE-SIMEON CHARDIN, French
(1699-1779)
Kitchen Still Life, c. 1732
Oil on panel; 17.1 x 21 cm. (6¾ x 8¼ in.)
Bequest of Robert H. Tannahill (70.164)
See *Chardin*, exh. cat., Réunion des musées
nationaux, Paris, 1979: no. 50.

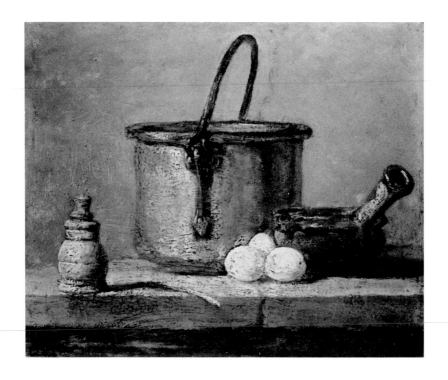

78
JEAN-BAPTISTE OUDRY, French (1686-1755)
Corner of M. de la Bruyère's Garden, 1744
Oil on canvas; 146.1 x 181 cm. (57½ x 71¼ in.)
Founders Society Purchase, John N. and Rhoda
Lord Family Fund and General Endowment
Fund (67.78)
See P. Rosenberg, *The Age of Louis XV, French
Painting 1710-1774*, exh. cat., The Toledo
Museum of Art, Ohio, etc., 1975: no. 77.

79
JEAN-BAPTISTE-MARIE PIERRE, French
(1713-1789)
The Adoration of the Shepherds, 1745
Oil on canvas; 279.4 x 355 cm. (110 x 139¾ in.)
Gift of Elizabeth Shelden in memory of her son
Allan Shelden III (76.145)
See M. Halbout and P. Rosenberg, "Jean-
Baptiste Marie Pierre's *The Adoration of the
Shepherds*," DIA *Bull.* 56, 3 (1978): 169-75.

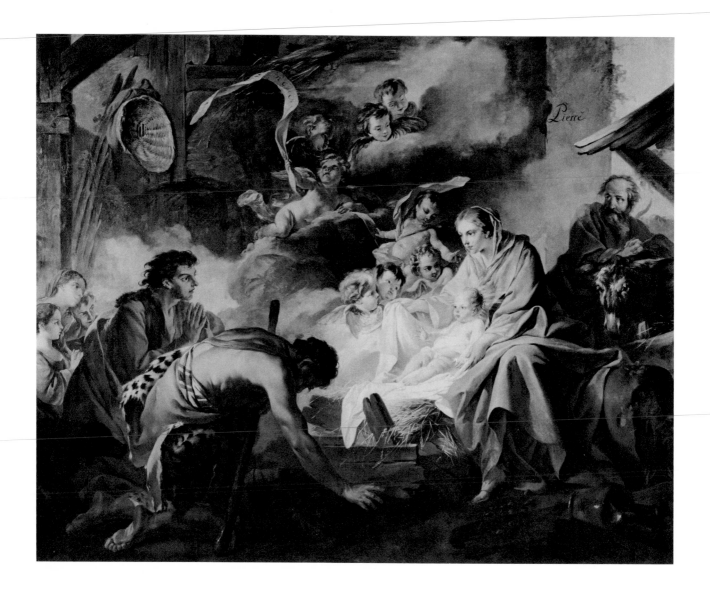

80
JEAN-BAPTISTE REGNAULT, French (1754-1829)
The Judgment of Paris, c. 1812
Oil on canvas; 221.6 x 175.6 cm. (87¼ x 69⅛ in.)
Gift of Mr. and Mrs. Henry Ford II (72.466)
See C. Sells, "Jean-Baptiste Regnault's *Judgment of Paris*," DIA *Bull.* 53, 3-4 (1975): 119-26.

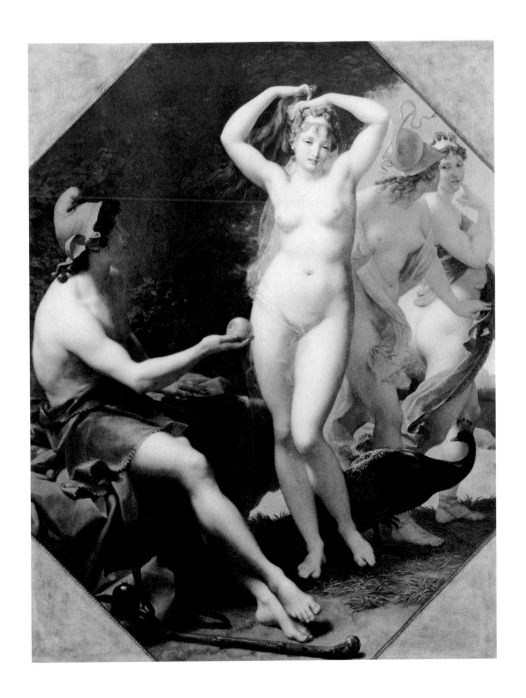

81

JEAN-FRANCOIS MILLET, French (1814-1875)
Portrait of Mme. Catherine Chancoigne, 1841
Oil on canvas; 73.7 x 59.7 cm. (29 x 23½ in.)
Founders Society Purchase, Robert H. Tannahill
Foundation Fund (77.23)
See D. F. Mosby, *The Figure in Nineteenth-
Century French Painting*, exh. cat., The Detroit
Institute of Arts, 1979: no. 12.

82
HIPPOLYTE-JEAN FLANDRIN, French (1809-1864)
Mme. Louis-Antoine de Cambourg, 1846
Oil on canvas; 100.3 x 76.2 cm. (39½ x 30 in.)
Gift of Mr. and Mrs. Alvan Macauley, Jr.
(73.169)
See D. F. Mosby, *The Figure in Nineteenth-
Century French Painting*, exh. cat., The Detroit
Institute of Arts, 1979: no. 11.

83

ALFRED DEDREUX, French (1810-1869)

Mlle. de Mosselmann Riding in the Bois de Boulogne, Paris, 1848

Oil on canvas; 264.1 x 200 cm. (104 x 78¾ in.)

Gift of Mr. and Mrs. Allan Shelden III in memory of Frances Weir Millsop (75.61)

See DIA *Bull.* 55, 1 (*Annual Report*): (color cover).

84
HONORE DAUMIER, French (1808-1879)
The First Bath, 1852/55
Oil on board; 25.1 x 32.4 cm. (9⅞ x 12¾ in.)
Bequest of Robert H. Tannahill (70.166)
See E. Waldmann, "Modern French Pictures:
Some American Collections," *Burlington Maga-
zine* 17 (1910): 62.

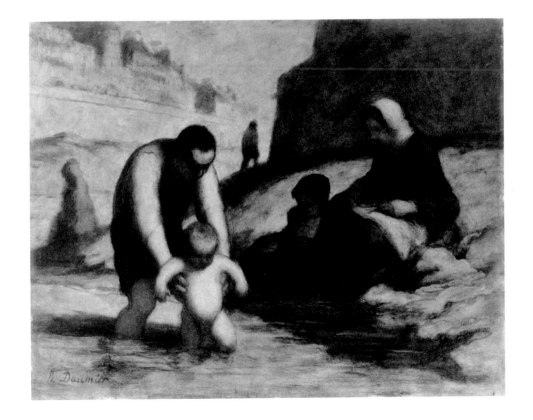

85
THEODORE ROUSSEAU, French (1812-1867)
The Forest of Fontainebleau, c. 1862
Oil on panel; 41.1 x 63.5 cm. (16³⁄₁₆ x 25 in.)
Gift of Mrs. Joseph B. Schlotman (64.449)

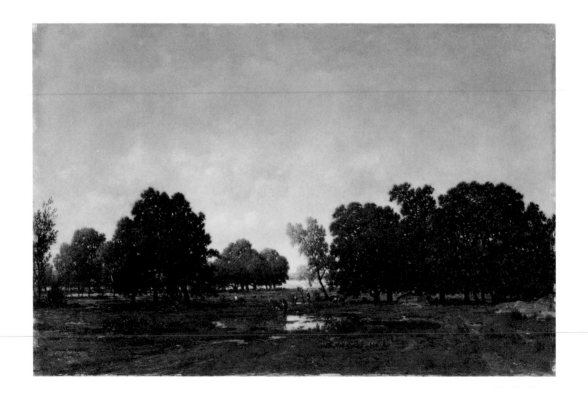

86
JULES BRETON, French (1827-1906)
Fire in a Haystack, c. 1863
Oil on canvas; 139.7 x 209.6 cm. (55 x 82½ in.)
Founders Society Purchase, Robert H. Tannahill
Foundation Fund (76.86)
See M. F. Beaufort, *"Fire in a Haystack* by Jules
Breton," DIA *Bull.* 57, 2 (1979): (forthcoming).

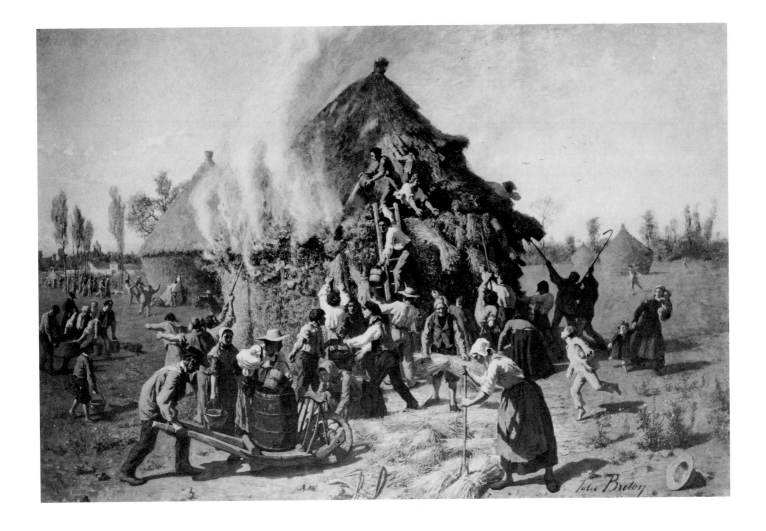

87
JEAN-BAPTISTE-CAMILLE COROT, French
(1796-1875)
Young Girl with a Mandolin, 1870/72
Oil on canvas; 55.9 x 38.1 cm. (22 x 15 in.)
Bequest of Robert H. Tannahill (70.165)
See J. Alazard, *Corot,* Milan, 1952: no. 118.

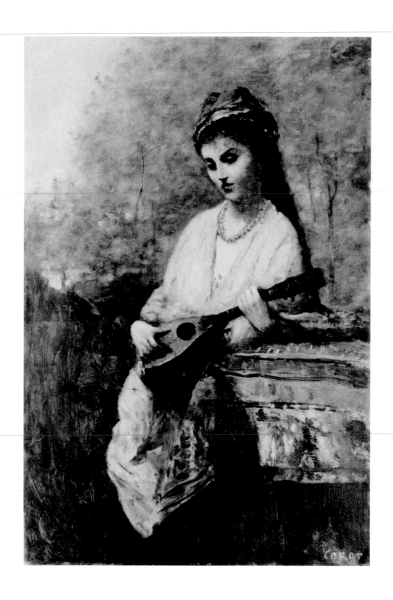

88
EDGAR DEGAS, French (1834-1917)
Violinist and Young Woman, 1870/72
Oil on canvas; 46.4 x 55.9 cm. (18¼ x 22 in.)
Bequest of Robert H. Tannahill (70.167)
See T. Reff, "Works by Degas in the Detroit
Institute of Arts," DIA *Bull.* 53, 1 (1974): no. 8.

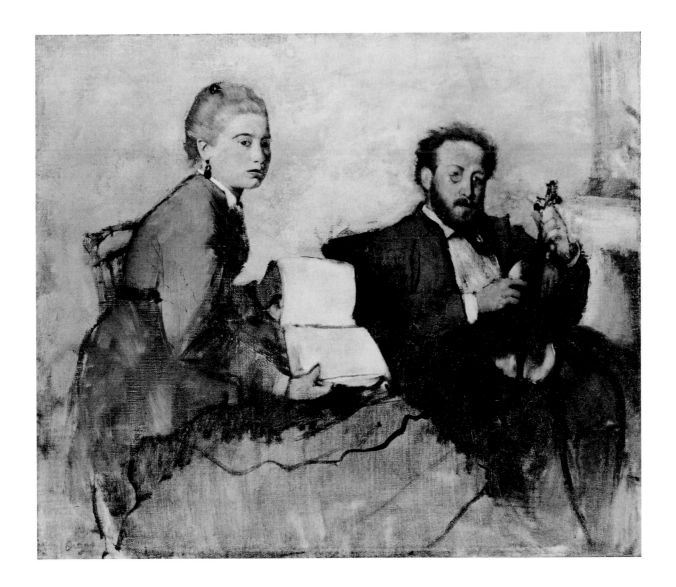

89
PAUL CEZANNE, French (1839-1906)
Mont Sainte-Victoire, c. 1897
Oil on canvas; 55.7 x 46.1 cm. (21⅞ x 18⅛ in.)
Bequest of Robert H. Tannahill (70.161)
See *Arts and Crafts in Detroit 1906-1976, The Movement, The Society, The School*, exh. cat., DIA, 1976: no. 252.

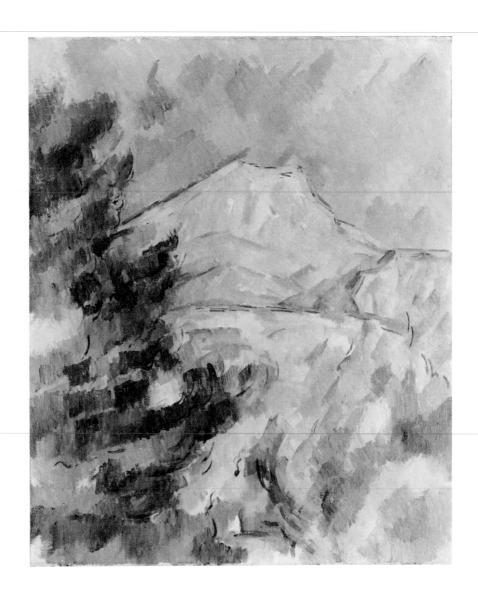

90
PIERRE-AUGUSTE RENOIR, French (1841-1919)
Seated Bather, c. 1903/06
Oil on canvas; 116.2 x 88.9 cm. (45¾ x 35 in.)
Bequest of Robert H. Tannahill (70.177)
See DIA *Handbook,* 1971: 159.

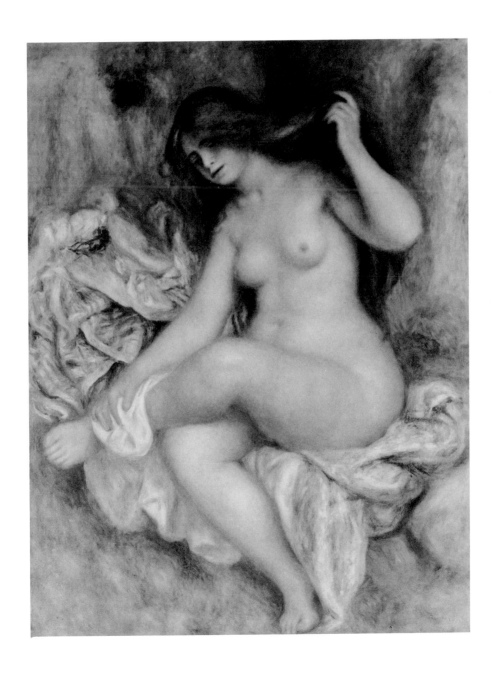

91
Madonna and Child, French (Ile-de-France), 1300/50
Marble with traces of polychrome; h. 101.6 cm. (40 in.)
Founders Society Purchase, Ralph H. Booth Bequest Fund (40.1)
See F. W. Robinson, "A French Gothic Virgin of the Fourteenth Century," DIA *Bull.* 19, 7 (1940): 74-76.

92
PIERRE LEGROS II, French (active in Rome 1666-1719)
St. Luigi Gonzaga in Glory, 1697/1703
Terracotta relief; 86.4 x 40.6 cm. (34 x 16 in.)
Founders Society Purchase (42.52)
See E. P. Richardson, "Three Masters of the Roman Baroque: Cortona, Duquesnoy, Legros," DIA *Bull.* 22, 2 (1942): 10-15.

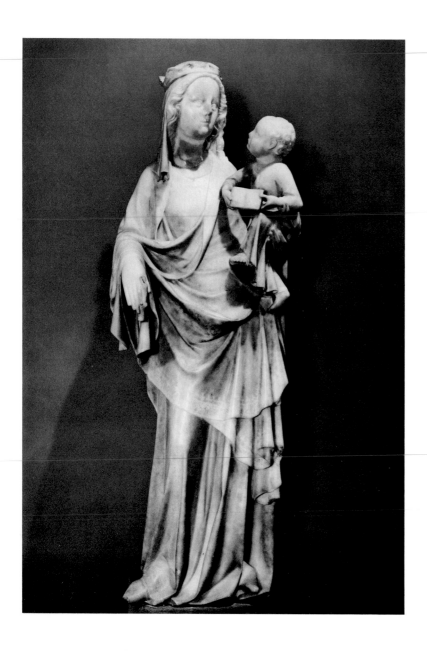

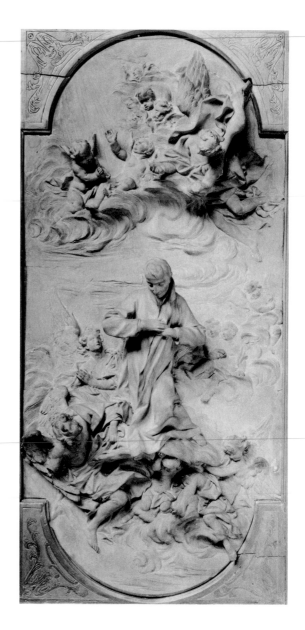

93
CLAUDE MICHEL, called Clodion, French
(1738-1814)
Nymph and Satyr with Child Satyr
Terracotta; h. 47.6 cm. (18¾ in.)
Bequest of Mrs. Horace E. Dodge in memory of
her husband (71.173)
See R. L. Winokur, "The Mr. and Mrs. Horace
E. Dodge Memorial Collection," DIA *Bull.* 50, 3
(1971): 46.

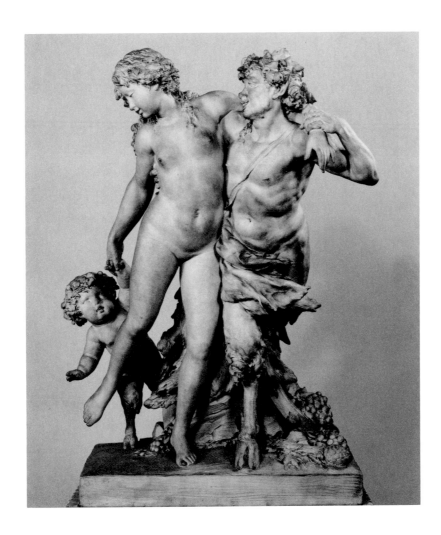

94
JEAN-BAPTISTE STOUF, French (1742-1826)
Hercules Fighting Two Centaurs, 1785
Terracotta; h. 39.4 cm. (15½ in.)
Founders Society Purchase (71.396)

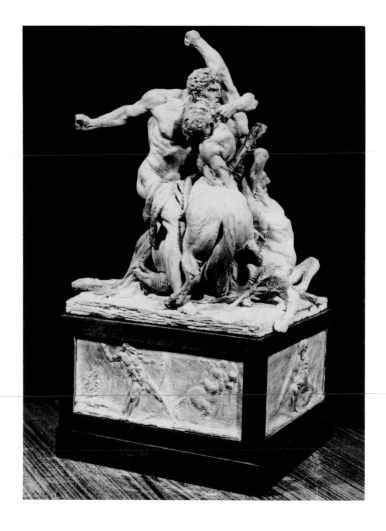

95
AUGUSTE RODIN, French (1840-1917)
Eve, 1881
Bronze; h. 174 cm. (68½ in.)
Founders Society Purchase (53.145)
See P. L. Grigaut, "Rodin's *Eve*," DIA *Bull.*
33, 1 (1953-54): 14-16.

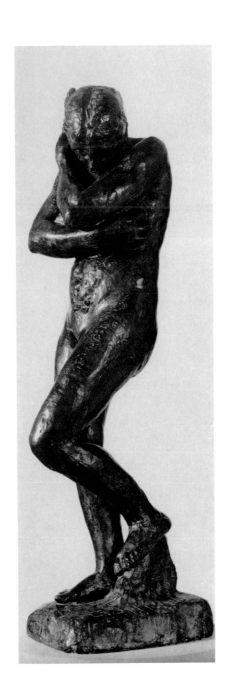

96
Crozier, French, 1225/50
Gilded copper and champlevé enamel; h. 31.6
cm. (12 7/16 in.)
Gift of Mr. and Mrs. Henry Ford II (59.297)
See F. W. Robinson, "An Enameled Crozier of
St. Michael," DIA *Bull.* 41, 4 (1962): 69-71.

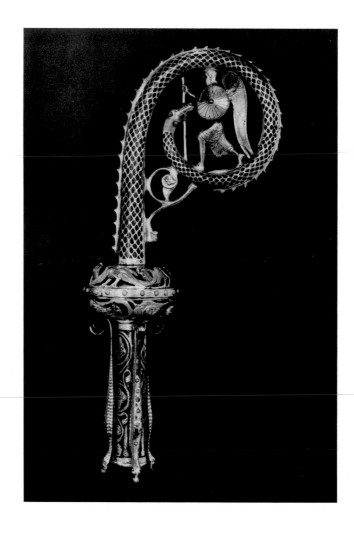

97
Fragment of a Tapestry Hanging: The Triumph of Cupid, French or Flemish, 1500/1600
Wool tapestry; 289.6 x 106.7 cm. (114 x 42 in.)
Founders Society Purchase, Ralph H. Booth Bequest Fund (35.6)
See *Chefs-d'oeuvre de la tapisserie du XIVe au XVIe siècle,* exh. cat., Grand Palais, Paris, and The Metropolitan Museum of Art, New York, 1973: no. 60 (French edition), no. 65 (English edition).

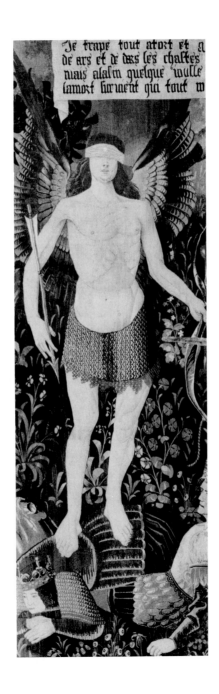

98
Soup Tureen in Form of a Turkey, French
(Strasbourg), c. 1755
Faience; h. 47.6 cm. (18¾ in.)
Founders Society Purchase, Mrs. Edsel B. Ford
Fund (65.25)
See DIA *Handbook*, 1971: 129.

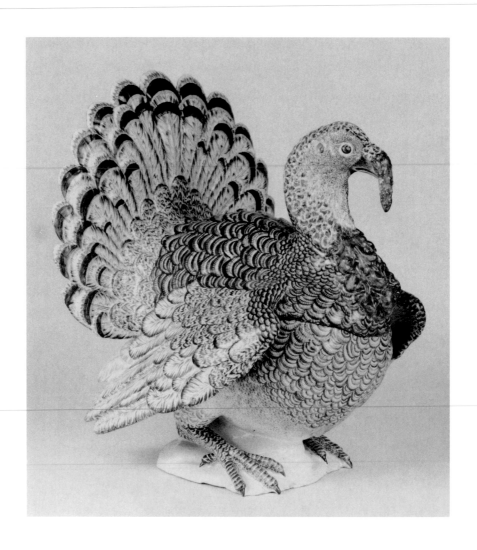

99
CHARLES-NICOLAS DODIN, French (Sèvres)
(active 1754-1802)
Triangular Pot-Pourri Vases with Covers, 1761
(pair)
Soft-paste porcelain; h. 29.2 cm. (11½ in.)
Bequest of Mrs. Horace E. Dodge in memory of
her husband (71.247)

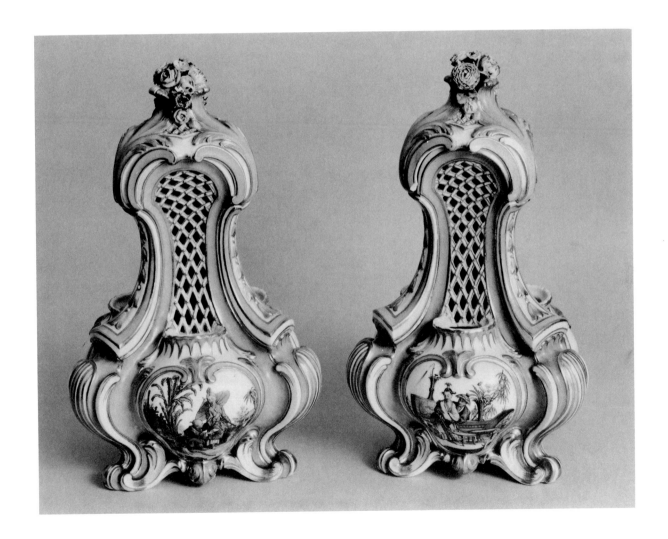

100
JEAN-HENRI RIESENER, French (1735-1806)
Commode, 1783
Mahogany and ormolu; w. 145.1 cm. (57⅛ in.)
Bequest of Mrs. Horace E. Dodge in memory of
her husband (71.194)

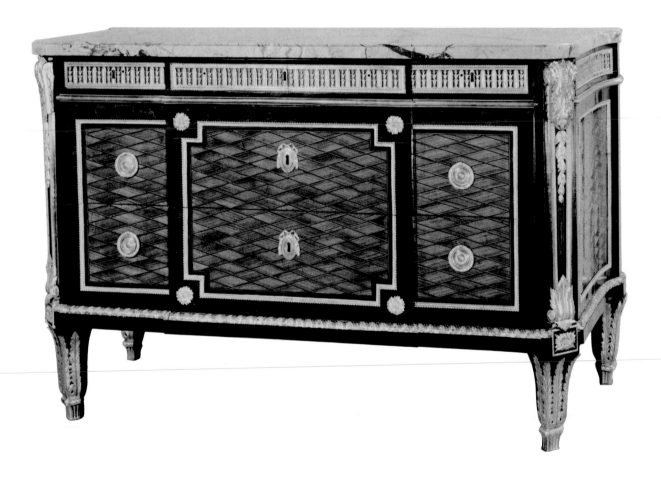

101
JACQUES BONHOMME, French (active
c. 1777-1793)
Two-Handled Covered Bowl, 1783
Silver; diam. 14.6 cm. (5¾ in.)
Gift of the Lewis E. Williams Estate (52.215)

102
JEAN-FRANCOIS ROUMIER, French (active
c. 1788-1793)
Chalice, 1788
Silver gilt; h. 30.8 cm. (12⅛ in.)
Gift of Mr. and Mrs. Henry Ford II (58.382)
See J. Helft, *Les Grands Orfèvres de Louis XIII
à Charles X*, Paris, 1965: 320, 323, 327.

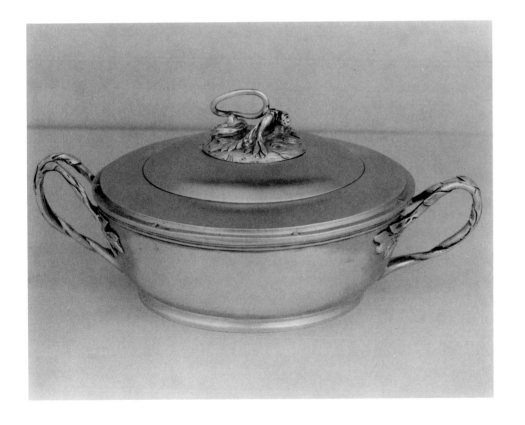

103
JEAN-BAPTISTE-CLAUDE ODIOT, French
(1763-1850)
Wine Coolers, c. 1810 (pair)
Silver gilt; h. 36.8 cm. (14½ in.)
Gift of Mrs. Roger Kyes in memory of her
husband (71.296-7)

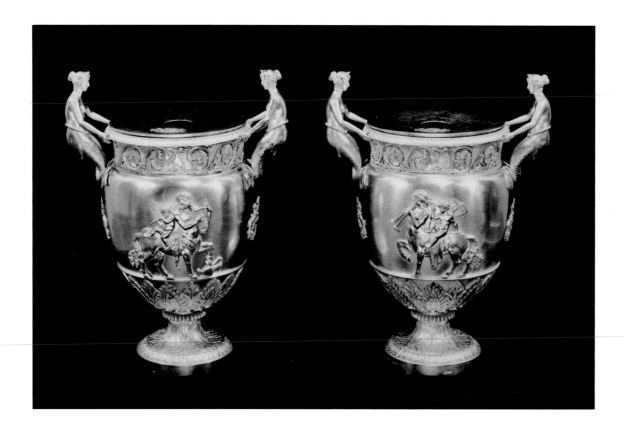

104
SASSETTA, Italian (1392-1450)
The Betrayal of Christ, after 1444
Tempera and gold leaf on panel; 37.8 x 59.4 cm.
(14⅞ x 23⅜ in.)
Founders Society Purchase (46.56)
See E. P. Richardson, "The Betrayal of Christ
by Sassetta," *Art Quarterly* 9, 4 (1946): 356-59.

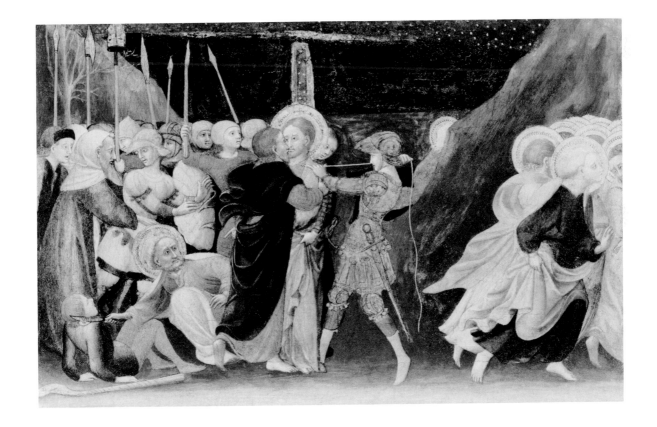

105
BENOZZO GOZZOLI, Italian (1420-1497)
Madonna and Child with Angels, c. 1460
Panel; 64.8 x 50.8 cm. (25½ x 20 in.)
Bequest of Eleanor Clay Ford (77.2)
See J. Pope-Hennessy, "The Ford Italian Paintings," DIA *Bull.* 57, 1 (1979): 18-20.

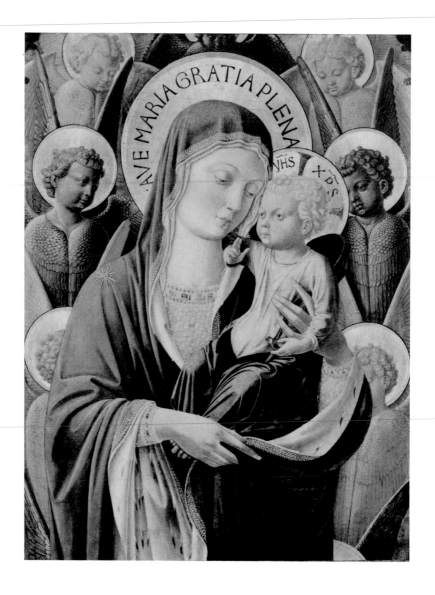

106
FRA ANGELICO, Italian (c. 1400-1455)
Virgin Annunciate (one of pair—see pl. xx)
Panel; 33 x 27 cm. (13 x 10⅝ in.)
Bequest of Eleanor Clay Ford (71.1.2)
See J. Pope-Hennessy, "The Ford Italian Paint-
ings," DIA *Bull.* 57, 1 (1979): 15-18.

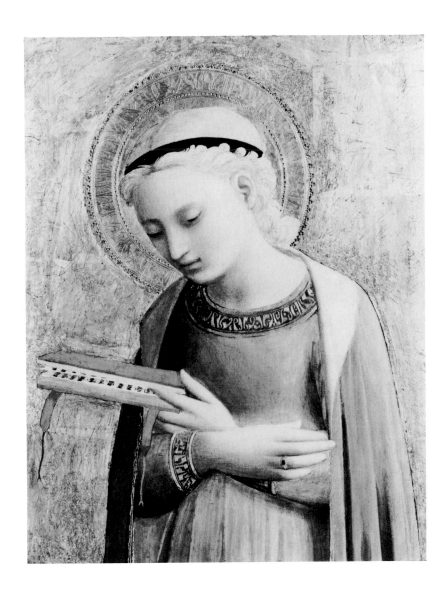

107
CARLO CRIVELLI, Italian (c. 1430-c. 1495)
Lamentation, c. 1470
Tempera and gold leaf on panel; 41.3 x 114.3 cm.
(16½ x 45 in.)
Founders Society Purchase (25.35)
See *Crivelli e Crivelleschi,* exh. cat., Ducal Palace,
Venice, 1961: no. 7.

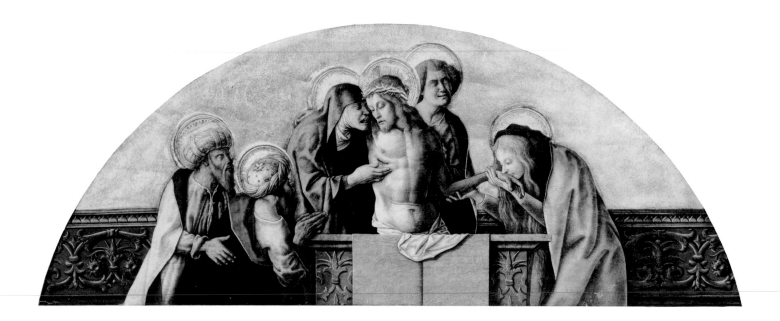

108
DOMENICO GHIRLANDAIO, Italian (1449-1494)
Portrait of a Young Man, 1475/94
Oil on panel; 33 x 22.9 cm. (13 x 9 in.)
Gift of Mr. and Mrs. Alfred J. Fisher (53.468)
See *Loan Exhibition of Italian Paintings from the
XIV to XVI Century,* exh. cat., DIA, 1933: no. 27.

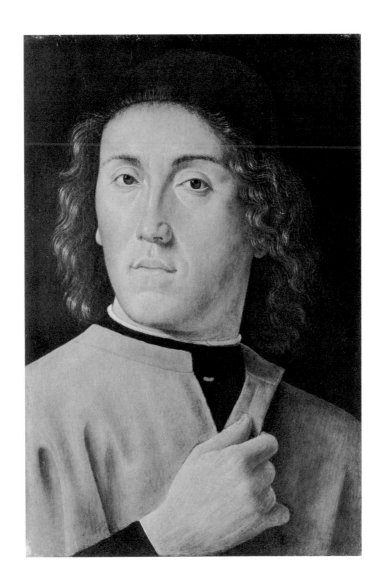

109
GIOVANNI BELLINI, Italian (c. 1430-1516)
Madonna and Child, 1509
Oil on panel; 84.8 x 106 cm. (33⅜ x 41¾ in.)
City Purchase (28.115)
See *Giovanni Bellini*, exh. cat., Ducal Palace,
Venice, 1949: no. 119.

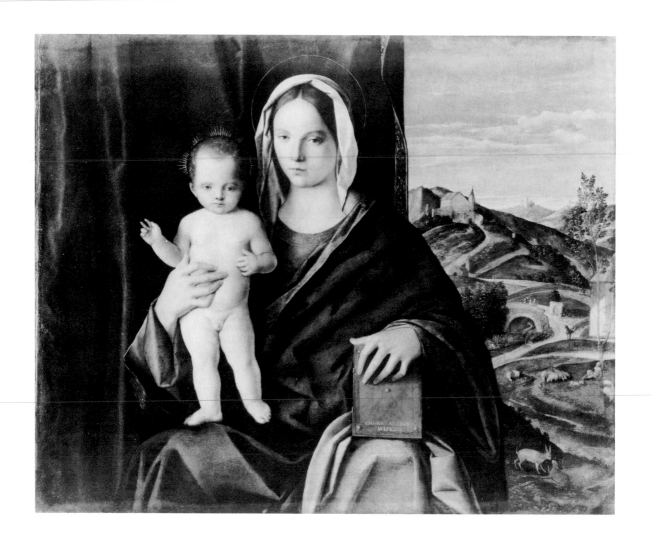

110

ANTONIO ALLEGRI DA CORREGGIO, Italian
(1489/94-1534)
The Mystic Marriage of St. Catherine, c. 1514
Oil on panel; 134 x 123.2 cm. (52¾ x 48½ in.)
Gift of Mrs. Anna Scripps Whitcomb in memory
of her father, James E. Scripps (26.94)
See W. R. Valentiner, "Gift of Four Important
Paintings: Correggio, Van Dyck, Poussin and
Zurbaran," DIA *Bull.* 8, 1 (1926): 2-5.

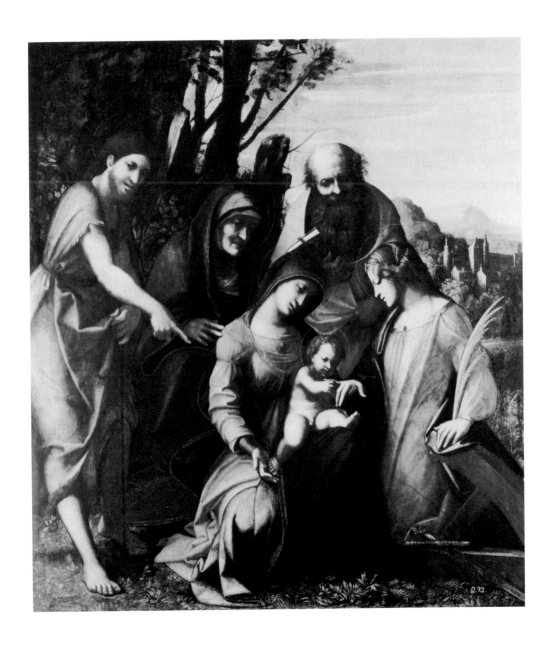

111
PARMIGIANINO, Italian (1503-1540)
The Circumcision, c. 1523
Oil on panel; 41.9 x 31.4 cm. (16½ x 12⅜ in.)
Gift of Axel Beskow (30.295)
See S. J. Freedberg, "Parmigianino's *Circumcision,*" DIA *Bull.* 55, 3 (1977): 129-32 (color cover).

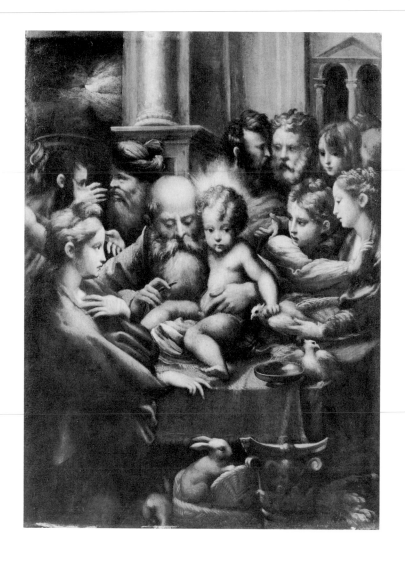

112

AGNOLO BRONZINO, Italian (1503-1572)
Eleanora of Toledo and Her Son, c. 1555
Oil on panel; 120.7 x 99.7 cm. (47½ x 39¼ in.)
Gift of Mrs. Ralph H. Booth in memory of her
husband (42.57)
See B. Berenson, *Italian Pictures of the Renaissance,* New York, 1963, I: 41.

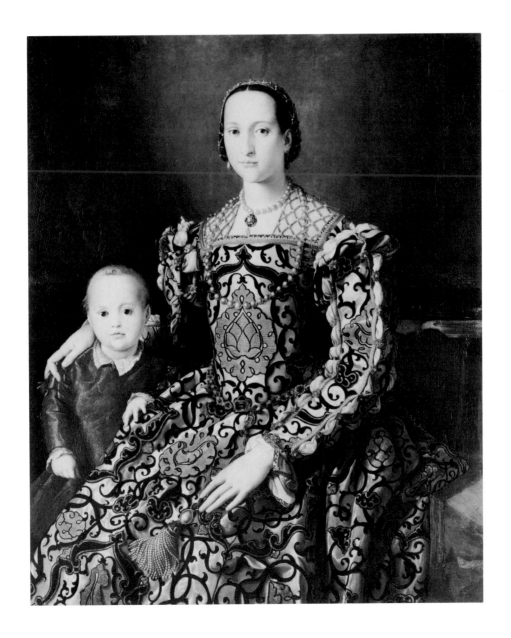

113
NICCOLO DELL'ABBATE, Italian (c. 1512-1571)
Eros and Psyche, c. 1560
Oil on canvas; 99.7 x 92.7 cm. (39¼ x 36½ in.)
Founders Society Purchase, Robert H. Tannahill
Fund (65.347)
See W. Johnson, "Niccolò dell'Abbate's *Eros and
Psyche,*" DIA *Bull.* 45, 2 (1966): 27-34.

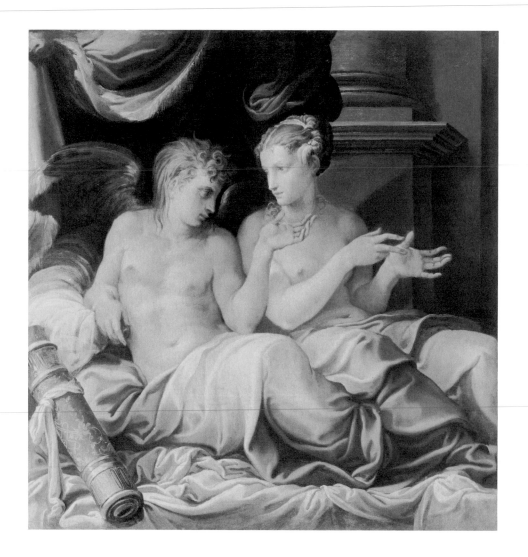

114
TITIAN, Italian (1485/90-1576)
Portrait of Man Holding a Flute, c. 1560/65
Oil on canvas; 97.8 x 76.2 cm. (38½ x 30 in.)
Founders Society Purchase (27.385)
See W. Heil, "A Portrait by Titian," DIA *Bull.* 9,
2 (1927): 14-15.

115
ORAZIO GENTILESCHI, Italian (1563-1639)
Young Woman with a Violin, c. 1612
Oil on canvas; 83.2 x 97.8 cm. (32¾ x 38½ in.)
Gift of Mrs. Edsel B. Ford (68.47)
See R. W. Bissell, "Orazio Gentileschi's *Young Woman with a Violin*," DIA *Bull.* 46, 4 (1967): 71-77.

116
ARTEMISIA GENTILESCHI, Italian (1593-c. 1651)
Judith and Maidservant with the Head of Holofernes, c. 1620/25
Oil on canvas; 184.2 x 141.6 cm. (72½ x 55¾ in.)
Gift of Leslie H. Green (52.253)
See E. P. Richardson, "A Masterpiece of Baroque Drama," DIA *Bull.* 32, 4 (1952-53): 81ff.

117
GUIDO RENI, Italian (1575-1642)
The Angel Appearing to St. Jerome, c. 1640
Oil on canvas; 198.1 x 148.6 cm. (78 x 58½ in.)
Founders Society Purchase, Ralph H. Booth
Bequest, Henry Ford II, Mr. and Mrs. Benson
Ford, and New Endowment Funds (69.6)
See D. S. Pepper, "*The Angel Appearing to Saint
Jerome* by Guido Reni, a New Acquisition," DIA
Bull. 48, 2 (1969): 28-35 (color cover: detail).

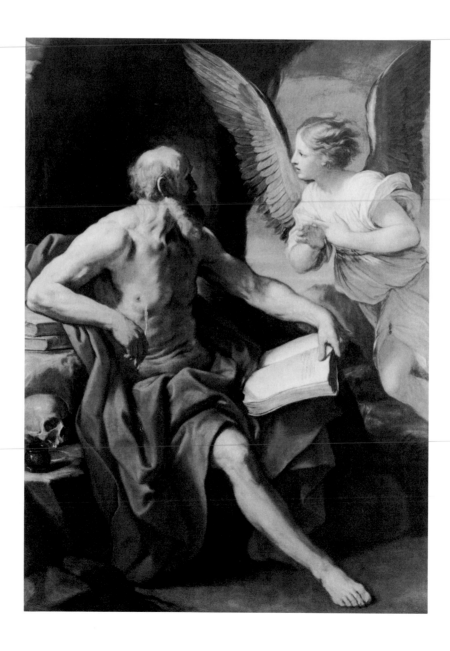

118

GUERCINO, Italian (1591-1666)
The Assumption of the Virgin, 1650
Oil on canvas; 308 x 219.7 cm. (121¼ x 86½ in.)
Founders Society Purchase, Robert H. Tannahill
Foundation and Josephine and Ernest Kanzler
Founders Funds (71.1)
See F. J. Cummings, *"The Assumption of the
Virgin* by Guercino," DIA *Bull.* 51, 2-3 (1972):
53-62 (color cover).

119

GIOVANNI BATTISTA PIAZZETTA, Italian
(1682-1754)
Madonna and Child with Adoring Figure,
1700/25
Oil on canvas; 188 x 144.8 cm. (74 x 57 in.)
Gift of Mr. and Mrs. Edsel B. Ford (38.56)
See E. P. Richardson, *"The Madonna and Child
with an Adoring Figure* by Tiepolo," DIA *Bull.*
18, 3 (1938): 2-6.

120
CANALETTO, Italian (1697-1768)
The Piazza of St. Mark, Venice, 1730/40
Oil on canvas; 75.6 x 118.7 cm. (29¾ x 46¾ in.)
Founders Society Purchase (43.38)
See E. P. Richardson, "With Canaletto in
Venice," DIA *Bull.* 23, 2 (1943): 14-16.

121

GIOVANNI BATTISTA TIEPOLO, Italian (1696-1770)
Girl with a Lute (Pandorina), 1753/57
Oil on canvas; 93.3 x 74.9 cm. (36¾ x 29½ in.)
Gift of Mr. and Mrs. Henry Ford II (57.180)
See E. P. Richardson, "An Unrecorded Painting
by Tiepolo," DIA *Bull.* 37, 4 (1957-58): 80-81
(color cover).

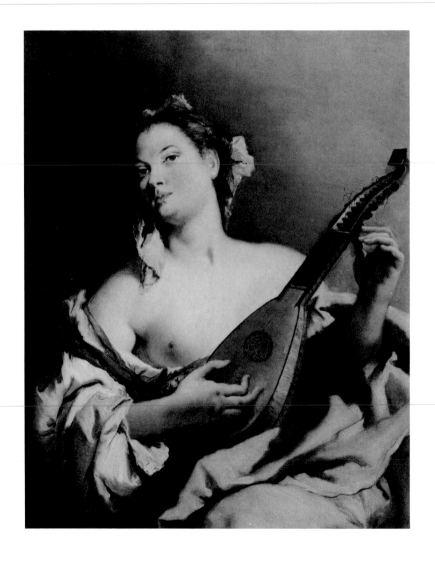

122
CORRADO GIAQUINTO, Italian (1703-1765)
The Rest on the Flight into Egypt, 1764/65
Oil on canvas; 284.5 x 177.8 cm. (112 x 70 in.)
Founders Society Purchase, Robert H. Tannahill
Foundation Fund (77.73)

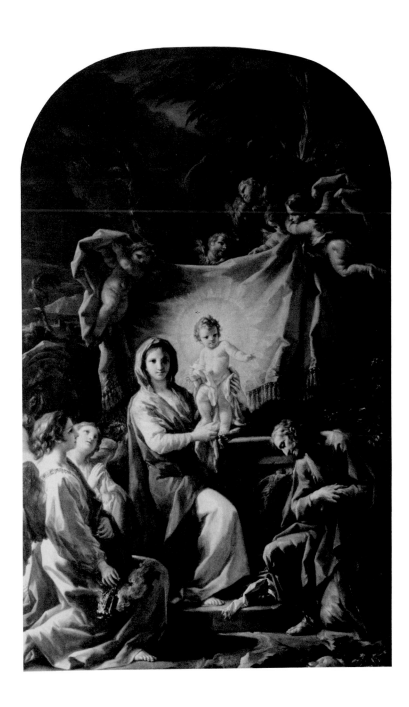

123
TINO DI CAMAINO, Italian (c. 1285-1337)
Madonna and Child, 1325/37
Marble; h. 48.9 cm. (19¼ in.)
City Purchase (25.147)
See W. R. Valentiner, "Gothic Sculpture From
Siena and Pisa," DIA *Bull.* 7, 3 (1925): 26.

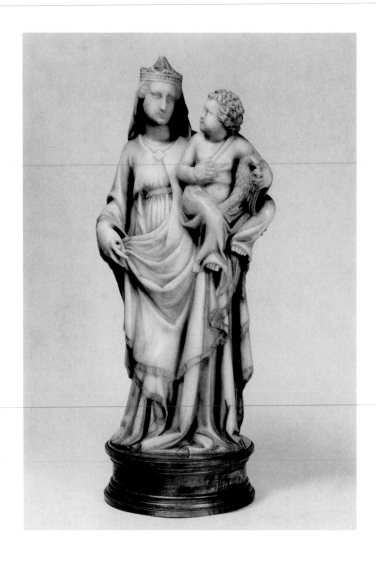

124
ANDREA PISANO, Italian (c. 1290-1348/50)
Madonna and Child, 1325/50
Marble with traces of gilding; h. (incl. base)
76.2 cm. (30 in.)
Gift of Mr. and Mrs. Edsel B. Ford (27.150)
See W. R. Valentiner, "Andrea Pisano as Marble
Sculptor," *Art Quarterly* 10, 3 (1947): 163-87.

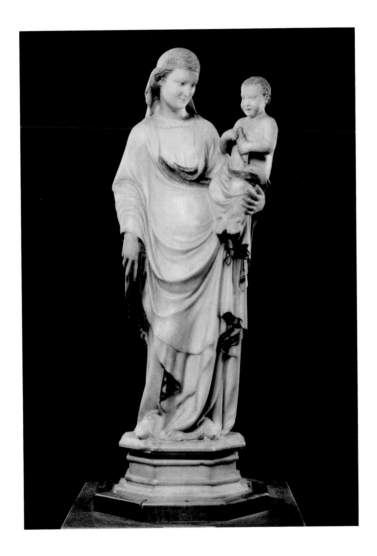

125
SCHOOL OF LORENZO GHIBERTI, Italian
Madonna and Child, c. 1440
Polychrome terracotta; h. 68.6 cm. (27 in.)
Founders Society Purchase, Ralph H. Booth
Bequest Fund (40.19)
See L. Goldscheider, *Ghiberti*, New York, 1949:
no. 19.

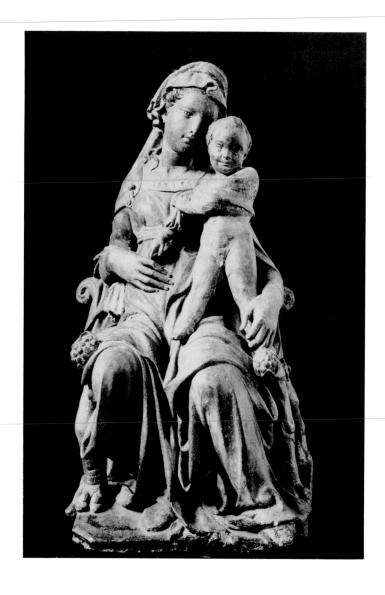

126
LUCA DELLA ROBBIA, Italian (c. 1400-1482)
Madonna and Child (The Genoese Madonna),
1450/60
Glazed terracotta relief; 49.5 x 36.8 cm. (19½ x
14½ in.)
City Purchase (29.355)
See J. Walther, "The Genoese Madonna by
Luca della Robbia," DIA *Bull.* 11,2 (1929): 34-35.

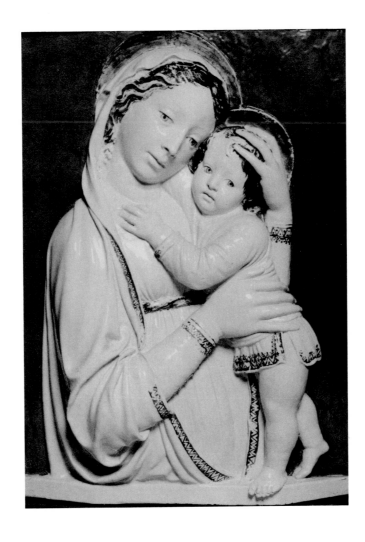

127
ANTONIO POLLAIUOLO, Italian (c. 1431-1498)
Judith, 1475/1500
Bronze; h. 42.9 cm. (16⅞ in.)
Gift of Mrs. Edsel B. Ford (37.147)
See W. R. Valentiner, "Late Gothic Sculpture in
Detroit," *Art Quarterly* 6, 4 (1943): 302ff.

128
SCHOOL OF JACOPO SANSOVINO, Italian
Neptune, c. 1525/50
Bronze; h. 94 cm. (37 in.)
Gift of Mr. and Mrs. Edgar B. Whitcomb (49.417)
See E. P. Richardson, "Two Bronze Figures by
Jacopo Sansovino," DIA *Bull.* 29, 3 (1949-50):
58-62.

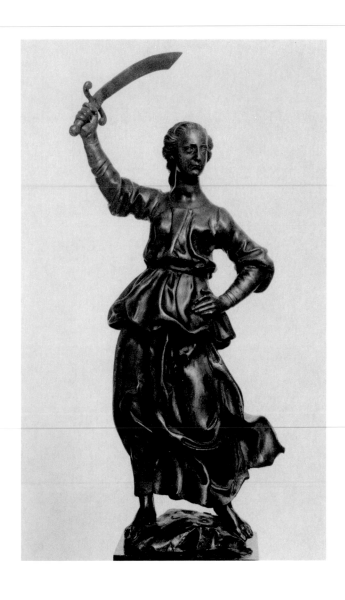

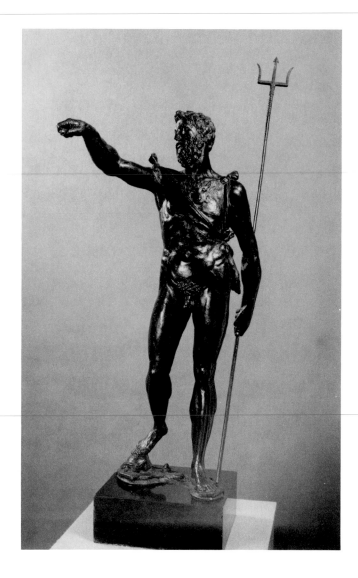

129
GIANLORENZO BERNINI, Italian (1598-1680)
Model of the Chair of St. Peter's, 1656/65
Terracotta; h. 58.4 cm. (23 in.)
Founders Society Purchase, Ralph H. Booth
Bequest Fund (52.220)
See P. L. Grigaut, "A Terracotta Model of St.
Peter's Cattedra," DIA *Bull*. 32, 3 (1952-53):
65-68.

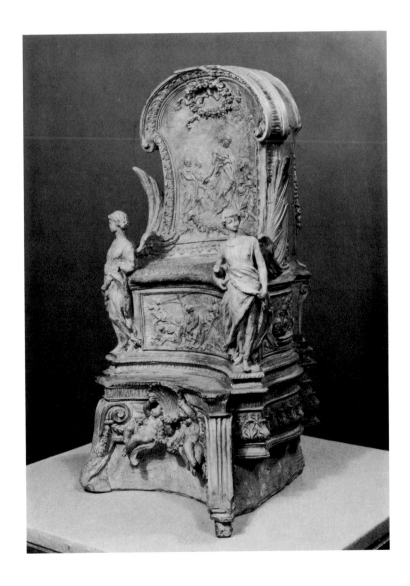

130
ANTONIO MONTAUTI, Italian (d. after 1740)
The Return of the Prodigal Son, 1724
Bronze; h. 63.2 cm. (24⅞ in.)
Founders Society Purchase, Robert H. Tannahill
Foundation Fund (73.254)
See J. Montagu, "Antonio Montauti's *Return of the Prodigal Son,*" DIA *Bull.* 54, 1 (1975): 14-23.

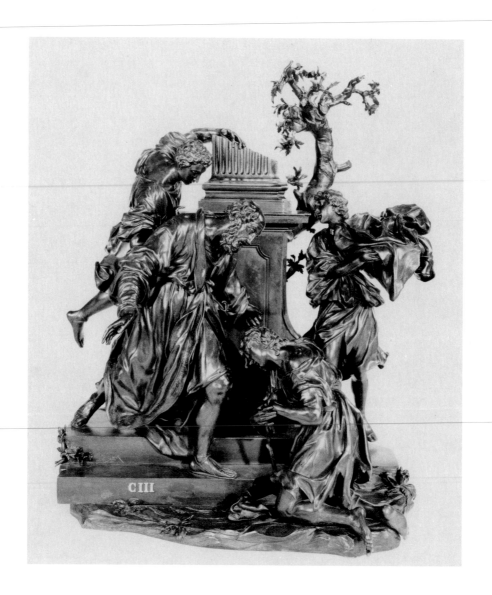

131
Christening Set, Italian (Urbino), c. 1550/75
Faience; cup, diam. 14 cm. (5½ in.); cover, diam.
17.8 cm. (7 in.); bowl, diam. 21.6 cm. (8½ in.)
Gift of Mr. and Mrs. Henry Ford II (59.124)
See P. L. Grigaut, "Two Pieces of Ceramic," DIA
Bull. 38, 4 (1958-59): 85-89.

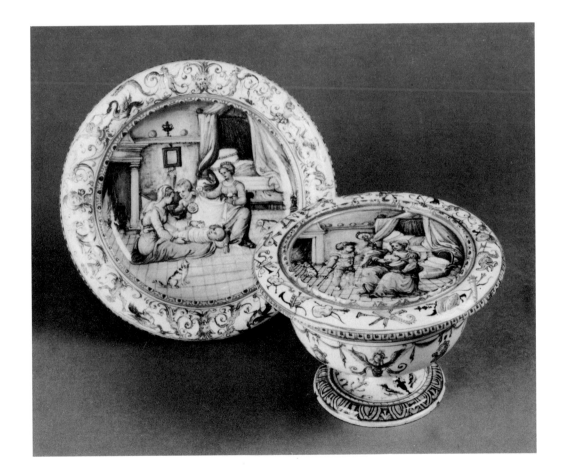

132

LEONARDO VAN DER VINNE, Flemish, active in
Florence (d. 1713)

Table, c. 1667

Ebony veneer with fruitwoods and ivory mar-
quetry; 77.9 x 116 x 78.4 cm. (30¹¹⁄₁₆ x 45¹¹⁄₁₆ x
30⅞ in.)

Founders Society Purchase, Josephine and
Walter B. Ford Fund (71.293)

See A. Gonzalez-Palacios, "A Grand Ducal
Table," DIA *Bull.* 55, 4 (1977): 168-181 (color
cover).

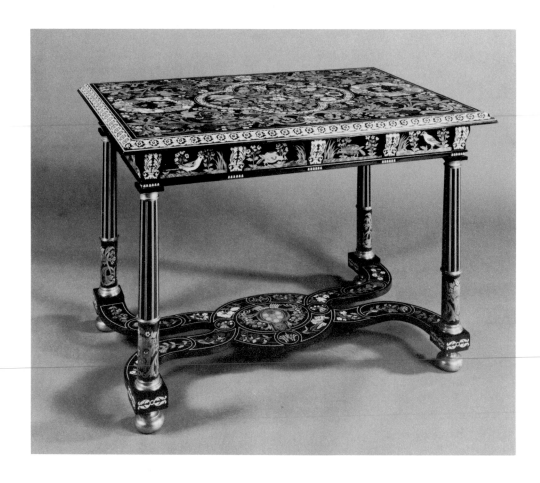

133
PIETRO PIFFETTI, Italian (1700-1777)
Secretary, c. 1760
Inlaid wood with ivory veneer; h. 223.5 cm.
(88 in.)
Founders Society Purchase, Robert H. Tannahill
Foundation Fund (73.167)
See A. Pedrini, *Il Mobilio e gli ambienti e le
decorazioni nei secoli XVII e XVIII in Piemonte,*
Turin, 1953: no. 317.

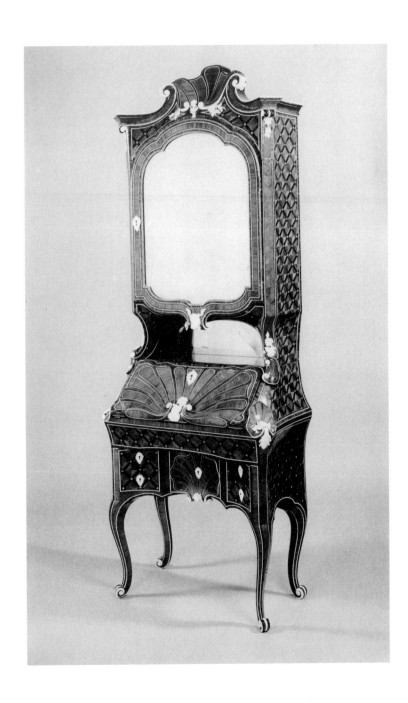

134
JUSEPE DE RIBERA, Spanish (1588-1652)
St. Jerome in the Wilderness, 1620/30
Oil on canvas; 196.2 x 152.4 cm. (77¼ x 60 in.)
Gift of Mr. and Mrs. Eugene H. Welker (49.4)
See E. P. Richardson, "A St. Jerome by Ribera,"
DIA *Bull.* 29, 3 (1949-50): 55ff.

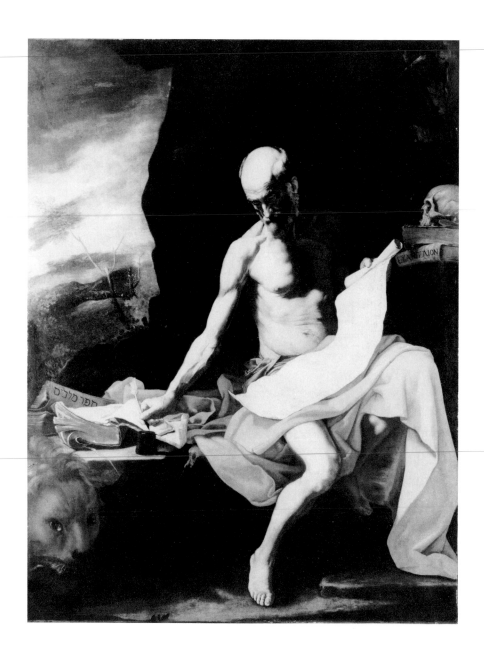

135
DIEGO VELASQUEZ, Spanish (1599-1660)
Portrait of a Man, 1623/30
Oil on canvas; 51.4 x 40 cm. (20¼ x 15¾ in.)
Founders Society Purchase (29.264)
See DIA *Handbook*, 1971:105.

136
FRANCISCO DE GOYA, Spanish (1746-1828)
Doña Amalia Bonells de Costa, c. 1805
Oil on canvas; 87.3 x 65.4 cm. (34⅜ x 25¾ in.)
Founders Society Purchase, Ralph H. Booth
Bequest Fund (41.80)
See E. P. Richardson, "The Condesa de Gondo-
mar by Goya," DIA *Bull.* 21, 2 (1941): 10-12.

COLOR PLATES

AMERICAN ART

XXV
JOHN SINGLETON COPLEY, American (1738-1815)
Hannah Loring, 1763
Oil on canvas; 126.4 x 99.7 cm. (49¾ x 39¼ in.)
Gift of Mrs. Edsel B. Ford in memory of
Robert H. Tannahill (70.900)
See G. Hood, "American Paintings Acquired
During the Last Decade," DIA *Bull.* 55, 2 (1977):
69ff. (color cover).

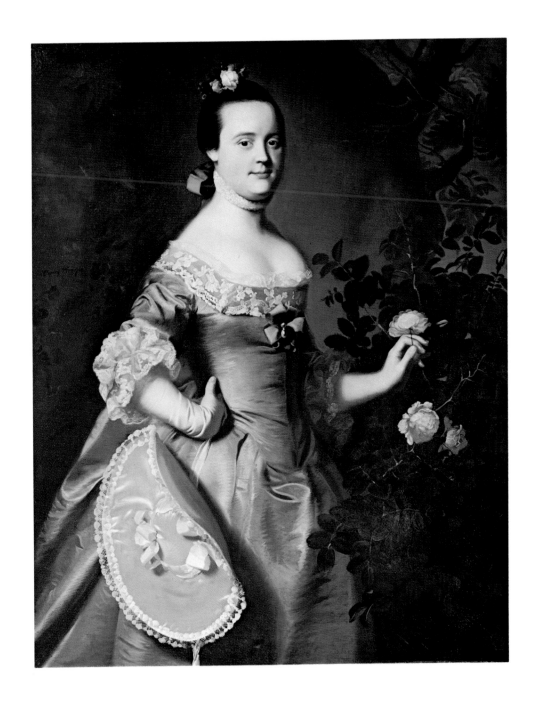

XXVI
WASHINGTON ALLSTON, American (1779-1843)
The Flight of Florimell, 1819
Oil on canvas; 91.4 x 71.1 cm. (36 x 28 in.)
City Purchase (44.165)
See E. P. Richardson, *Washington Allston*, Chicago, 1948: 139-141, 144, 206 (color frontispiece).

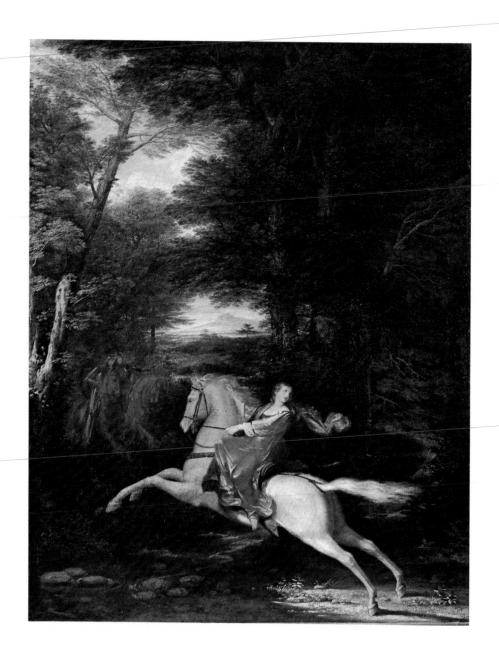

XXVII
FREDERIC EDWIN CHURCH, American (1826-1900)
Cotopaxi, 1862
Oil on canvas; 121.9 x 215.9 cm. (48 x 85 in.)
Founders Society Purchase, Robert H. Tannahill
Foundation, Gibbs-Williams, Dexter M. Ferry,
Jr., Merrill, Beatrice W. Rogers, and Richard A.
Manoogian Funds (76.89)
See D. C. Huntington, *The Landscapes of
Frederic Edwin Church, Vision of an American
Era,* New York, 1966: 11-20, 26, 49.

XXVIII
ALBERT BIERSTADT, American (1830-1902)
The Wolf River, Kansas, c. 1865
Oil on canvas; 122.6 x 97.2 cm. (48¼ x 38¼ in.)
Founders Society Purchase, Dexter M. Ferry, Jr.
Fund (61.28)
See G. Hendricks, "The Three Western Journeys
of Albert Bierstadt," *Art Bulletin* 46, 3 (1964):
333-65.

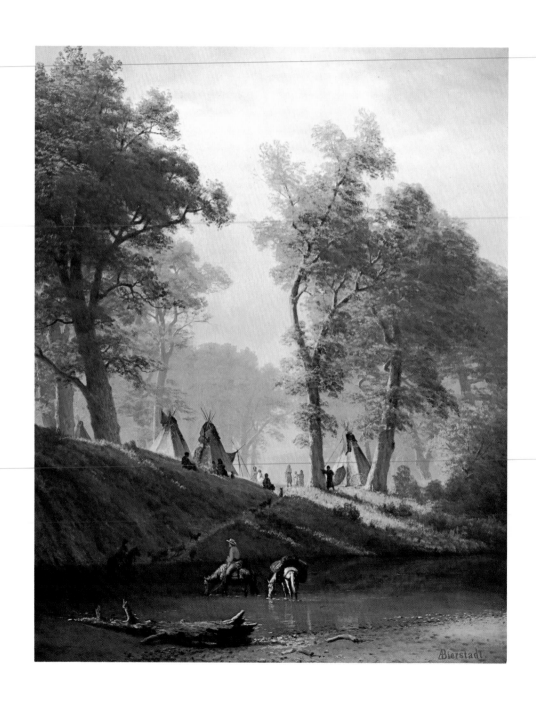

XXIX
WINSLOW HOMER, American (1836-1910)
Girl and Laurel, 1879
Oil on canvas; 57.5 x 40 cm. (22⅝ x 15¾ in.)
Gift of Dexter M. Ferry, Jr. (40.56)
See A. Ten Eyck Gardner, *Winslow Homer,* exh.
cat., National Gallery of Art, Washington, D.C.,
and The Metropolitan Museum of Art, New
York, 1958: no. 43.

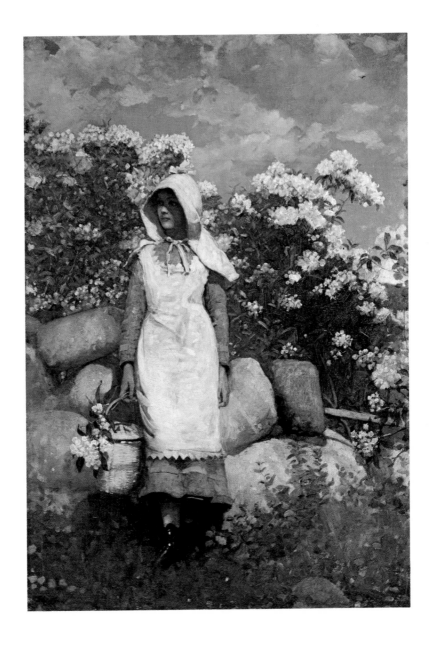

XXX
GEORGE WESLEY BELLOWS, American (1882-1925)
A Day in June, 1913
Oil on canvas; 106.7 x 121.9 cm. (42 x 48 in.)
Founders Society Purchase, The Merrill Fund
(17.17)
See C. H. Morgan, *George Bellows, Painter of America*, New York, 1965: 332.

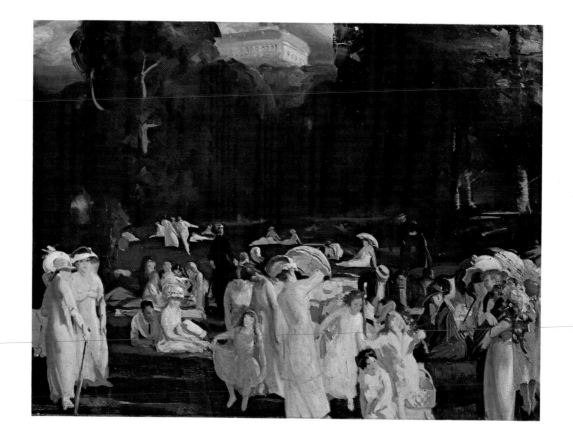

XXXI
ARTHUR B. DAVIES, American (1862-1928)
Dances, 1914/15
Oil on canvas; 213.4 x 381 cm. (84 x 150 in.)
Gift of Ralph H. Booth (27.158)
See D. A. Nawrocki, "Prendergast and Davies:
Two Approaches to a Mural Project," DIA *Bull*.
56, 4 (1978): 243-52.

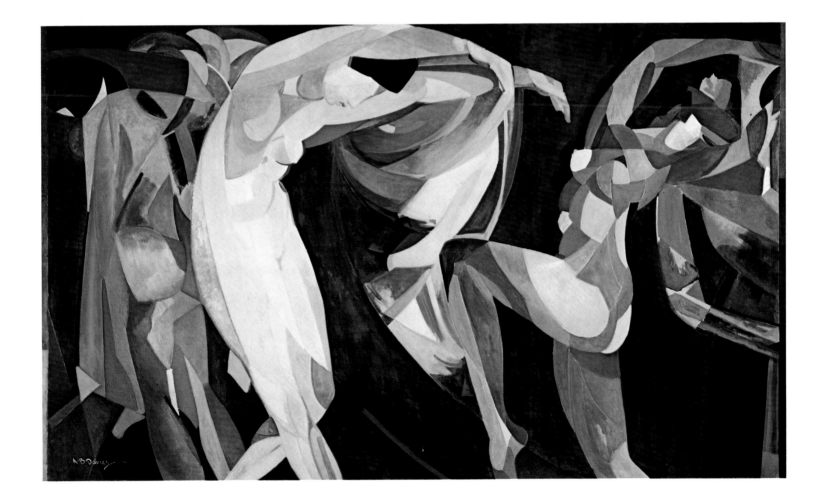

XXXII
LOUIS COMFORT TIFFANY, New York (1848-1933)
Flower-form Vase, 1901/05
Favrile glass; h. 30.8 cm. (12⅛ in.)
Gift of Miss Marie Fedderkin (59.289)
See R. Koch, *Louis C. Tiffany, Rebel in Glass,*
New York, 1966: 119-29.

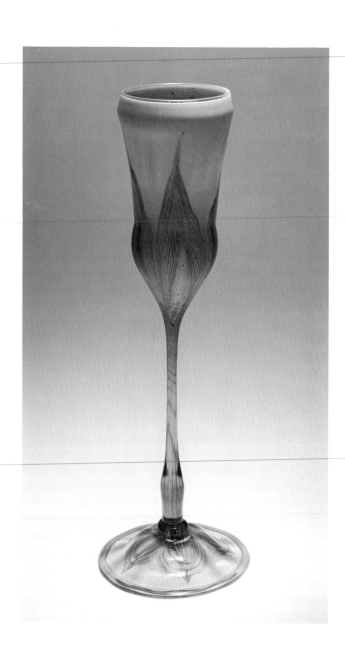

Nancy J. Rivard, Curator

In 1883, the newly founded Detroit Museum of Art made its first acquisition from the "Detroit Art Loan Exhibition," purchasing an oil painting by Francis D. Millet entitled *Reading the Story of Oenone* (no. 152). Millet's most ambitious and successful pictorial expression of his interest in classical costume and motifs, *Oenone* was an appropriate beginning for what is today one of the finest and most representative museum collections of 18th-, 19th-, and early 20th-century American painting. In addition to an impressive number of masterpieces, there are major examples of the work of recently rediscovered painters and important paintings by well-known Michigan artists.

The American collections were largely developed by Edgar P. Richardson, who came to the museum's Education Department in 1931 and served as Director of the museum from 1945 to 1962. Subsequent curators Charles Elam, Graham Hood, and Larry Curry added significant strength to the collections, most notably in the areas of painting, silver, and furniture. Under the present curator, Nancy J. Rivard, the policy is to continue to acquire major works in all media. Most recently, for example, the department acquired the very famous and important 19th-century landscape by Frederic Edwin Church, *Cotopaxi* (pl. XXVII).

In addition to direct gifts, many individuals established permanent funds specifically for the purchase of American art, and thus their support of the department's acquisitions program has continued during the years following their deaths. One of the department's earliest and most devoted patrons was Dexter M. Ferry, Jr., President of the Founders Society from 1920 to 1947. In collaboration with Clyde H. Burroughs, then Curator of American Art, Mr. Ferry made possible the acquisition of such major 19th-century masterpieces as James McNeill Whistler's *Nocturne in Black and Gold: The Falling Rocket,* George Caleb Bingham's *Trappers' Return,* Winslow Homer's *Girl and Laurel,* William Sidney Mount's *Banjo Player,* and many others (nos. 150, 144, pl. XXIX, no. 145).

Another outstanding patron was Robert H. Tannahill, who served as a museum trustee, commissioner, Honorary Curator of American Art, and contributed significantly to the museum's painting and sculpture collections. Among the most important works acquired through the Tannahill Foundation Fund are Benjamin West's *Lot Fleeing from Sodom,* the splendid 19th-century marble bust of *Medusa* by Harriet Hosmer; William Harnett's *American Exchange* and Charles Sheeler's *Home, Sweet Home* were given as personal gifts from Tannahill (nos. 137, 161, 151, 160). In addition, Mr. Tannahill helped to create a superb collection of colonial decorative arts. The Boston *Secretary Desk,* for example, attributed to George Bright, was acquired during Mr. Tannahill's lifetime, as were major pieces of silver by important 17th- and 18th-century Boston makers such as Paul Revere (nos. 168, 166). Many examples of American glass entered the collections under Mr. Tannahill's guidance, and the Institute's important French Canadian silver collection was largely acquired through his generosity and interest, as well as through that of Mrs. Allan Shelden (nos. 172, 173).

Some of the department's decorative arts are featured in a series of period rooms from the eastern United States. Two rooms from Whitby Hall, a country house built in the western environs of Philadelphia in 1754, were incorporated into the American Wing in 1927. In 1953 two other rooms were acquired from houses on the Delaware River below Philadelphia—a bedroom from Vauxhall Gardens, built in the 1720s in Salem, New Jersey; and a bedroom from Spring Garden Mansion, built about 1770 in New Castle, Delaware. Recently refurbished through funds provided by the Michigan Chapter of the National Society of the Colonial Dames of America, the period rooms house such fine examples of American furniture as an important *Chippendale Highboy* made in Philadelphia and purchased in 1973 through the Robert H. Tannahill and Henry Ford II Funds, and a superb Chippendale standing clock with works by Thomas Harland which came to the museum in 1959 as a gift from Mrs. Alger Shelden and others (nos. 167, 169).

Other important contributors to the collections of American art include Lizzie Merrill Palmer, who established the Merrill Fund in 1910; Mrs. Mary E. Gibbs, who established the Gibbs-Williams Fund in 1927 for the development of a collection of American colonial arts and crafts; Beatrice W. Rogers, whose fund was founded in 1968; and Mr. and Mrs. Adolph H. Meyer, whose American Foundation was begun in 1968.

The prominence of the American collections of the Institute inspired a number of people in the Detroit area to become personally involved as students and collectors in the field of traditional American art. Their interest led to the formation in 1967 of an important affiliated organization of the Founders Society called the Associates of the American Wing. Although no general acquisitions fund has been established by the Associates, many individual members have generously contributed to the strength and significance of the American collections. Notable gifts from members include John Singleton Copley's *Hannah Loring,* presented by Mrs. Edsel B. Ford in 1970 in memory of her cousin Robert H. Tannahill; generous contributions from Richard A. Manoogian toward the acquisition of Sargent's *Portrait of Mme. Paul Poirson;* and Church's *Cotopaxi* (pl. xxv, no. 153, pl. xxvII). Thus, Detroit's American collection continues to expand in scope, maintaining the standards of quality which have made it one of the finest in this country.

137
BENJAMIN WEST, American (1738-1820)
Lot Fleeing from Sodom, 1810
Oil on panel; 119.7 x 198.4 cm. (47⅛ x 78⅛ in.)
Founders Society Purchase, Robert H. Tannahill
Foundation Fund (70.831)
See J. Dillenberger, *Benjamin West, The Context
of His Life's Work* . . ., San Antonio, Texas,
1977: 122.

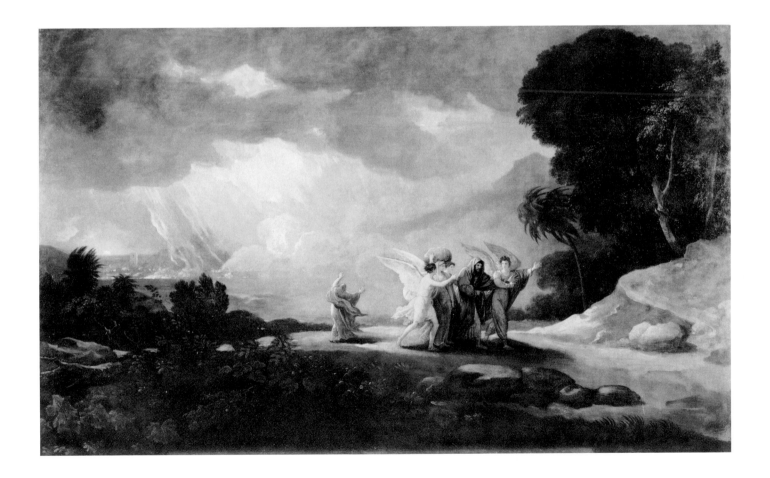

138

RAPHAELLE PEALE, American (1774-1825)

Still Life with Wineglass, 1818

Oil on panel; 26 x 34.6 cm. (10¼ x 13⅝ in.)

Founders Society Purchase, Laura H. Murphy Bequest Fund (39.7)

See J. I. H. Baur, "The Peales and the Development of American Still Life," *Art Quarterly* 3, 1 (1940): 81-92.

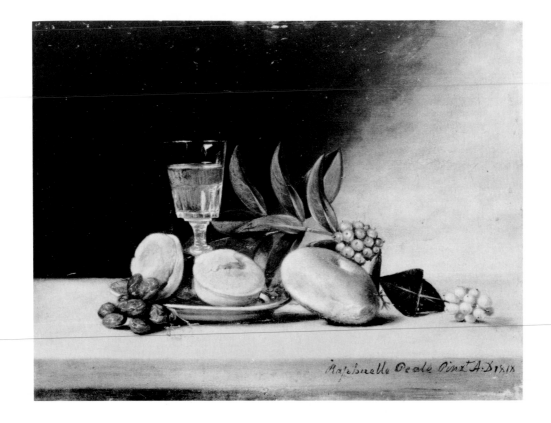

139
GILBERT STUART, American (1755-1828)
General Amasa Davis, c. 1820
Oil on panel; 83.2 x 66.7 cm. (32¾ x 26¼ in.)
Gift of Mrs. J. Bell Moran (45.17)
See L. Park, *Gilbert Stuart, An Illustrated Descriptive List of His Works,* New York, 1926, 1: no. 212.

140
REMBRANDT PEALE, American (1778-1860)
Self Portrait, 1828
Oil on canvas; 48.3 x 36.2 cm. (19 x 14¼ in.)
Founders Society Purchase, Dexter M. Ferry, Jr. Fund (45.469)
See C. H. Elam, *The Peale Family, Three Generations of American Artists,* exh. cat., DIA and the Munson-Williams-Proctor Institute, Utica, New York, 1967: no. 136.

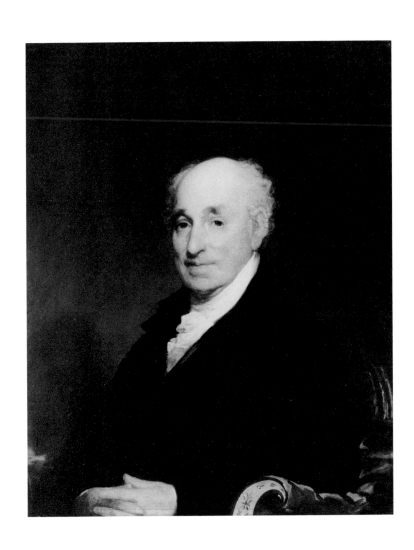

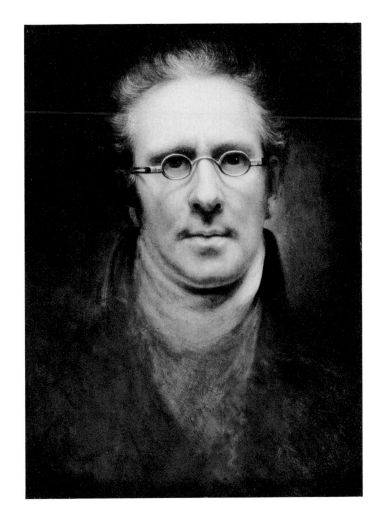

141
THOMAS DOUGHTY, American (1793-1856)
In Nature's Wonderland, 1835
Oil on canvas; 61.6 x 76.2 cm. (24¼ x 30 in.)
Founders Society Purchase, Gibbs-Williams Fund
(35.119)
See F. H. Goodyear, Jr., *Thomas Doughty,
1793-1856: An American Pioneer in Landscape
Painting,* exh. cat., Pennsylvania Academy of the
Fine Arts, Philadelphia, etc., 1973: no. 32.

142
ASHER B. DURAND, American (1796-1886)
View of Rutland, Vermont, 1840/50
Oil on canvas; 74 x 107 cm. (29⅛ x 42⅛ in.)
Gift of Dexter M. Ferry, Jr. (42.59)
See *Heritage and Horizon: American Painting
1776-1976,* Toledo Museum of Art, Ohio, etc.,
1976: no. 9.

143
THOMAS COLE, American (1801-1848)
American Lake Scene, 1844
Oil on canvas; 46.4 x 62.2 cm. (18¼ x 24½ in.)
Gift of Douglas F. Roby (56.31)
See D. C. Huntington, *Art and the Excited Spirit,*
exh. cat., University of Michigan, Ann Arbor,
1972: no. 39.

144
GEORGE CALEB BINGHAM, American (1811-1879)
The Trappers' Return, 1851
Oil on canvas; 66.7 x 92.1 cm. (26¼ x 36¼ in.)
Gift of Dexter M. Ferry, Jr. (50.138)
See E. M. Bloch, *George Caleb Bingham*, Berkeley, 1967: A222.

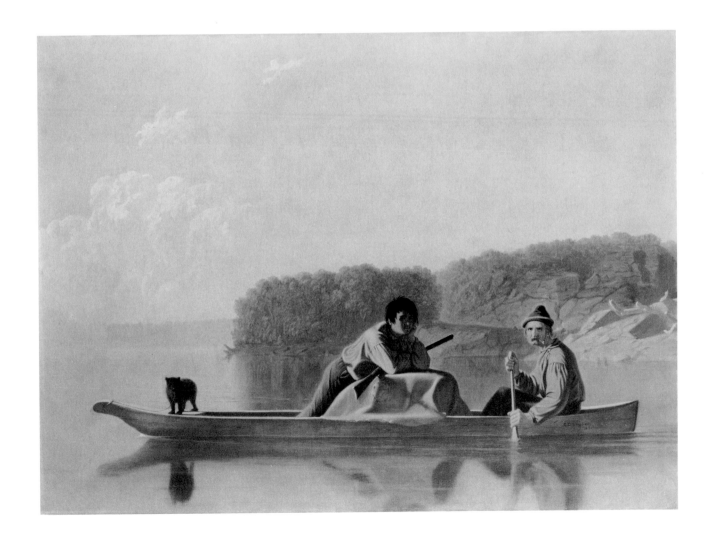

145
WILLIAM SIDNEY MOUNT, American (1807-1868)
The Banjo Player, c. 1858
Oil on canvas; 63.5 x 76.2 cm. (25 x 30 in.)
Gift of Dexter M. Ferry, Jr. (38.60)
See A. Frankenstein, *William Sidney Mount*,
New York, 1975: color pl. 37.

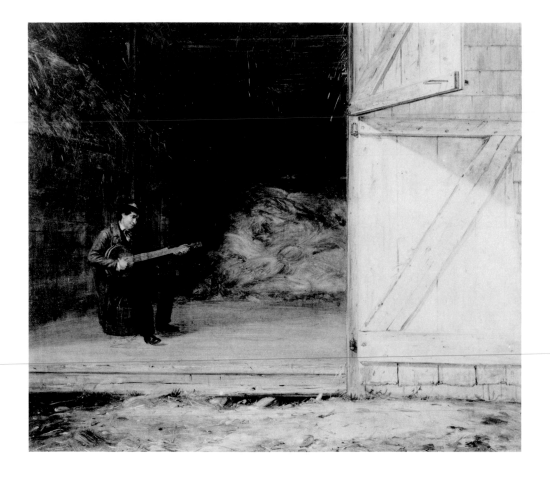

146
WILLIAM PAGE, American (1811-1885)
Mrs. William Page (Sophia Stevens Hitchcock),
c. 1860
Oil on canvas; 153 x 92.1 cm. (60¼ x 36¼ in.)
Gift of Mr. and Mrs. George S., Mr. Blinn S., and
Mr. Lowell B. Page, and Mrs. Lesslie S. Howell
(37.61)
See E. P. Richardson, "Two Portraits by William
Page," *Art Quarterly* 1, 2 (1938): 90-103.

147
WILLIAM PAGE, American (1811-1885)
Self Portrait, 1860
Oil on canvas; 149.9 x 91.4 cm. (59 x 36 in.)
Gift of Mr. and Mrs. George S., Mr. Blinn S., and
Mr. Lowell B. Page, and Mrs. Lesslie S. Howell
(37.60)
See J. C. Taylor, *William Page, the American
Titian,* Chicago, 1957: no. 82.

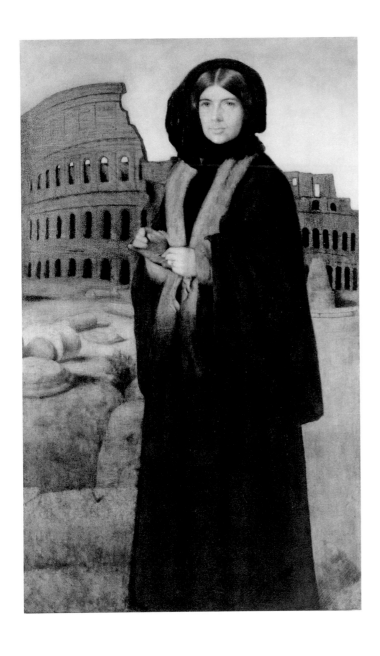

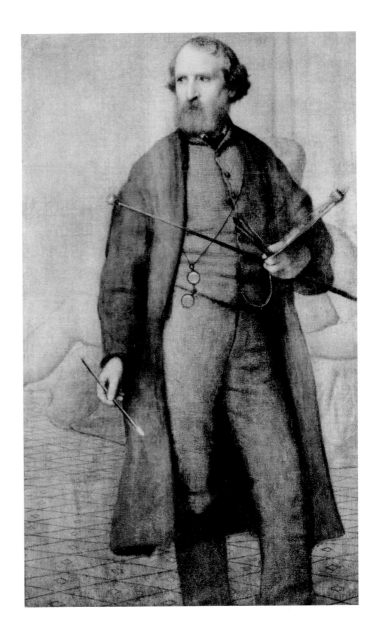

148
JASPER FRANCIS CROPSEY, American (1823-1900)
Indian Summer, 1866
Oil on canvas; 134.6 x 241.3 cm. (53 x 95 in.)
Founders Society Purchase, Robert H. Tannahill
Foundation, James and Florence Beresford,
Gibbs-Williams and Beatrice W. Rogers Funds
(78.38)
See W. S. Talbot, *Jasper F. Cropsey 1823-1900,*
exh. cat., The National Collection of Fine Arts,
Washington, D.C., etc., 1970: no. 50.

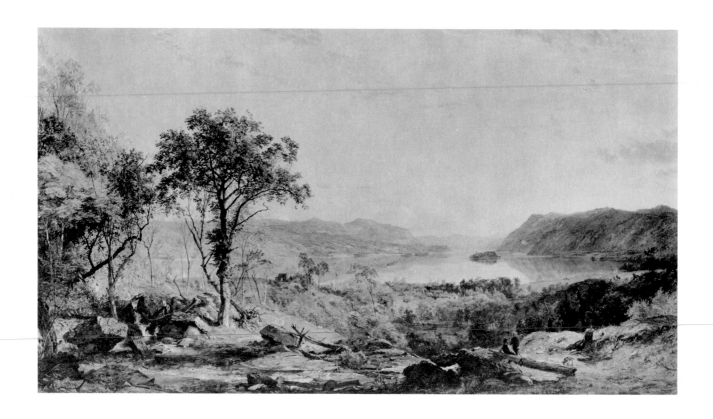

149
EASTMAN JOHNSON, American (1824-1906)
In the Fields, c. 1875
Oil on board; 45.1 x 69.9 cm. (17¾ x 27½ in.)
Founders Society Purchase, Dexter M. Ferry, Jr.
Fund (38.1)
See P. Hills, *Eastman Johnson,* exh. cat., Whitney
Museum of American Art, New York, etc., 1972:
no. 87.

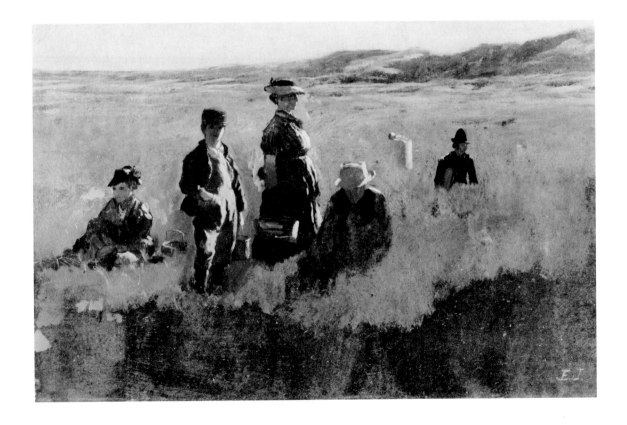

150
JAMES ABBOTT MC NEILL WHISTLER, American
(1834-1903)
Nocturne in Black and Gold: The Falling Rocket,
c. 1875
Oil on panel; 60.3 x 46.7 cm. (23¾ x 18⅜ in.)
Founders Society Purchase, Dexter M. Ferry, Jr.
Fund (46.309)
See D. Sutton, *James McNeill Whistler,* London,
1966: no. 70 (color ill.)

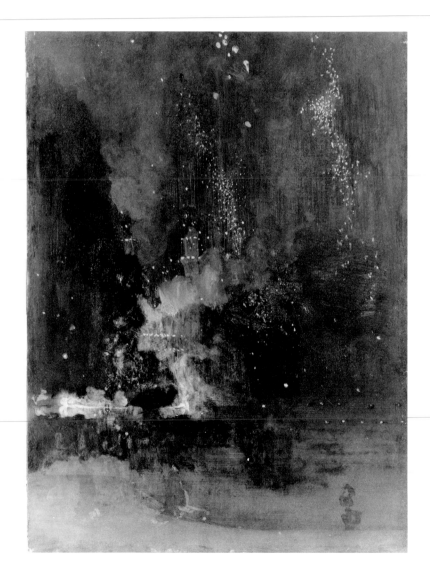

151
WILLIAM MICHAEL HARNETT, American
(1848-1892)
American Exchange, 1878
Oil on canvas; 20.3 x 30.5 cm. (8 x 12 in.)
Gift of Robert H. Tannahill (46.304)

See A. Frankenstein, *The Reminiscent Object,
Paintings by William Michael Harnett, John
Frederick Peto and John Haberle,* exh. cat.,
La Jolla Museum of Art and Santa Barbara
Museum of Art, California, 1965: no. 6.

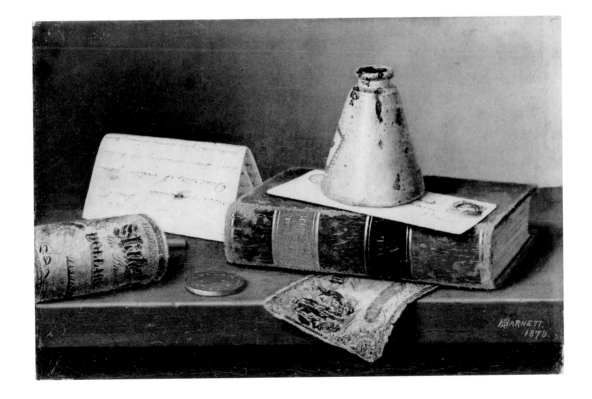

152

FRANCIS DAVIS MILLET, American (1846-1912)
Reading the Story of Oenone, c. 1882
Oil on canvas; 76.2 x 147 cm. (30 x 57⅞ in.)
Purchased with proceeds of the Art Loan Exhibition and Popular Subscription (83.1)
See H. B. Weinberg, "The Career of Francis Davis Millet," *Archives of American Art Journal* 17, 1 (1977): 7.

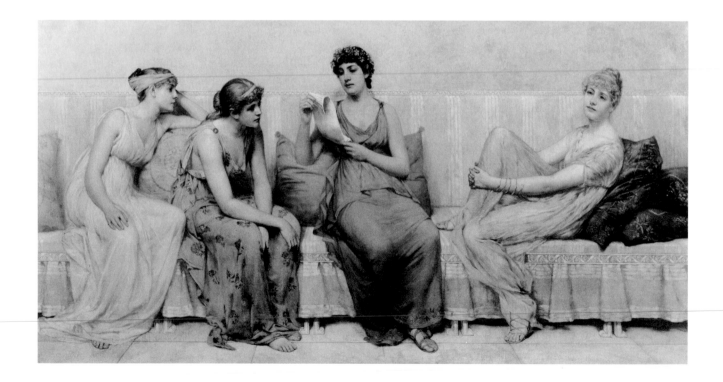

153
JOHN SINGER SARGENT, American (1856-1925)
Portrait of Mme. Paul Poirson (Seymourina Cuthbert), 1885
Oil on canvas; 149.9 x 85.1 cm. (59 x 33½ in.)
Founders Society Purchase, Mr. and Mrs. Richard A. Manoogian, Beatrice W. Rogers, Gibbs-Williams and Ralph H. Booth Bequest Funds (73.41)
See L. J. Curry, *"Madame Paul Poirson:* An Early Portrait by Sargent," DIA *Bull.* 51, 4 (1972): 96-104 (color cover).

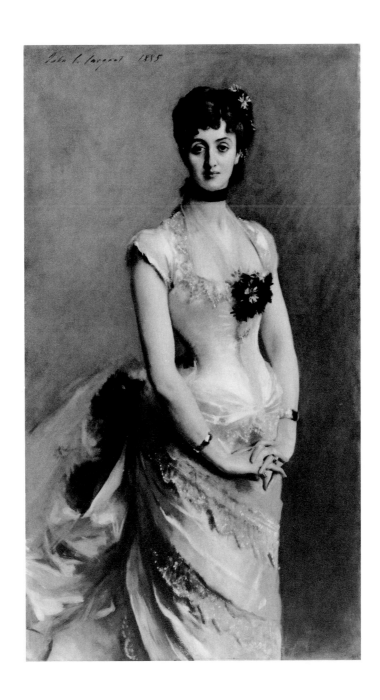

154
THEODORE ROBINSON, American (1852-1896)
Scene at Giverny, 1890
Oil on canvas; 40.6 x 65.4 cm. (16 x 25¾ in.)
Gift of Mrs. Christian H. Hecker (70.680)
See K. Pyne in "American Paintings Acquired
During the Last Decade," DIA *Bull.* 55, 2 (1977):
no. 20.

155
THOMAS WILMER DEWING, American (1851-1938)
The Recitation, 1891
Oil on canvas; 76.2 x 139.7 cm. (30 x 55 in.)
Founders Society Purchase (08.9)
See J. Wilmerding, *The Genius of American
Painting*, London, 1973: 186-88.

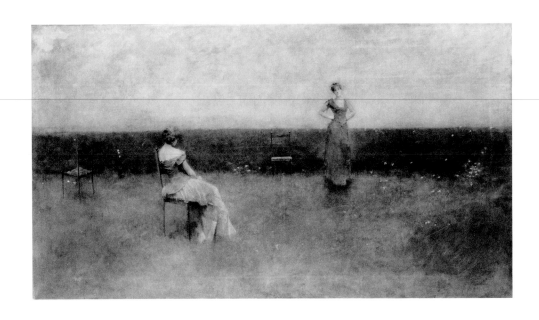

156
MARY CASSATT, American (1844-1926)
Women Admiring a Child, c. 1897
Pastel; 66 x 81.3 cm. (26 x 32 in.)
Gift of Edward Chandler Walker (08.8)
See A. D. Breeskin, *Mary Cassatt, A Catalogue Raisonné*, Washington, D.C., 1970: no. 272.

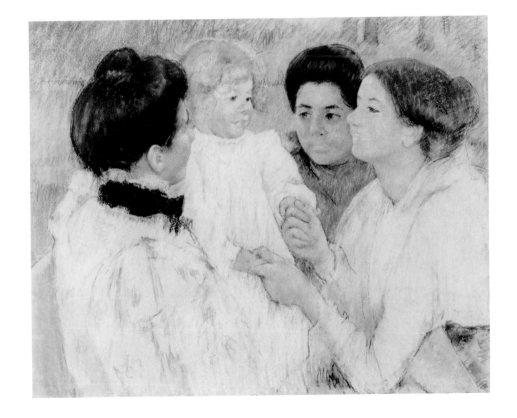

157
JOHN SLOAN, American (1871-1951)
Wake of the Ferry, 1907
Oil on canvas; 66 x 81.3 cm. (26 x 32 in.)
Gift of Miss Amelia E. White (61.165)
See M. S. Young, *The Eight*, New York, 1973:
52 (color ill.).

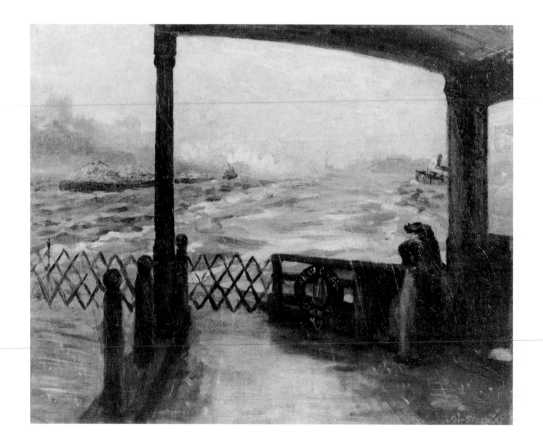

158
MAURICE B. PRENDERGAST, American (1859-1924)
Promenade, 1914/15
Oil on canvas; 212.7 x 340.4 cm. (83¾ x 134 in.)
City Purchase (27.159)
See D. A. Nawrocki, "Prendergast and Davies: Two Approaches to a Mural Project," DIA *Bull.* 56, 4 (1978): 243-52.

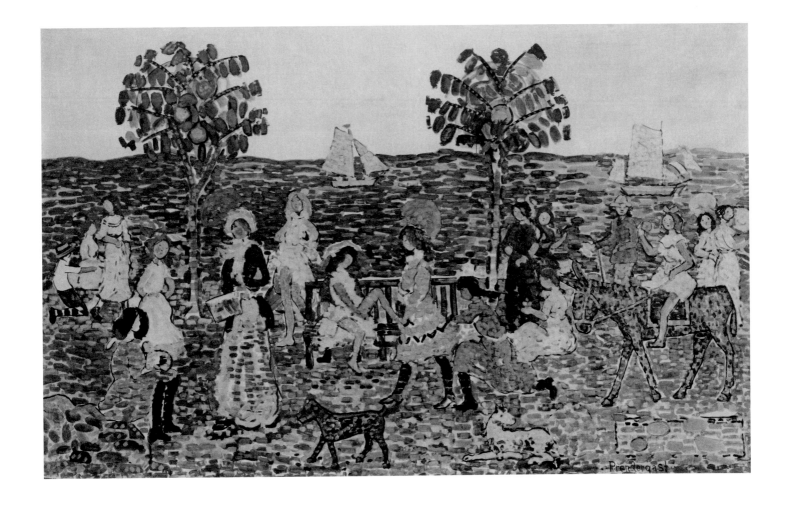

159
CHARLES DEMUTH, American (1883-1935)
Buildings Abstraction-Lancaster, 1931
Oil on board; 70.8 x 60 cm. (27⅞ x 23⅝ in.)
Founders Society Purchase (54.118)
See *Heritage and Horizon: American Painting
1776-1976*, exh. cat., The Toledo Museum of Art,
Ohio, etc., 1976: no. 42.

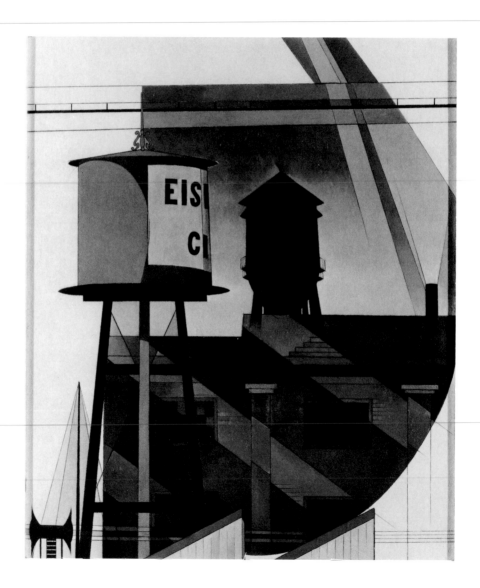

160
CHARLES SHEELER, American (1883-1965)
Home, Sweet Home, 1931
Oil on canvas; 91.4 x 73.7 cm. (36 x 29 in.)
Gift of Robert H. Tannahill (45.455)
See M. Friedman, *Charles Sheeler*, New York,
1975: 64 (color ill.), 92.

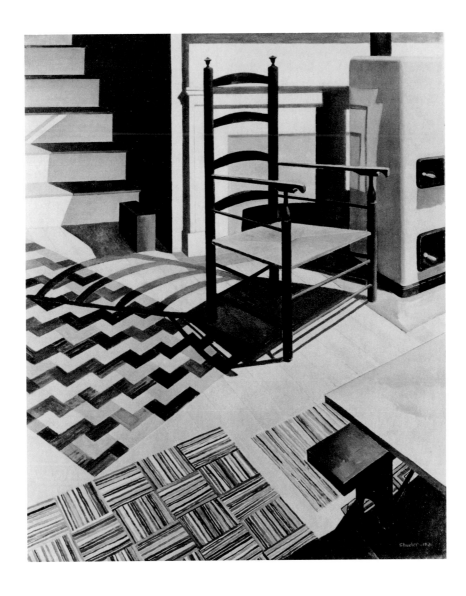

161

HARRIET GOODHUE HOSMER, American
(1830-1908)

Medusa, 1854

Marble; h. 68.6 cm. (27 in.)

Founders Society Purchase, Robert H. Tannahill
Foundation Fund (76.6)

See W. H. Gerdts, "The *Medusa* of Harriet
Hosmer," DIA *Bull.* 56, 2 (1978): 96-107.

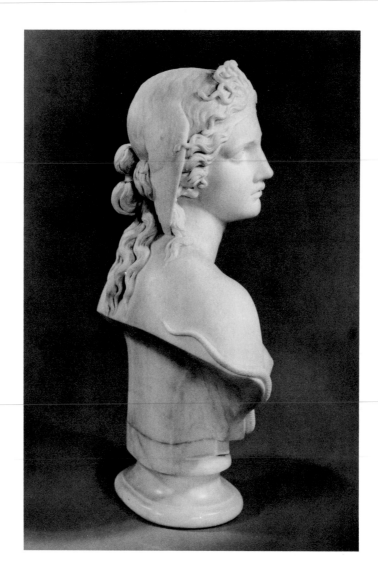

162
AUGUSTUS SAINT-GAUDENS, American (1848-1907)
Amor Caritas, 1898
Bronze; 101.6 x 43.2 cm. (40 x 17 in.)
Purchased by Popular Subscription (15.9)
See H. Saint-Gaudens, *The Reminiscences of Augustus Saint-Gaudens*, New York, 1913, I: 179, 222-24, 272-74, 350, 354; II: 128, 193, 197, 202, 345.

163
ELIE NADELMAN, American (1885-1946)
Reverie, 1916/17
Marble; h. 44.5 cm. (17½ in.)
Founders Society Purchase, William C. Yawkey, Octavia W. Bates and Henry A. Harmon Bequest Funds (18.3)
See L. Kirstein, *Elie Nadelman*, New York, 1973: no. 41.

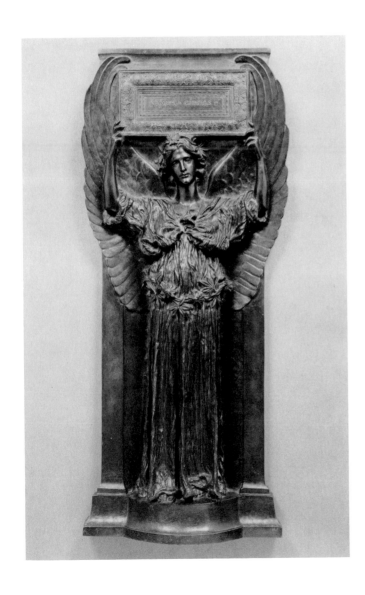

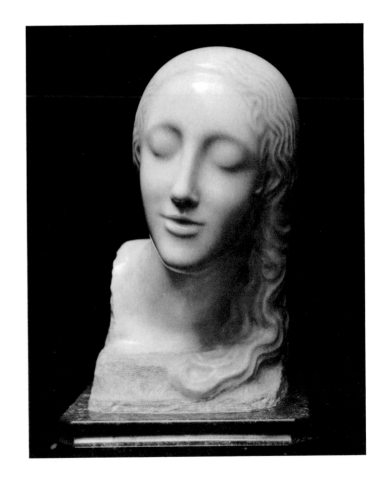

164
JOHN EDWARDS, Boston (1671-1746) and
JOHN ALLEN, Boston (1671-1760)
Caudle Cup, 1700/07
Silver; h. 8.9 cm. (3½ in.)
Founders Society Purchase, Robert H. Tannahill
Fund (69.62)
See D. A. Hanks, "Recent Acquisitions of
American Silver," DIA *Bull.* 55, 2 (1977): 111.

165
MYER MYERS, New York (1723-1795)
Bowl, 1750/60
Silver; h. 11.1 cm. (4⅜ in.)
Founders Society Purchase, Gibbs-Williams Fund
(69.260)
See G. Hood, *American Silver,* New York, 1971:
149, 151.

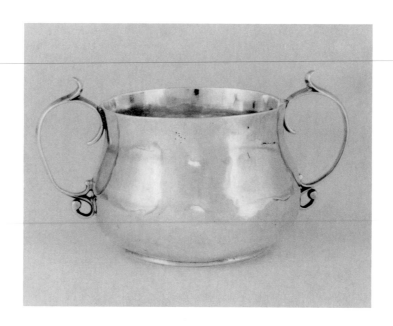

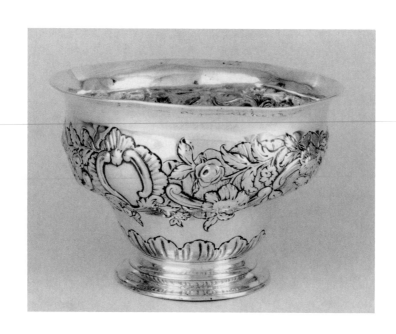

166
PAUL REVERE, Boston (1735-1818)
Teapot, c. 1790/95
Silver; h. 14.6 cm. (5¾ in.)
Founders Society Purchase, Gibbs-Williams Fund
(37.92)
See G. Hood, *American Silver,* New York, 1971:
166-71.

167
Philadelphia Chippendale Highboy, 1760/90
Mahogany; h. 245.7 cm. (96¾ in.)
Founders Society Purchase, Robert H. Tannahill
Foundation and Henry Ford II Funds (73.3)
See M. H. Heckscher, "18th-Century American
Furniture: Notable Acquisitions, 1966-1976,"
DIA *Bull.* 55, 2 (1977): 117ff.

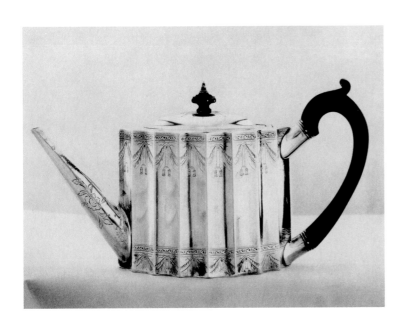

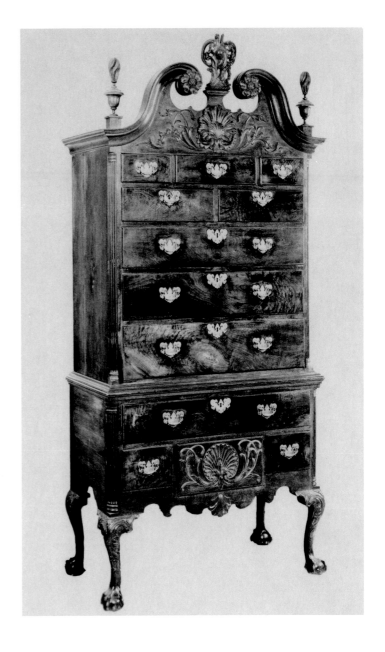

168
GEORGE BRIGHT (attrib.), Boston
(1726-1805)
Secretary Desk, 1770/85
Mahogany and pine; h. 260.4 cm. (102½ in.)
Founders Society Purchase, Robert H. Tannahill,
Louis Hamburger, Gibbs-Williams, and General
Funds (66.131)
See *American Decorative Arts From the Pilgrims
to the Revolution,* exh. cat., DIA, 1967: no. 50.

169
THOMAS HARLAND (maker of works), Norwich,
Connecticut (1735-1807)
Tall Standing Clock, 1775/95
Mahogany; h. 222.3 cm. (87½ in.)
Gift of Mrs. Alger Shelden, Mrs. Susan Kjellberg,
Mrs. Lyman White, Alexander Muir Duffield,
and Mrs. Oliver Pendar, in memory of Helen
Pitts Parker (59.149)
See A. R. Chase and H. Bulkeley, "Thomas Har-
land's Clock—Whose Case?" *Antiques* 87, 6
(1965): 700ff.

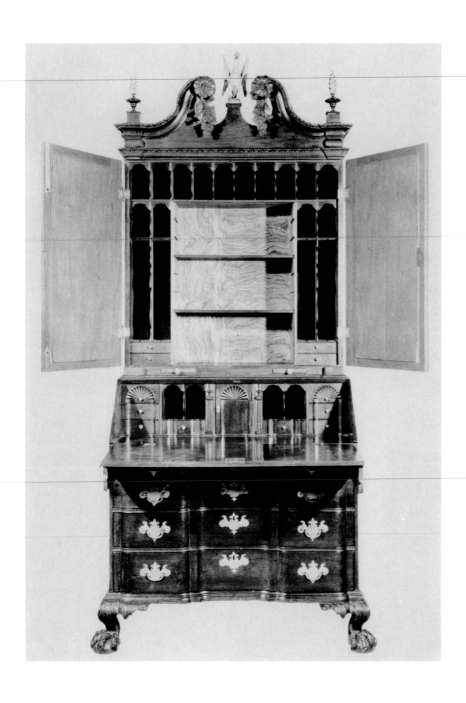

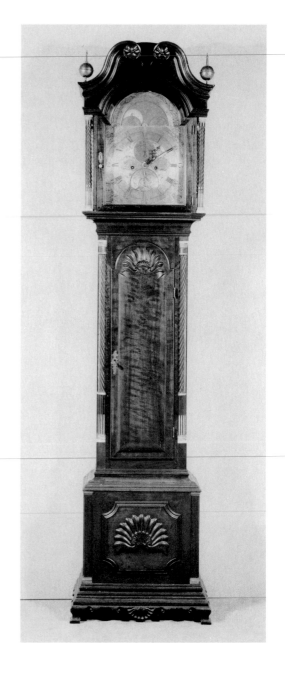

170
BONNIN AND MORRIS, Philadelphia
Fruit Basket, 1770/72
Soft-paste porcelain; h. 5.7 cm. (2¼ in.),
diam. 17.1 cm. (6¾ in.)
Founders Society Purchase, Gibbs-Williams Fund
(70.836)
See G. Hood, *Bonnin and Morris of Philadelphia,*
Chapel Hill, 1972: 33ff.

171
Pair of Candlesticks, Pittsburgh region, 1815/30
Glass; h. (each) 28.6 cm. (11¼ in.)
Gift of John Alexander Dalrymple in memory of
his wife Lotta Davies Dalrymple (51.134-35)
See E. Papert, *The Illustrated Guide to American
Glass,* New York, 1972: 86-89.

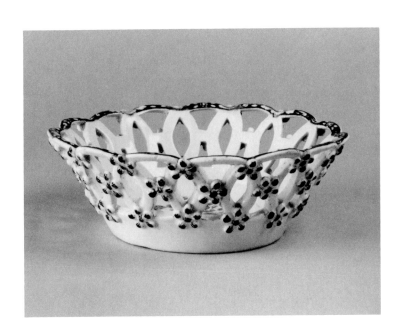

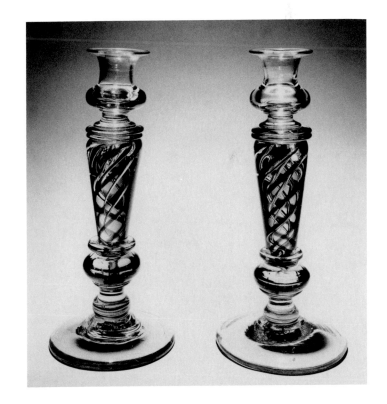

172
LAURENT AMIOT, Canadian (1764-1839)
Ciborium, c. 1800/10
Silver; h. 25.6 cm. (10¹/₁₆ in.)
Founders Society Purchase, Robert H. Tannahill Fund (69.297)
See R. A. C. Fox, *Quebec and Related Silver at The Detroit Institute of Arts*, DIA, 1978: no. 7.

173
FRANCOIS SASSEVILLE, Canadian (1797-1864)
Monstrance, 1841/63
Silver; h. 66.4 cm. (26⅛ in.)
Founders Society Purchase, Elizabeth, Allan, and Warren Shelden Fund (70.650)
See R. A. C. Fox, *Quebec and Related Silver at The Detroit Institute of Arts*, DIA, 1978: no. 42.

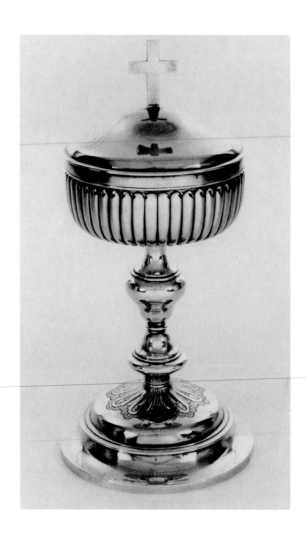

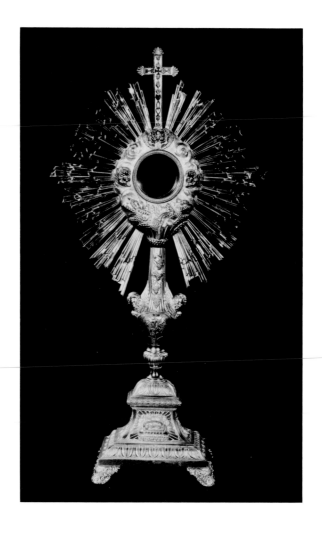

COLOR PLATES

MODERN AND GRAPHIC ARTS
AFRICAN, OCEANIC, AND NEW WORLD CULTURES

XXXIII
WASSILY KANDINSKY, Russian (1866-1944)
Composition: Painting with a White Shape, 1913
Oil on canvas; 99.7 x 89.3 cm. (39¼ x 34¾ in.)
Gift of Mrs. Ferdinand Moeller (57.234)
See A. F. Page, "An Early Kandinsky," DIA *Bull.*
38, 2 (1958-59): 27ff.

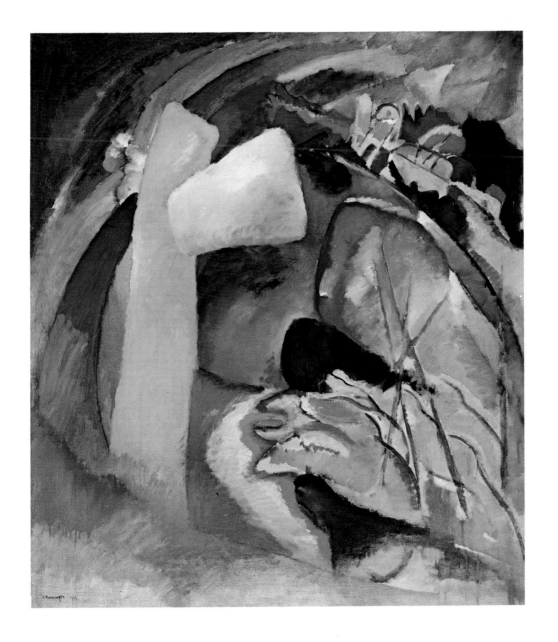

XXXIV
OSKAR KOKOSCHKA, Austrian (b. 1886)
The Elbe near Dresden, 1920/21
Oil on canvas; 59.7 x 80 cm. (23½ x 31½ in.)
City Purchase (21.203)
See H. M. Wingler, *Oskar Kokoschka, The Work
of the Painter*, Salzburg, 1958: 309.

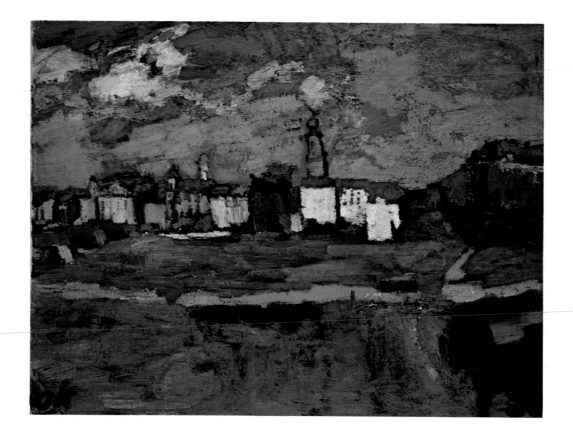

XXXV
CLYFFORD STILL, American (b. 1904)
Painting—1951, 1951
Oil on canvas; 236.9 x 192.4 cm. (93¼ x 75¾ in.)
Founders Society Purchase, W. Hawkins Ferry
Fund (65.310)
See DIA *Handbook,* 1971: 183.

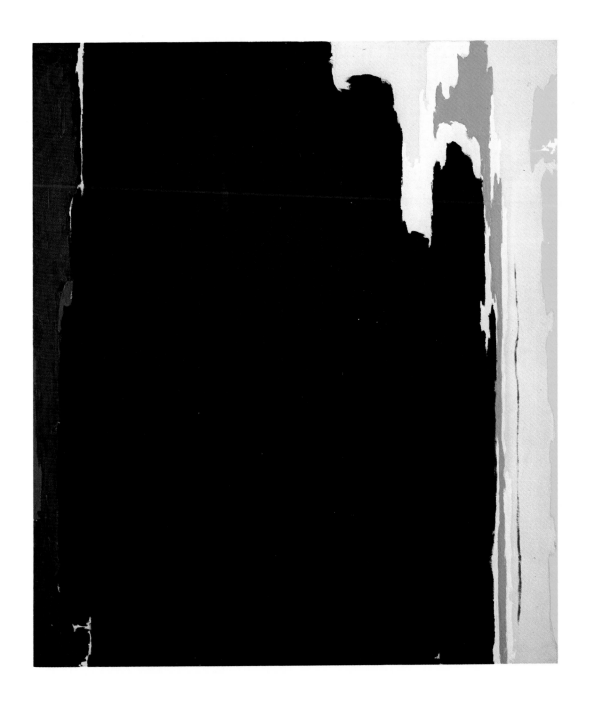

XXXVI

HENRI MATISSE, French (1869-1954)
The Wild Poppies (Les Coquelicots), 1953
(center panel)

Gouached paper and charcoal; 80 x 342 cm.
(31½ x 134⅝ in.)

Founders Society Purchase, Robert H. Tannahill
and Friends of Modern Art Funds; Gift of Mrs.
Allan Shelden, through the Elizabeth, Allan and
Warren Shelden Fund; Gift of Alice Kales Hart-
wick in memory of her husband, Robert G.
Hartwick; and General Subscription (78.31)

See *Henri Matisse Paper Cut-Outs,* exh. cat.,
The St. Louis Art Museum and the DIA, 1977:
no. 209.

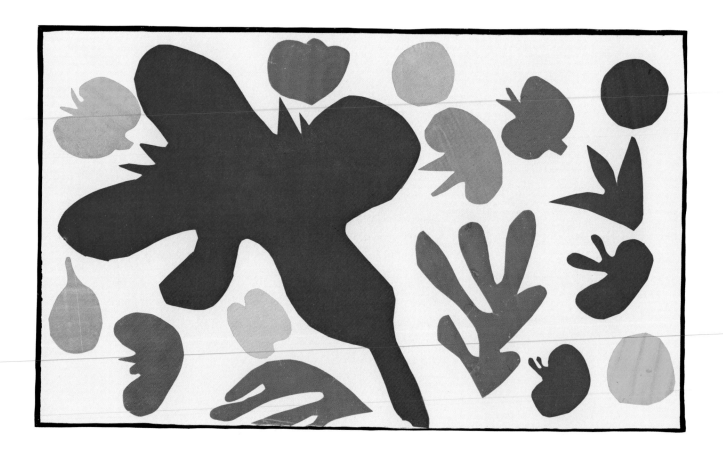

XXXVII
ANDY WARHOL, American (b. 1930)
Self-Portrait, 1967 (one of pair)
Silkscreen on canvas; 182.9 x 182.9 cm.(72 x 72 in.)
Founders Society Purchase, Friends of Modern
Art Fund (68.292. 1-2)
See S. F. Hilberry, "Two Andy Warhol Self-
Portraits," DIA *Bull.* 50, 4 (1971): 63-69.

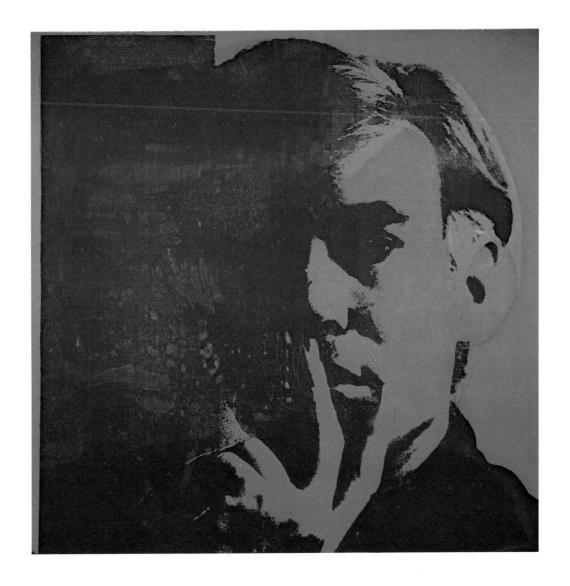

XXXVIII
BARNETT NEWMAN, American (1905-1970)
Be I (second version), 1970
Acrylic on canvas; 283.2 x 213.4 cm.
(111½ x 84 in.)
Gift of W. Hawkins Ferry and the Mr. and Mrs.
Walter B. Ford II Fund (76.78)
See J. H. Neff, "A Barnett Newman for Detroit,"
DIA *Bull.* 56, 3 (1978): 159-167.

XXXIX
HENRY MOORE, English (b. 1898)
Reclining Figure, 1939
Elmwood; l. 200.7 cm. (79 in.)
Gift of the D. M. Ferry, Jr. Trustee Corporation
(65.108)
See H. Read, *Henry Moore: Sculpture and Draw-ings,* New York, 1944: pls. 86a, 87a-b.
See DIA *Handbook,* 1971: 180.

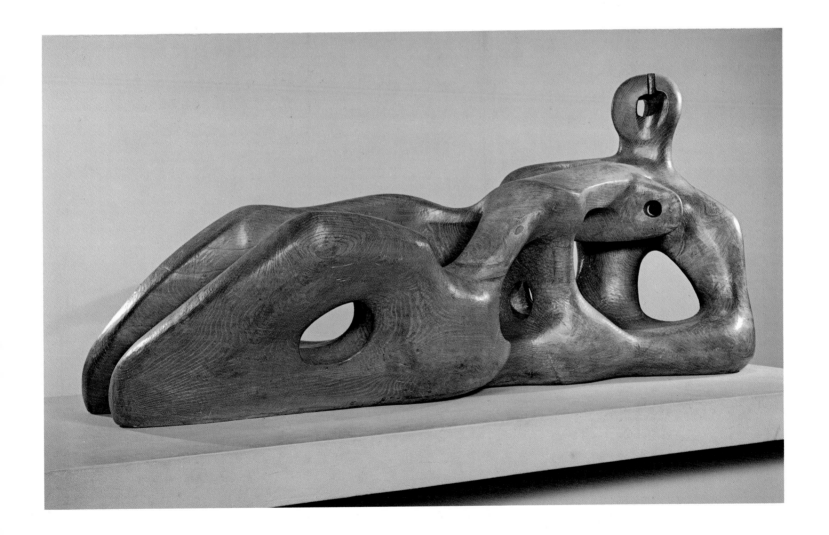

XL
CAMILLE PISSARRO, French (1831-1903)
The Pond at Kew Gardens, 1892
Watercolor over pencil; 17.8 x 25.5 cm.
(7 x 10¹⁄₁₆ in.)
Bequest of John S. Newberry (65.222)
See *The John S. Newberry Collection,* exh. cat.,
DIA, 1965: 73.

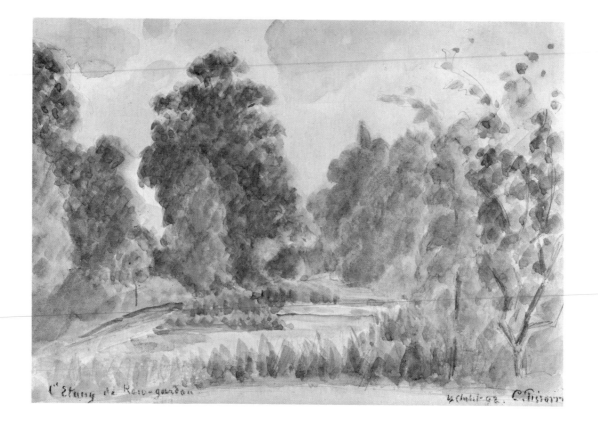

XLI
PAUL KLEE, Swiss (1879-1940)
Arrival of the Air-Steamer, 1921
Black ink and watercolor; 24.1 x 31.1 cm.
(9½ x 12½ in.)
Bequest of Robert H. Tannahill (70.345)
See *The Robert Hudson Tannahill Bequest*, exh.
cat., DIA, 1970: 65, 114.

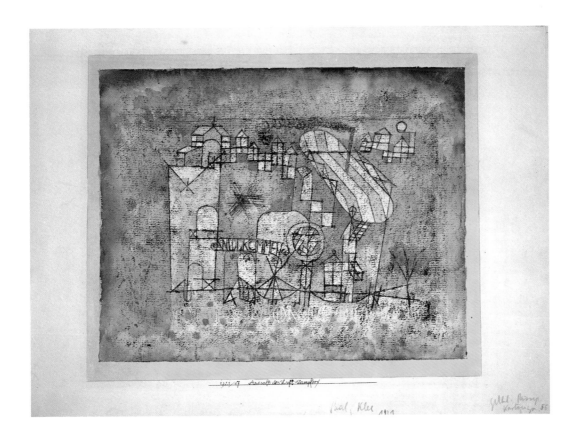

XLII

CHARLES DEMUTH, American (1833-1935)

Still Life: Apples and Bananas, 1925

Watercolor over pencil; 30.2 x 45.7 cm.
(11 ⅞ x 18 in.)

Bequest of Robert H. Tannahill (70.253)

See T. E. Stebbins, Jr., *American Master Drawings and Watercolors,* New York, 1976: 317.

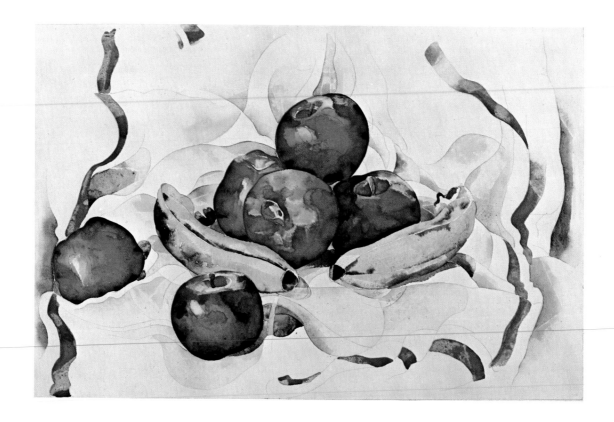

XLIII
EMIL NOLDE, German (1867-1956)
Portrait of the Artist and his Wife
Watercolor; 52.7 x 35.9 cm. (20¾ x 14⅛ in.)
Bequest of Robert H. Tannahill (70.323)
See *The Robert Hudson Tannahill Bequest*, exh.
cat., DIA, 1970: 65, 114.

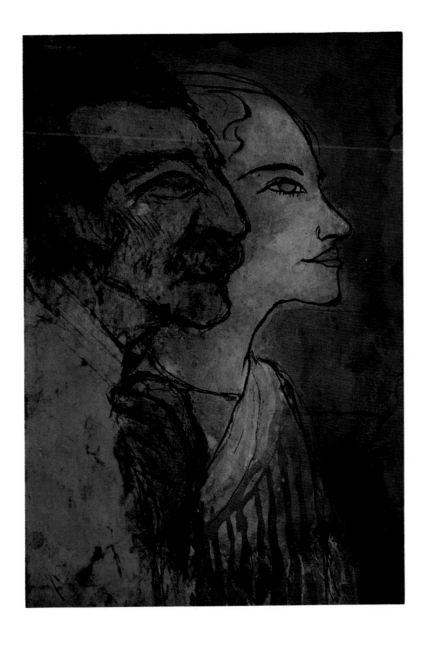

XLIV
EDVARD MUNCH, Norwegian (1863-1944)
Moonlight, 1896
Color woodcut; 40 x 47 cm. (15¾ x 18½ in.)
Founders Society Purchase, Robert H. Tannahill
Foundation Fund (F77.94)

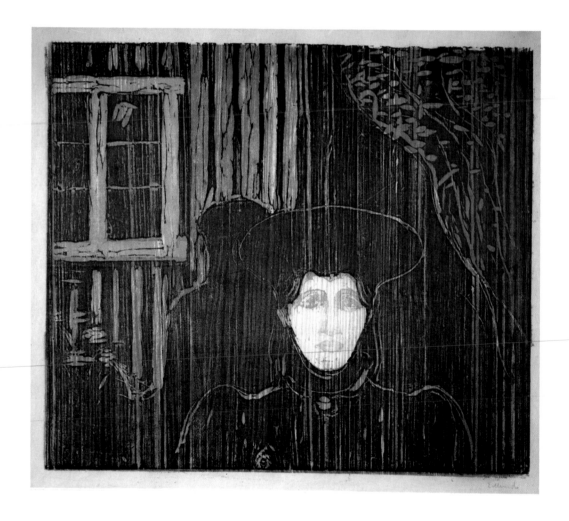

XLV
Nail Figure (nkisi n'kondi), African, Kongo,
Zaïre, 1800/1900

Wood with nails and blades; h. 116.8 cm. (46 in.)

Founders Society Purchase, Eleanor Clay Ford
Fund for African Art (76.79)

See R. F. Thompson, "The Grand Detroit
N'Kondi," DIA *Bull.* 56, 4 (1978): 207-21.

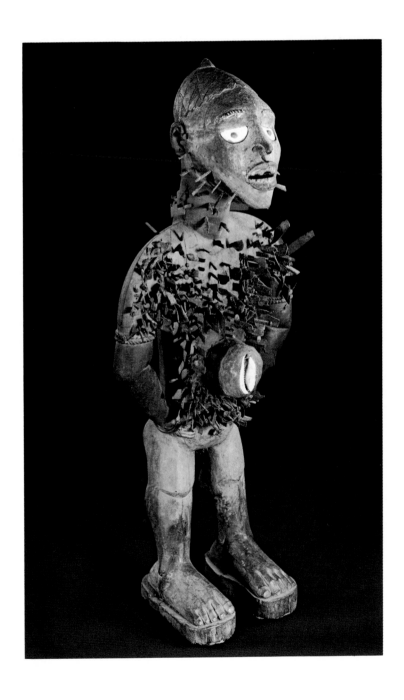

XLVI
BANGBOYE OF ODA-OWA (attrib.), African,
Yoruba, Nigeria
Epa Helmet Mask, c. 1925
Wood, pigments; h. 122 cm. (48 in.)
Gift of the African Art Gallery Committee (77.71)

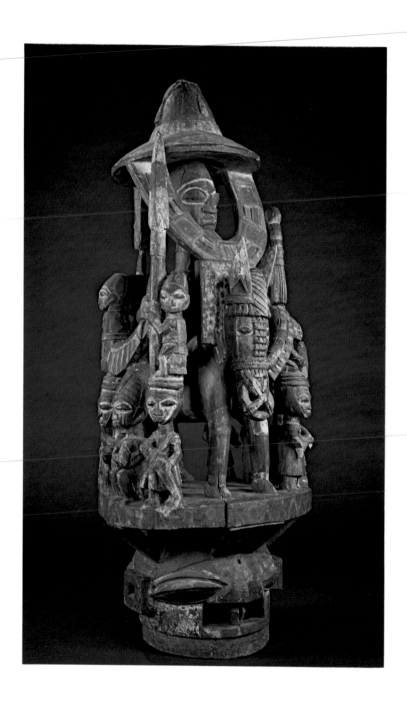

XLVII
Mask, North American Indian, Eskimo, Lower
Kuskokwim River, Alaska, c. 1850
Wood, feathers, pigment; h. 63.5 cm. (25 in.)
Gift of the Stroh Brewery Foundation (77.69)

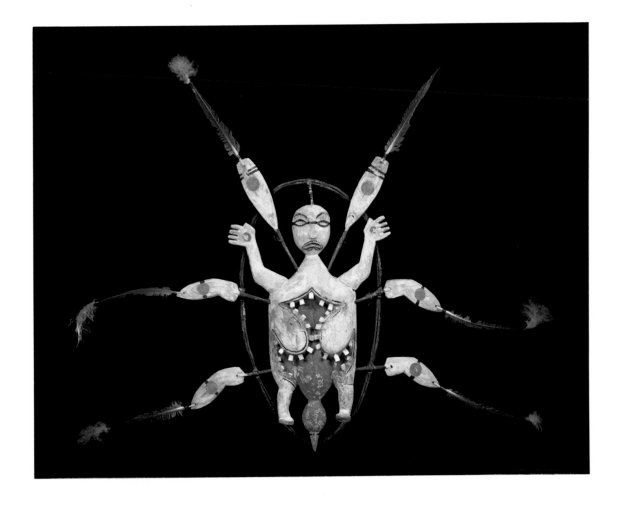

XLVIII
Sampler Mantle, Peruvian, Nazca-Huari,
c. 500/700
Cotton and wool; 281.3 x 113.7 cm.
(110¾ x 44¾ in.)
Gift of Mr. and Mrs. Lee Hills (77.78)

Mary Jane Jacob, Associate Curator

The Department of Modern Art includes American and European paintings and sculpture from 1913 on. The first step taken toward building a modern collection was the purchase in the early 1920s by the City of Detroit of such innovative works as Kokoschka's *The Elbe Near Dresden* and Matisse's *The Window,* the first Matisse to enter an American public collection (pl. XXXIV, no. 180).

The two individuals most responsible for the creation of a modern collection in the Institute's early years were museum Director William R. Valentiner and patron and trustee Robert H. Tannahill. Valentiner's foresight made possible the creation in the 1930s of a pioneering German Expressionist collection. At a time when modern German art was banned in its native country and unfashionable elsewhere, Valentiner encouraged Detroiters to collect works by outstanding German and Austrian artists, and thus the museum eventually was enriched by works by Heckel, Hofer, Kaus, Kirchner, Kokoschka, Lehmbruck, Marc, Marcks, Mueller, Pechstein, Rohlfs, and Schmidt-Rottluff (nos. 179, 181, 182). During the 1930s, Tannahill lent to the museum many of the finest pieces from his own collection, works which he later donated or bequeathed to the museum at his death in 1969. Under Tannahill's leadership, the museum's oldest auxiliary group, the Friends of Modern Art, was formed in 1931 with the purpose of acquiring one or more contemporary works for the permanent collection each year. The group's first acquisition, Chagall's *Snow-Covered Church,* was followed by watercolors, drawings, and prints by Barlach, Kolbe, Pechstein, Picasso, and Schmidt-Rotluff.

The collecting of modern art for the museum was slow in the 1940s, but in 1951 it received new impetus with the reorganization of the Friends under the chairmanship of John S. Newberry, Curator of Graphic Arts. One of Newberry's innovations, the staging by the Friends of annual exhibitions of modern European and American art from which purchases for the permanent collection were made, was continued by the group into the late 1960s. Addison Franklin Page served as the first Curator of Contemporary Art from 1957 until 1963, when he was replaced by Robert D. Kinsman, who was Associate Curator in charge of the department until 1965.

Perhaps the most significant event in these years was the election in 1964 of W. Hawkins Ferry as Chairman of the Friends of Modern Art, an office he has held with great distinction ever since. Formerly organizer of the Metropolitan Art Association's lecture series, Mr. Ferry expanded the Friends' educational program to include several annual lectures and carried on the Friends' exhibitions program begun under Newberry on a more ambitious scale. These exhibitions resulted in the addition of works by such major American painters as Albers, Anuszkiewicz, Frankenthaler, Kelly, and Louis (no. 188). In 1966, two of the collection's most significant sculptures were purchased—the now famous *Cubi I* by David Smith, and the monumental *Homage to the World* by Louise Nevelson (nos. 195, 196). In the same year, in recognition of the opening of the South Wing, the Friends acquired for the museum paintings by Frank Stella and Lichtenstein; in 1968 they made a major contribution to the Pop Art collection with the *Self-Portrait* by Warhol (p. XXXVII).

In addition to his activities as Chairman of the Friends, Mr. Ferry has been greatly responsible for the development of the modern collection into a true survey of modern art in Europe and America. Either by direct gifts or through the W. Hawkins Ferry Fund, he has enabled the museum to add major sculptures by Arp, Bill, Calder, Caro, Gabo, and Nakian, as well as paintings by Dubuffet, Kelly, Masson, Matta, Miró, Moholy-Nagy, Rauschenberg, and Vasarely (nos. 197, 193, 185, 186, 189). His gifts of works by Kline, Rothko, Still, and Motherwell, among others, virtually created the museum's strong selection of America's major international art movement, Abstract Expressionism (pl. XXXV). In 1976, Ferry, along with Mr. and Mrs. Walter B. Ford, II, provided funds to purchase the monumental painting *Be I (second version)* by Barnett Newman (pl. XXXVIII).

The modern collection was significantly enriched by several important bequests in the last two decades. The 1964 bequest of Dr. and Mrs. George Kamperman, who were among the original founders of the Friends of Modern Art, included examples of German painting, sculpture, and graphics, as well as an extensive selection of works by Michigan artists. The Kamperman bequest fund has enabled us to continue to purchase important works of art, including examples by contemporary Michigan artists. The 1965 John S. Newberry bequest, rich in the graphic arts, also included important sculptures by Barlach, Kolbe, Maillol, Marcks, and Moore, to name a few. Undoubtedly, the most important bequest for the department was that of Robert H. Tannahill. Over 200 watercolors, drawings, paintings, and sculptures were received by the museum in 1970. With this single gift, which included works by Barlach, Brancusi, Maillol, Matisse, Modigliani, Moore, Picasso, Rouault, Rousseau, and Soutine, the Institute's holdings of early 20th-century art could finally rank with other outstanding public collections in America.

Other Detroiters have played major roles in building the modern collection. To be mentioned are Mr. and Mrs. Walter B. Ford II, James F. Duffy, Jr., Sylvia G. Zell, and especially Lydia Winston Malbin, Honorary Curator of Modern Art since 1973. For many years, Mrs. Malbin, whose collection of Italian Futurist and European modern works is one of this country's most important, has given the department thoughtful guidance, has lent many of her works to the Institute for exhibition, and has presented major gifts, recently including an important Surrealist painting by Tanguy (no. 183), and works by Soutine and Richier. Mrs. Malbin must also be credited in part for the addition of three highly unusual and beautiful plasters by Jean Arp, presented to the Institute by the artist's widow in recognition of the museum's, and particularly Mrs. Malbin's, support of Arp's work (no. 192).

Samuel J. Wagstaff, Jr. served as Curator of Contemporary Art from 1968 until his resignation in 1971. With the opening of the museum's North Wing in 1971, the modern collection was installed in its entirety for the first time. More major American sculpture was added to the collection, including works by Robert Morris and Claes Oldenburg (no. 199). Under Wagstaff's guidance, the Friends undertook its first major fund-raising campaign, to acquire the monumental sculpture *Gracehoper* by Tony Smith; Smith's largest work, it was installed on the Institute's north lawn under the supervision of the artist in 1972 (no. 200).

John Hallmark Neff was appointed Curator of Modern Art in 1974 and continued to enrich the museum's increasingly important selection of contemporary American sculpture with works by Morris, Smithson, Oldenburg, Shapiro, Winsor, Le Witt, and Stoltz (nos. 198, 201, 202). The most significant acquisition under Dr. Neff was Matisse's paper cut-out *The Wild Poppies* (pl. XXXVI) and the stained glass window for which it served as the maquette. This purchase, which resulted from one of the museum's most significant 20th-century exhibitions, *Henri Matisse Paper Cut-Outs,* was made possible by an extensive fund-raising project organized by the Friends and established the Institute's collection of works by Matisse as one of this country's most important, noteworthy both for the range of media and periods represented.

In addition to acquiring works by nationally and internationally known artists of our time, the department has also encouraged and supported Michigan artists by annual juried exhibitions, invitational shows, historical surveys, and purchases. This area of activity has been increased over the past five years with the help of the Michigan Council for the Arts, which has helped make possible a very active exhibitions program of work by local artists. With the support given by individuals in the community, the Founders Society, the Friends of Modern Art, and local and national arts organizations, we can look forward to a strengthening of the present collection and a continued high level of activity, both in exhibitions and acquisitions, that hopefully will help sustain the interest and vital involvement of our community in contemporary art.

174
FELIX-EDOUARD VALLOTTON, French (1865-1925)
Standing Nude Holding Her Gown on Her Knee,
1904
Oil on canvas; 130.2 x 97.1 cm. (51¼ x 38¼ in.)
Founders Society Purchase, Robert H. Tannahill
Fund (75.59)
See J. H. Neff, "Félix Vallotton: A Forgotten
Master Painter," DIA *Bull.* 54, 4 (1976): 165-73
(color cover).

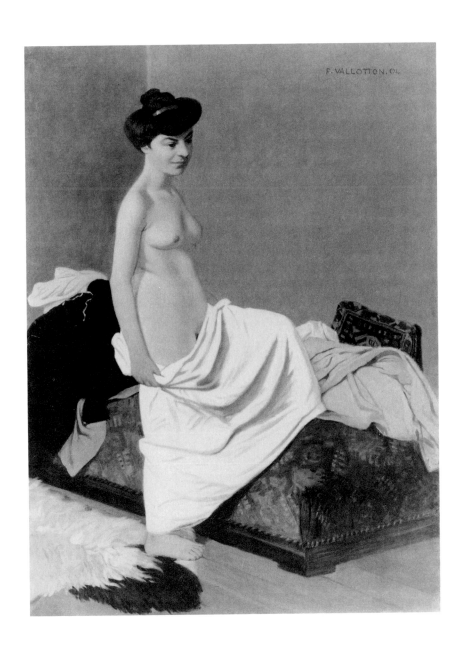

175
PAULA MODERSOHN-BECKER, German (1876-1907)
Old Peasant Woman Praying, 1905
Oil on canvas; 75.6 x 57.8 cm. (29¾ x 22¾ in.)
Gift of Robert H. Tannahill (58.385)
See A. S. Harris and L. Nochlin, *Women Artists:
1550-1950*, exh. cat., Los Angeles County Mu-
seum of Art, etc., 1976: no. 117.

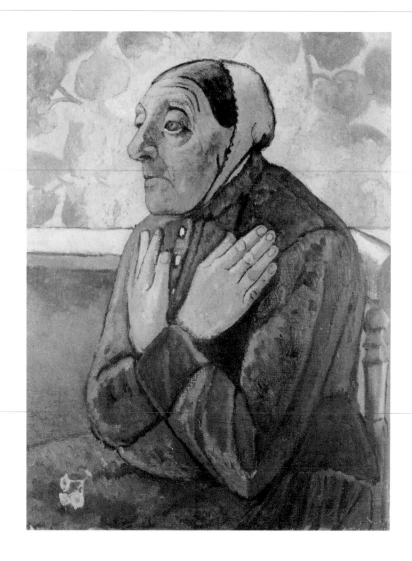

176
PABLO PICASSO, Spanish (1881-1973)
Portrait of Manuel Pallarés, 1909
Oil on canvas; 67.9 x 49.5 cm. (26¾ x 19½ in.)
Gift of Mr. and Mrs. Henry Ford II (62.126)
See W. F. Woods, "Picasso in 1909 and 1954,"
DIA *Bull.* 42, 1 (1962): 3ff.

177
FERDINAND HODLER, Swiss (1853-1918)
Portrait of a Woman, c. 1910
Oil on canvas; 54.9 x 38.7 cm. (21⅝ x 15¼ in.)
City Purchase (22.203)

178
OTTO DIX, German (1891-1969)
Self Portrait, 1912
Oil on panel; 73.7 x 49.5 cm. (29 x 19½ in.)
Gift of Robert H. Tannahill (51.65)
See F. Löffler, *Otto Dix, Leben und Werk*, Dresden, 1961: 303, pl. 1.

179
FRANZ MARC, German (1880-1916)
Animals in Landscape, 1914
Oil on canvas; 122.8 x 99.7 cm. (43⅜ x 39¼ in.)
Gift of Robert H. Tannahill (56.144)
See W. S. Lieberman, ed., *Modern Masters: Manet to Matisse,* exh. cat., The Museum of Modern Art, New York, etc., 1975: no. 62.

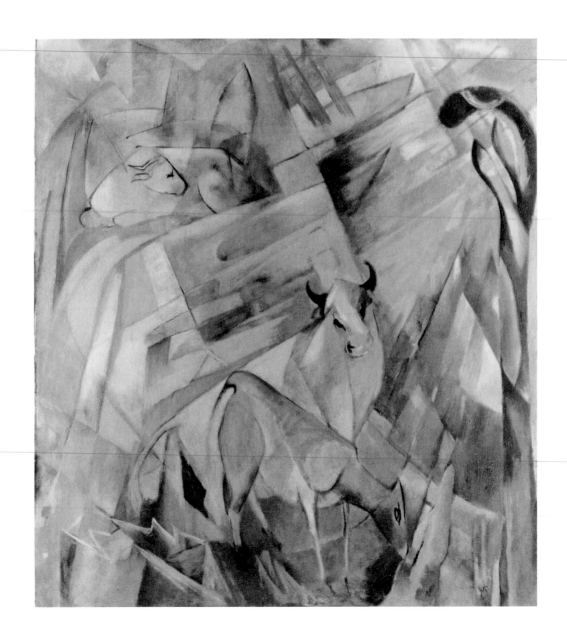

180
HENRI MATISSE, French (1869-1954)
The Window, 1916
Oil on canvas; 146 x 116.8 cm. (57½ x 46 in.)
City Purchase (22.14)
See A. H. Barr, Jr., *Matisse: His Art and His
Public,* New York, 1951: 190, 558.

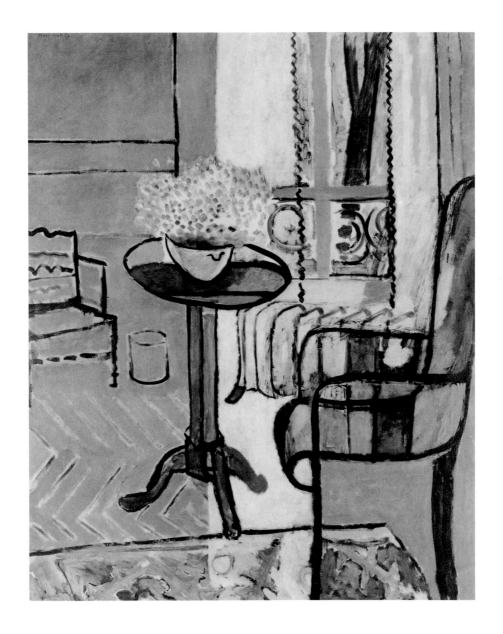

181

ERNST LUDWIG KIRCHNER, German (1880-1938)

Alpine Landscape, 1919

Oil on canvas; 120.7 x 120.7 cm. (47½ x 47½ in.)

Gift of Curt Valentin on the 60th birthday of Dr. W. R. Valentiner (40.58)

See D. E. Gordon, *Ernst Ludwig Kirchner: A Retrospective Exhibition,* exh. cat., Museum of Fine Arts, Boston, etc., 1969: no. 49 (color ill.).

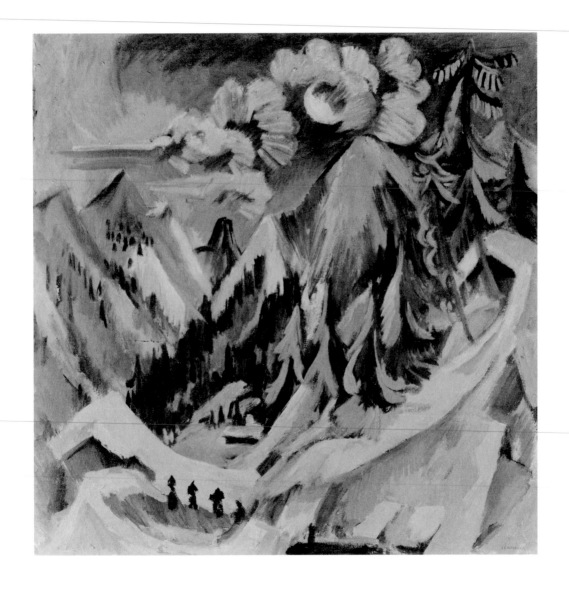

182
KARL SCHMIDT-ROTTLUFF, German (1884-1976)
Figure by the Sea, c. 1920
Oil on canvas; 86.4 x 99.7 cm. (34 x 39¼ in.)
Bequest of Dr. William R. Valentiner (63.135)

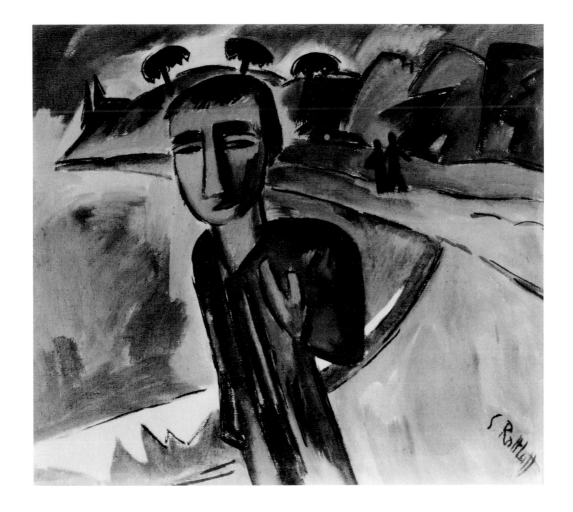

183
YVES TANGUY, French (1900-1955)
Shadow Country, 1927
Oil on canvas; 99 x 80.3 cm. (39 x 31⅝ in.)
Gift of Mrs. Lydia Winston Malbin (74.122)
See D. Ades, *Dada and Surrealism Reviewed*, exh.
cat., The Arts Council of Great Britain, London,
1978: no. 9.66.

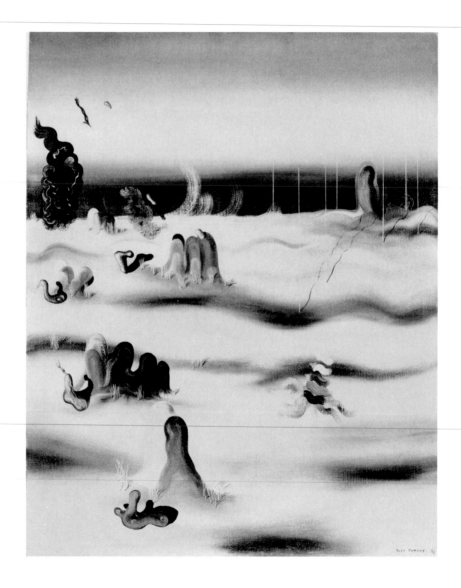

184
EMIL NOLDE, German (1867-1956)
Sunflowers, 1932
Oil on canvas; 73.7 x 88.9 cm. (29 x 35 in.)
Gift of Robert H. Tannahill (54.460)
See V. Harriman, "A Masterpiece of German Ex-
pressionist Painting," DIA *Bull.* 35, 1 (1955-56):
17-18.

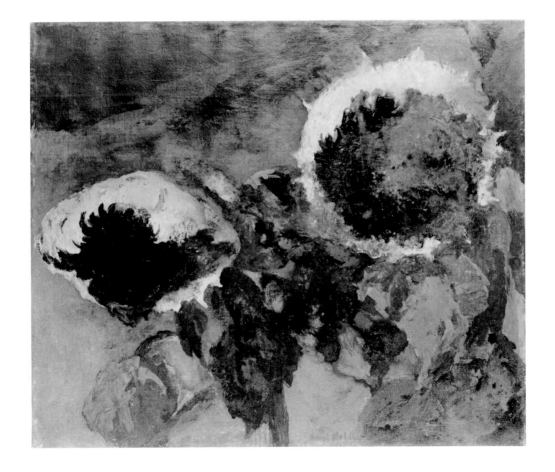

185
JOAN MIRO, Spanish (b. 1893)
Self Portrait II, 1938
Oil on canvas; 129.5 x 195.6 cm. (51 x 77 in.)
Gift of W. Hawkins Ferry (66.66)
See T. A. Messer, "Mirò Twice Removed," DIA
Bull. 51, 4 (1972): 105-11.

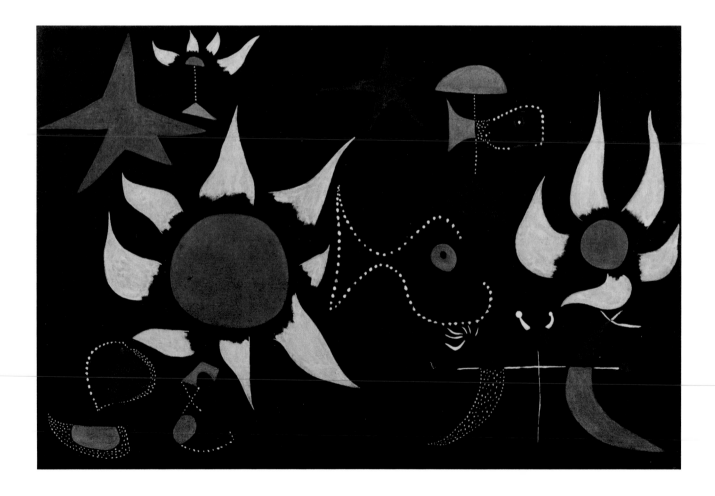

186
LASZLO MOHOLY-NAGY, American (1895-1946)
Space Modulator: Red Over Black, 1946
Oil on transparent plastic with screening; 46 x
64.8 cm. (18⅛ x 25½ in.)
Gift of W. Hawkins Ferry (48.3)
See V. Harriman, "Red Over Black," DIA *Bull.*
29, 1 (1949-50): 11ff.

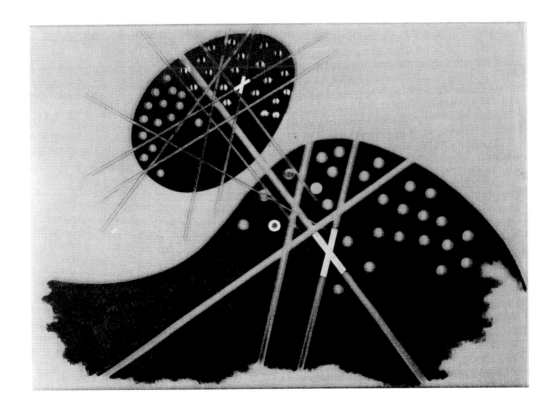

187
STUART DAVIS, American (1894-1964)
Standard Brand, 1961
Oil on canvas; 152.4 x 116.8 cm. (60 x 46 in.)
Founders Society Purchase (63.156)
See *Heritage and Horizon: American Paintings,
1776-1976*, exh. cat., The Toledo Museum of Art,
Ohio, etc., 1976: no. 48 (color ill.).

188
HELEN FRANKENTHALER, American (b. 1928)
The Bay, 1963
Acrylic resin on canvas; 205.1 x 207.6 cm.
(80¾ x 81¾ in.)
Gift of Dr. and Mrs. Hilbert H. DeLawter (65.60)
See B. Rose, *Frankenthaler,* New York, 1970:
color pl. 1, 96.

189
ROBERT RAUSCHENBERG, American (b. 1925)
Creek, 1964
Silkscreen and oil on canvas; 182.9 x 243.8 cm.
(72 x 96 in.)
Gift of W. Hawkins Ferry (69.48)
See *Heritage and Horizon: American Paintings,
1776-1976*, exh. cat., The Toledo Museum of Art,
Ohio, etc., 1976: no. 60.

190
BRENDA GOODMAN, American (b. 1943)
The Cat Approaches, 1974
Oil and pencil on canvas; 167.6 x 129.5 cm.
(66 x 51 in.)
Founders Society Purchase, Mr. and Mrs. Conrad H. Smith Memorial Fund and Gift of Gertrude Kasle Gallery (74.183)
See *Arts and Crafts in Detroit 1906-1976: The Movement, The Society, The School*, exh. cat., DIA, 1976: no. 299.

191
ARISTIDE MAILLOL, French (1861-1944)
Flora, Nude, 1910/11
Bronze; h. 170.2 cm. (67 in.)
Gift of Ben L. Silberstein (76.77)
See *Aristide Maillol: 1861-1944,* exh. cat., The
Solomon R. Guggenheim Museum, New York,
1975: no. 67.

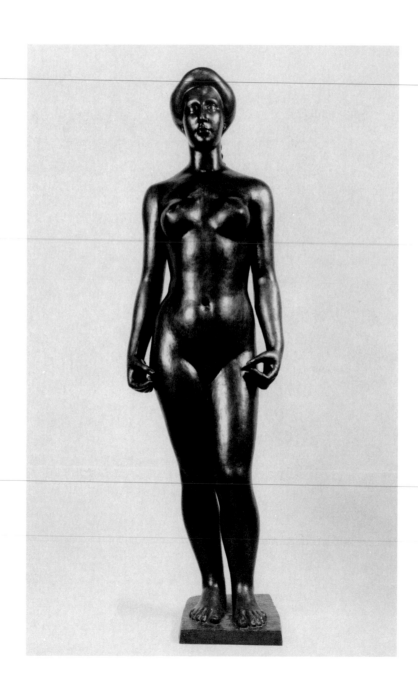

192
JEAN ARP, French (1887-1966)
Demeter, 1961
Plaster; h. 104.1 cm. (41 in.)
Gift of Mme. Jean Arp (74.124)

193
NAUM GABO, American (1890-1977)
Linear Construction No. 4, 1962
Bronze and stainless steel strings; h. 128.3 cm.
(50½ in.)
Gift of W. Hawkins Ferry (72.437)
See S. F. Hilberry, "Naum Gabo, A Constructivist
Sculptor," DIA *Bull.* 54, 4 (1976): 174-83.

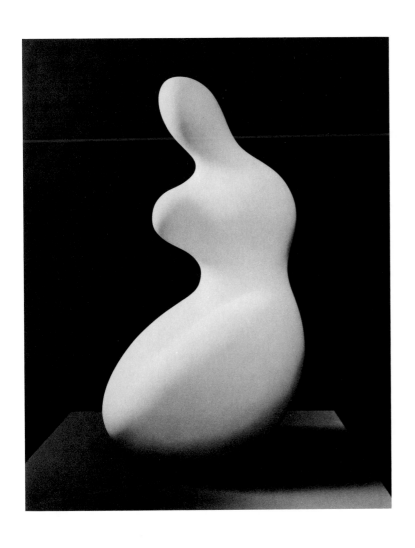

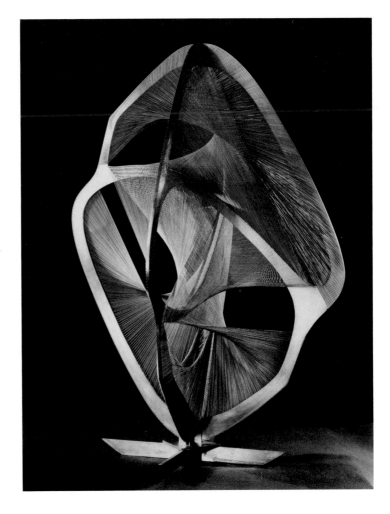

194

MARK DI SUVERO, American (b. 1933)

Tom, 1959

Wood, metal, rope, and wire cable; h. 274.3 cm. (108 in.)

Founders Society Purchase, Friends of Modern Art and Mr. and Mrs. Walter B. Ford II Funds, and Gift of Samuel J. Wagstaff, Jr. (74.5)

See *Mark di Suvero,* exh. cat., Whitney Museum of American Art, New York, 1975: 20-21.

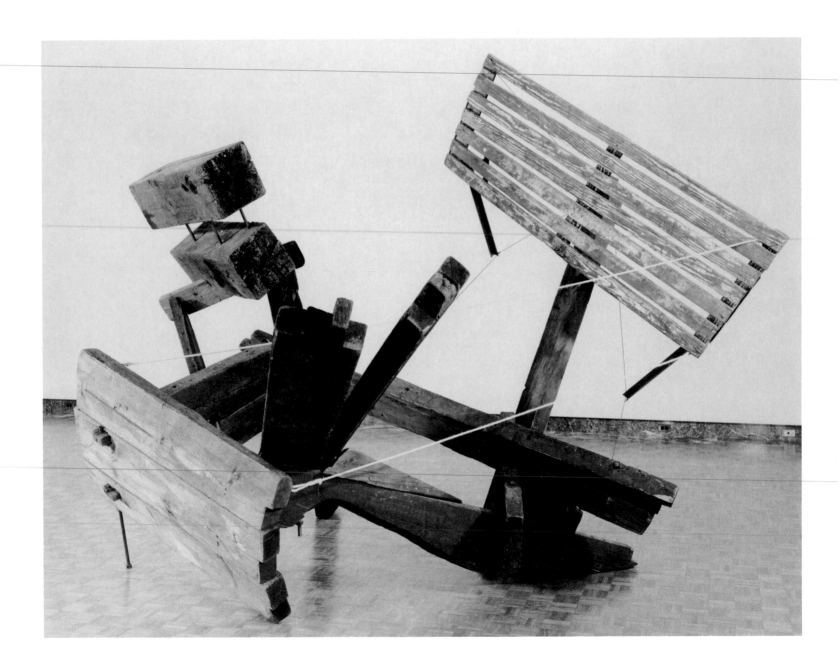

195
DAVID SMITH, American (1906-1965)
Cubi I, 1963
Stainless steel; h. 315 cm. (124 in.)
Founders Society Purchase (66.36)
See *200 Years of American Sculpture,* exh. cat.,
Whitney Museum of American Art, New York,
1976: no. 255 (color cover).

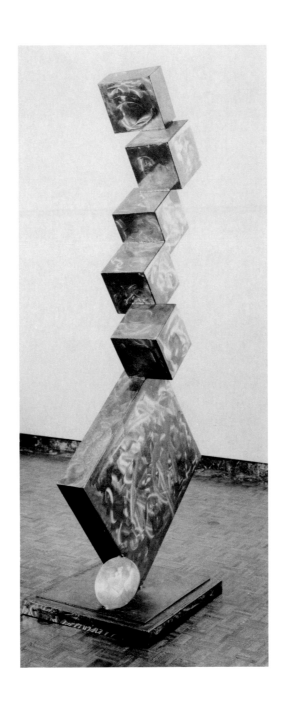

196
LOUISE NEVELSON, American (b. 1900)
Homage to the World, 1966
Painted wood; l. 873.8 cm. (344 in.)
Founders Society Purchase, Friends of Modern
Art and other Funds (66.192)
See *Louise Nevelson*, exh. cat., Whitney Museum
of American Art, New York, etc., 1967: no. 94.

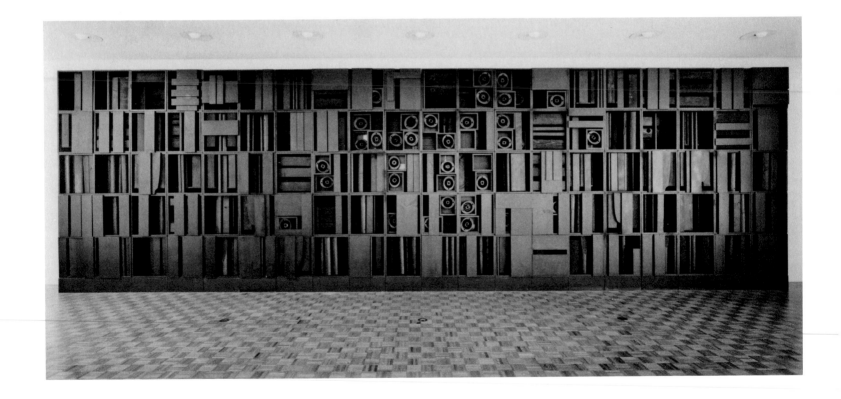

197
ALEXANDER CALDER, American (1898-1976)
The X and Its Tails, 1967
Painted steel plate; h. 304.8 cm. (120 in.)
Gift of W. Hawkins Ferry (67.113)
See DIA *Handbook*, 1971: 181.

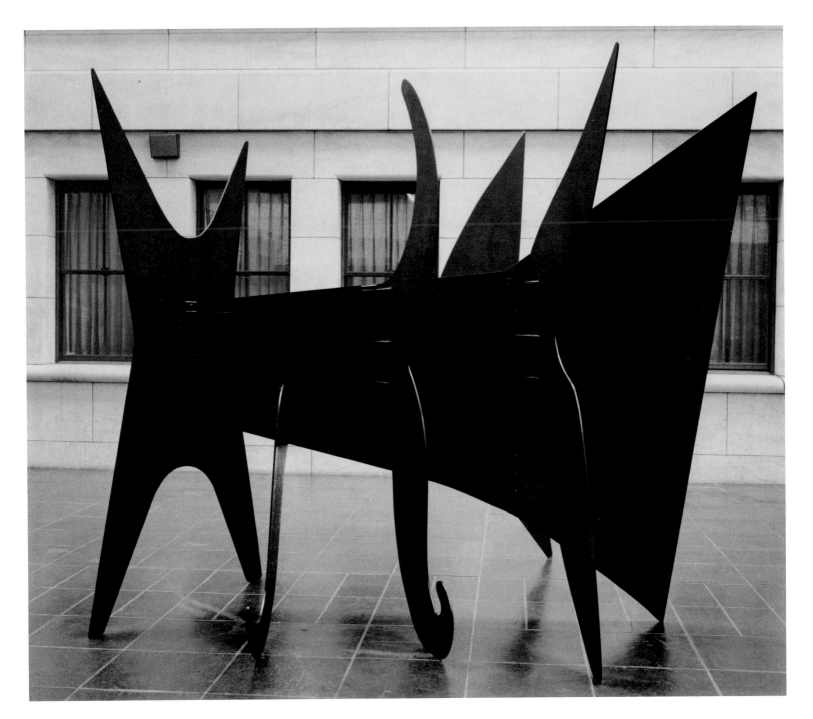

198
ROBERT SMITHSON, American (1938-1973)
Site Uncertain—Non Site, 1968
Painted steel bins and cannel coal; 38.1 x 228.6 x 228.6 cm. (15 x 90 x 90 in.)
Founders Society Purchase, Dr. and Mrs. George Kamperman and New Endowment Funds (76.95)

199
CLAES OLDENBURG, American (b. 1929)
Giant Three-Way Plug, 1970
Mahogany veneer; h. 148.9 cm. (58⅝ in.)
Founders Society Purchase, Friends of Modern Art Fund (71.7)
See L. Downs, "Oldenburg's *Profile Airflow* and *Giant Three-Way Plug,*" DIA *Bull.* 50, 4 (1971): 69-78.

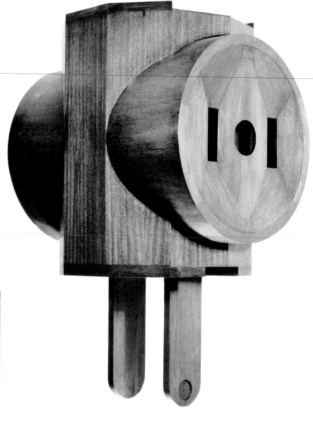

200
TONY SMITH, American (b. 1912)
Gracehoper, 1972
Sheet steel; 7 x 6.7 x 14 m. (23 x 22 x 46 ft.)
Donation of W. Hawkins Ferry and Founders
Society Purchase, Walter and Josephine Ford,
Eleanor Clay Ford, Marie and Alex Manoogian
Funds, and Various Contributions (72.436)
See F. L. Kolbert, "Tony Smith's *Gracehoper,*"
DIA *Bull.* 50, 2 (1971): 19-22.

201
JACQUELINE WINSOR, Canadian (b. 1941)
1 x 1 Piece, 1974
Wood and nails; h. 114.3 cm. (45 in.)
Founders Society Purchase, Friends of Modern
Art Fund (75.20)
See *Jackie Winsor/Sculpture*, exh. cat., The Contemporary Arts Center, Cincinnati, Ohio, etc.,
1976: no. 23.

202
SOL LE WITT, American (b. 1928)
*Modular Open Cube Pieces (9 x 9 x 9): Floor/
Corner 2*, 1976
Painted wood; 110.5 x 110.5 x 110.5 cm.
(43½ x 43½ x 43½ in.)
Founders Society Purchase, Friends of Modern
Art and National Endowment for the Arts
Museum Matching Purchase Funds (76.83)

Linda Downs, Curator of Education

The *Detroit Industry* frescoes by Diego Rivera are the most outstanding murals by this celebrated Mexican artist outside Mexico and among the most famous holdings of The Detroit Institute of Arts. Museum Director William R. Valentiner first met Diego Rivera in 1930 in California, where Rivera, already a well-known muralist, was painting a fresco at the San Francisco Stock Exchange. Rivera had studied Italian Renaissance frescoes as a student in Europe and found the medium particularly appealing as a means of depicting contemporary life on a grand public scale while integrating painting with architecture.

Rivera discussed with Valentiner his interest in machines and expressed his desire to see Detroit's industrial complexes. With great foresight, Valentiner turned this interest into a commission to decorate the Detroit museum's central court. The Arts Commission urged Rivera to relate the frescoes in some way to the history of Detroit and Michigan but gave Rivera the freedom to do what he wished. The commission was made possible by a generous gift of $20,896 from Edsel B. Ford, then head of the Ford Motor Company and President of the Arts Commission.

Rivera spent three months in the spring of 1932 visiting and studying the industries in and around Detroit before he began to paint. His fascination with machinery and his vision of modern technology as a powerful force in the growth of civilization superceded the harsh and devastating realities of the Depression. Through the microcosm of Detroit, Rivera presented in 27 panels the macrocosmic realities of modern industry. In the frescoes, the age of steel is shown as a natural outgrowth of technological evolution from its primordial beginnings in agriculture. Man and nature's interdependence is demonstrated through industry's need for the earth's raw materials, which are transformed by intellectual genius and the collective strength of the work force for constructive and destructive purposes that can both liberate and tyrannize mankind.

With a group of artists to assist him, Rivera painted his Detroit murals in a true fresco technique, applying water-based paint to wet plaster. The frescoes can be seen as a cycle beginning on the east wall, where the origins of man and the earliest form of technology—agriculture—are depicted. The west wall opposite represents the industries of water and air—freighters and pleasure boats are juxtaposed with warplanes and bombers (nos. 204, 206). The largest panels on the north and south walls are devoted to the production and manufacture of the 1932 Ford V-8 automobile—the north wall presenting all major processes involved in creating the motor; the south wall shows the making of the car body and final assembly of the automobile (nos. 203, 205). The upper four corner panels of the north and south walls illustrate the drug and commercial chemical industries of Detroit, as well as the medical profession and the manufacture of poisonous gas bombs. The four races which created North American culture and the industrial work force are represented in the upper registers of the north and south walls. Each one holds a basic raw material whose geological origin is indicated in the register below.

Rivera and his assistants and apprentices completed the actual fresco project in eight months. This great tribute to Detroit, which Rivera considered his finest work, met with immediate response—not all of which was positive. To some disappointed viewers, dreaded industry had invaded the museum—they labeled the nudes pornographic, the vaccination panel sacreligious, and criticized Rivera's communist politics. Through the efforts of the People's Museum Association (organized in defense of the frescoes), the museum staff, and Edsel B. Ford, the walls were not whitewashed or destroyed but today remain as powerful in impact and relevant in their ideas as when they were painted nearly 50 years ago.

203

DIEGO RIVERA, Mexican (1886-1957)

Detroit Industry/North Wall, 1933

Fresco; upper register side panels: 257.8 x 213.4
cm. (101½ x 84 in.); upper register center panel:
269.2 x 1371.6 cm. (106 x 540 in.); middle register
side panels: 67.9 x 185.4 cm. (26¾ x 73 in.); mid-
dle register center panel: 132.7 x 269.2 cm. (52¼ x
106 in.); lower panel: 539.8 x 1371.6 cm. (212½ x
540 in.)

Gift of Edsel B. Ford Fund (33.10)

See *The Rouge: The Image of Industry in the Art
of Charles Sheeler and Diego Rivera*, exh. cat.,
DIA, 1978: 47-91.

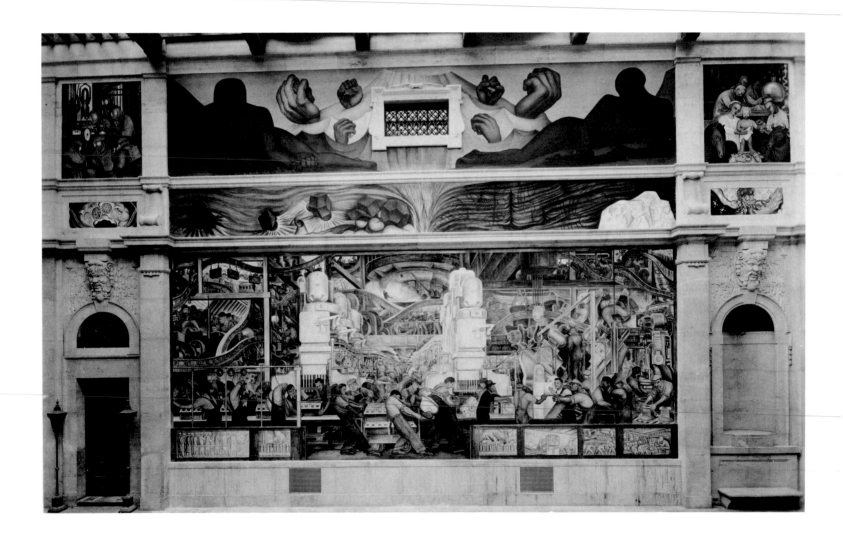

204
DIEGO RIVERA, Mexican (1886-1957)
Detroit Industry/East Wall, 1932
Fresco; upper register side panels: 257.8 x 213.4
cm. (101½ x 84 in.); lower register side panels:
68.3 x 185.4 cm. (26⅞ x 73 in.); lower register
center panel: 133.4 x 796.3 cm. (52½ x 313½ in.)
Gift of Edsel B. Ford Fund (33.10)

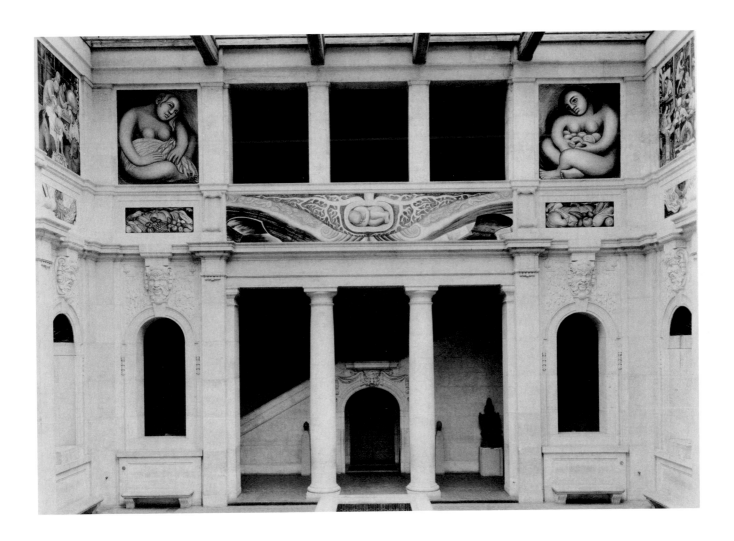

205

DIEGO RIVERA, Mexican (1886-1957)

Detroit Industry/South Wall, 1932/33

Fresco; upper register side panels: 257.8 x 213.4 cm. (101½ x 84 in.); upper register center panel: 269.2 x 1371.6 cm. (106 x 540 in.); middle register side panels: 67.9 x 185.4 cm. (26¾ x 73 in.); middle register center panel: 132.7 x 269.2 cm. (52¼ x 106 in.); lower panel: 539.8 x 1371.6 cm. (212½ x 540 in.)

Gift of Edsel B. Ford Fund (33.10)

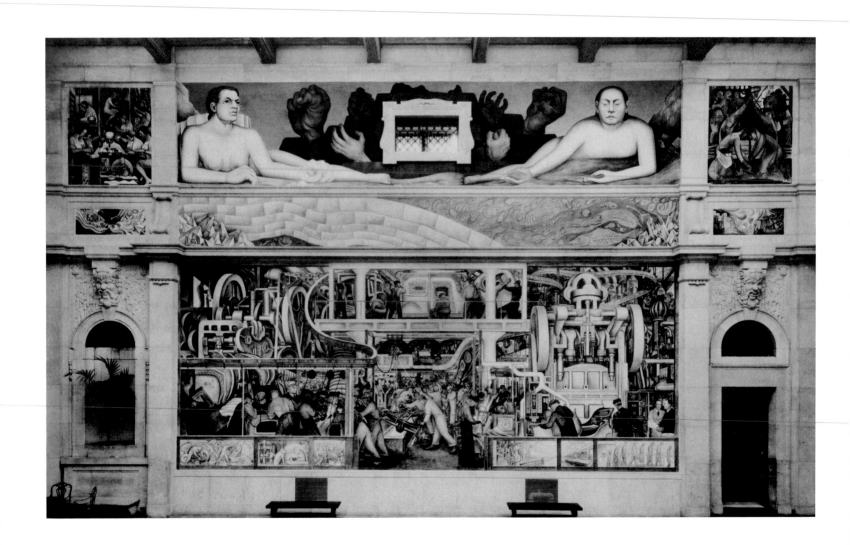

206
DIEGO RIVERA, Mexican (1886-1957)
Detroit Industry / West Wall, 1932/33
Fresco; upper register side panels: 257.8 x 213.4
cm. (101½ x 84 in.); upper register center panel:
133.4 x 796.3 cm. (52½ x 313½ in.); middle reg-
ister side panels: 68.3 x 185.4 cm. (26⅞ x 73 in.);
middle register center panel: 132.7 x 269.2 cm.
(52¼ x 106 in.); lower register side panel (steam):
518.2 x 168.9 cm. (204 x 66½ in.); lower register
side panel (electricity): 518.2 x 170.2 cm. (204 x
67 in.)
Gift of Edsel B. Ford Fund (33.10)

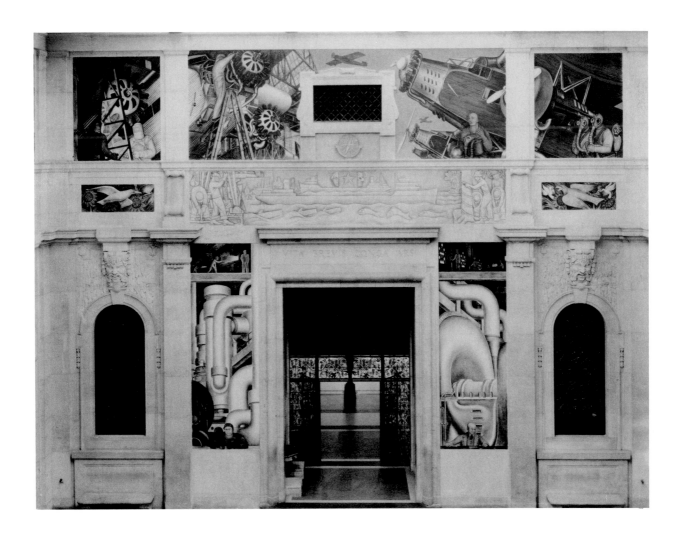

Ellen Sharp, Curator

Prints, drawings, and watercolors make up the major part of the holdings of the Department of Graphic Arts. The collection also includes photographs, posters, bound portfolios, and artists' books.

The department received its first impetus in 1909, when the collection of James E. Scripps was presented to the museum by his widow. This gift comprised some 1,300 prints and 335 drawings. Like many collectors of his era, Mr. Scripps acquired prints chiefly for their documentary and literary interest and collected a great many of what today are termed reproductive prints—prints executed by craftsmen after the designs of celebrated masters. Nevertheless, his collection also contained many important original works. Particularly notable is a striking impression of Ugo da Carpi's *Diogenes,* a chiaroscuro woodcut in shades of green (no. 223). Mr. Scripps was far ahead of his time in his interest in chiaroscuros. He collected a surprisingly large number of them, several of which are rare and highly prized today.

In the 1920s, '30s, and '40s, there was not as much emphasis placed on building the collection of prints and drawings as on other areas. The items which were acquired under the curatorship of Isabel Weadock, with Fitzroy Carrington acting as advisor, however, were of high quality and were valuable additions. A sizable collection of engravings by the "Little Masters" was purchased during this period. Other notable acquisitions included a fine impression of Rembrandt's *Descent from the Cross by Torchlight* and a rare edition of Piranesi's *Prisons (Carceri)* (nos. 224, 225).

It was due to the enthusiasm of William R. Valentiner, Director of the Institute from 1924 to 1945, that this museum was one of the first in this country to acquire works by the German Expressionists. Important woodcuts and etchings by Die Brücke artists such as Kirchner and Nolde were purchased during his tenure. In 1934, a significant purchase was made of 65 Old Master drawings by Italian, English, Dutch, and Flemish artists (no. 208).

The Hal H. Smith bequest of 250 prints by European and American artists from the 15th to the 20th centuries and the gift of Dr. and Mrs. George Kamperman of 80 prints and drawings, including fine early Whistlers and Picassos, were among the important additions to the department during the decade of the '40s. In 1965, upon the death of Dr. Kamperman, a fund was established by the Kampermans for the purchase of works by contemporary artists. With the aid of this fund the department has been able to add important contemporary graphic works, including one of the most beautiful artists' books to be created in recent years, Motherwell's *A la pintura* (no. 232). From 1948 to 1952, Charles Feinberg presented over 100 prints to the Institute, the majority of them works by British artists.

John S. Newberry, Jr. served as Honorary Curator of Graphic Arts at the Institute, working in the department from 1935 to 1941. In 1946, he was appointed Curator of Graphic Arts and remained in that capacity until he moved to New York in 1957. Mr. Newberry added a significant group of prints by masters of the School of Paris, in particular works by Picasso and Matisse. His acquisitions ranged over a wide area, from the German 16th century to contemporary prints. For eight years after Mr. Newberry's resignation, the department was without a curator. The space it occupied was taken over by the Archives of American Art, and the collection was put into storage in an inaccessible area on the third floor of the Institute.

During his lifetime, Mr. Newberry's gifts to the Institute exceeded 200 works of art, more than half of them fine prints. Upon his death in 1964, his bequest included almost 200 more works, chiefly drawings and watercolors. The superb quality of the 19th- and early 20th-century French drawings, including works by Ingres, Delacroix, Corot, Degas, Pissarro, Cézanne, Picasso, and Matisse made the Institute's collection in this area one of the most outstanding in the United States (pl. XL, nos. 215, 217, 219). Mr. Newberry's bequest and the substantial fund which he left for the acquisition of prints and drawings had an effect which would have given him great pleasure—the department was reactivated.

In December 1965, Ellen Sharp was appointed Curator of Graphic Arts. Working with Bernard F. Walker, Chairman of the Joint Museum Collections Sub-Committee on Graphic Arts and with a newly organized Drawing and Print Club, Ms. Sharp has pursued a continuous acquisitions program building on the strengths of the collection and endeavoring to fill lacunae. A major goal has also been to secure proper exhibition, study, and storage facilities for the collection.

Mr. Walker had already presented in 1964 a comprehensive collection of etchings and lithographs by John Sloan. Since 1966, he and Mrs. Walker have made important gifts each year, strengthening our holdings in the area of 19th- and 20th-century prints and drawings with works of fine quality by such artists as Ingres, Daumier, Bresdin, and Manet, to mention but a few (nos. 226, 227).

The Walker gifts and the 1970 bequest of Robert H. Tannahill, which contained over 100 drawings and watercolors by such figures as Toulouse-Lautrec, Nolde, Kollwitz, Picasso, Klee, Braque, and Feininger (pls. XLI-XLIII, nos. 213, 218, 220), complemented the Newberry bequest splendidly. During his lifetime, Mr. Tannahill had been a generous donor to the department, his gifts including watercolors by Americans such as Winslow Homer and Morris Graves, German Expressionist prints, French and American drawings, and artists' books. Other individuals who have consistently supported the department with gifts of works by modern artists include Lydia Winston Malbin and the late Paul G. Lutzeier. Mrs. Malbin's gifts include the 1911/12 etching *Fox* by Braque, the first analytic Cubist work to enter the collection (no. 230).

In 1971, the department began to collect photographs systematically. Previously, there had been only sporadic gifts or purchases. This aspect of the collection has rapidly assumed major importance, with the acquisition of rare 19th- and 20th-century works and a wide representation of the work of 20th-century photographs. Purchases have been made possible through the Mr. and Mrs. Lee Hills Fund and Founders Society general funds.

In the last decade the Founders Society has been most generous in making its funds available for such major additions as a group of rare Manet etchings, prints by Villon, a superb early impression of Dürer's *Adam and Eve,* and master prints by Munch and Matisse (nos. 228, 222, pl. XLIV, no. 231). With this continued support from the Founders Society and from private individuals and with the completion in 1980 of a new Graphic Arts Center for the exhibition, study, and storage of works of art on paper, the Institute's goal to build one of the finest graphic art collections in this country seems within reach.

207
MICHELANGELO BUONARROTI, Italian (1475-1564)
Sheet with Various Studies (recto), c. 1508
Black chalk, pen and brown ink; 37.2 x 25.4 cm.
(14⅝ x 10 in.)
City Purchase (27.2)
See *Great Master Drawings of Seven Centuries,*
exh. cat., Columbia University, New York, 1959:
no. 12.

208
FEDERICO BAROCCI, Italian (c. 1535-1612)
Virgin Kneeling Forward to Right, Adoring the Sleeping Christ Child, c. 1596/97
Black and white chalk; 20 x 17 cm.
(7 ⅞ x 6¹¹⁄₁₆ in.)
Founders Society Purchase, William H. Murphy Fund (34.139)
See G. Smith, "Two Drawings by Federico Barocci," DIA *Bull.* 52, 2-3 (1973): 88-91.

209
JACQUES CALLOT, French (1594-1635)
*Admiral Inghirami Presenting Barbary Prisoners
to King Ferdinand I of Tuscany*, c. 1615/20
Black chalk and brown wash; 20 x 30.5 cm.
(7⅞ x 12 in.)
Bequest of John S. Newberry (65.137)
See *Jacques Callot 1592-1635*, exh. cat., Museum
of Art, Rhode Island School of Design, Provi-
dence, 1970: no. 61.

210
JOACHIM WTEWAEL, Dutch (1566-1638)
Suffer the Little Children to Come unto Me, 1621
Red over black chalk, gray wash, heightened
with white; 27.7 x 37 cm. (10⅞ x 14⁹⁄₁₆ in.)
Founders Society Purchase, Hal H. Smith Fund
(59.4)
See *Dutch Mannerism: Apogee and Epilogue,*
exh. cat., Vassar College Art Gallery, Pough-
keepsie, New York, 1970: no. 105.

211

GIOVANNI DOMENICO TIEPOLO, Italian (1727-1804)
Punchinello Carried in Triumph in a Procession,
No. 37 from *Entertainment for Children,* c. 1800
Pen and brown ink, brown wash, over black
chalk; 29.8 x 41.9 cm. (11¾ x 16½ in.)
Founders Society Purchase (55.487)
See J. S. Newberry, Jr., "A Punchinello Drawing
by Domenico Tiepolo," DIA *Bull.* 35, 4 (1955-56):
92-94.

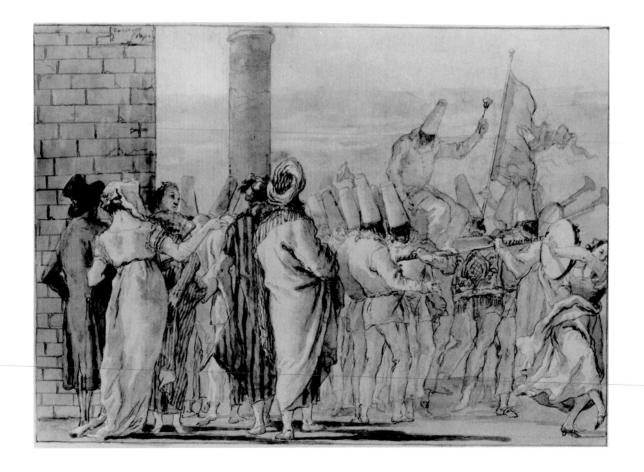

212
HENRY FUSELI, English (1741-1825)
Roland at Roncevalles (Fame), c. 1800/10
Pen and brown ink, brown and gray wash,
heightened with white; 57.5 x 68.6 cm. (22⅝
x 27 in.)
Gift of John S. Newberry (56.48)
See F. J. Cummings in *Romantic Art in Britain,
Paintings and Drawings 1760-1860,* exh. cat.,
DIA and The Philadelphia Museum of Art, 1968:
no. 70.

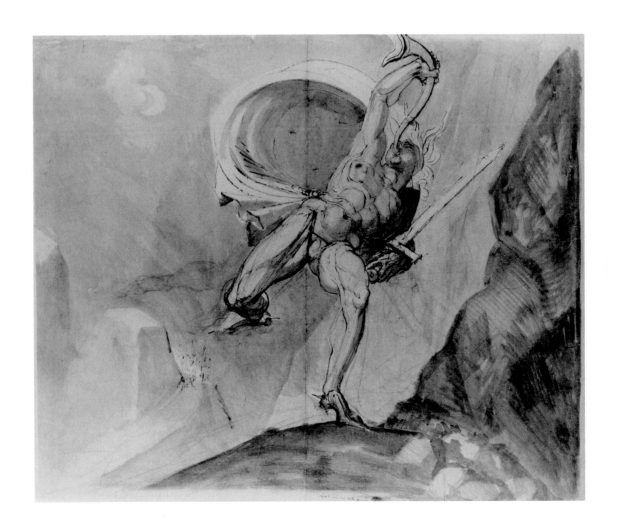

213

JEAN-AUGUSTE-DOMINIQUE INGRES, French
(1780-1867)
Portrait of Marie Marcoz, 1813
Pencil; 27 x 20 cm. (10⅝ x 7⅞ in.)
Bequest of Robert H. Tannahill (70.289)
See *Ingres Centennial Exhibition 1867-1967,
Drawings, Watercolors and Oil Sketches from
American Collections*, exh. cat., Fogg Art Museum, Cambridge, Mass., 1967: no. 24.

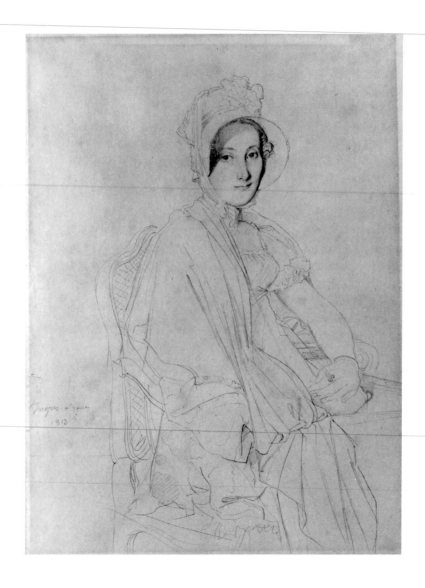

214
JEAN-FRANCOIS MILLET, French (1814-1875)
Mother Feeding Her Children
Pastel; 34.8 x 28.6 cm. (13¹¹⁄₁₆ x 11¼ in.)
Gift of Mrs. Joseph B. Schlotman (73.104)

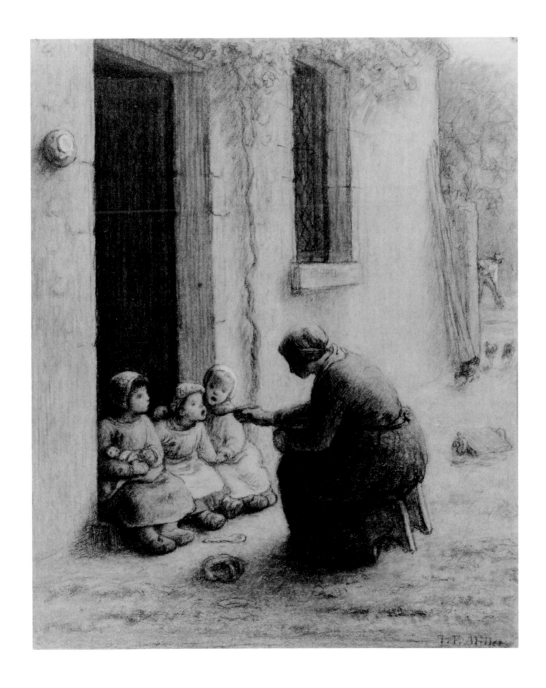

215
EDGAR DEGAS, French (1834-1917)
Ballet Dancer Adjusting Her Costume, 1875/76
Pencil heightened with white on pink paper;
39.4 x 26 cm. (15½ x 10¼ in.)
Bequest of John S. Newberry (65.145)
See T. Reff, "Works by Degas in The Detroit
Institute of Arts," DIA *Bull.* 53, 1 (1974): no. 11.

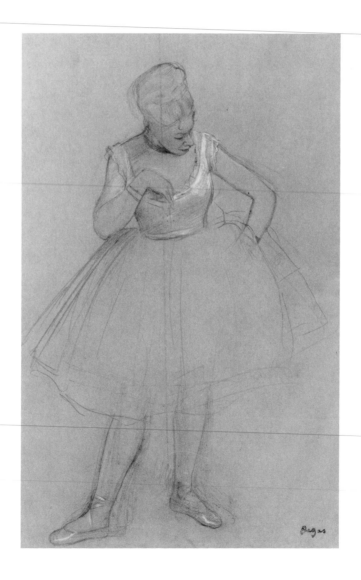

216
ADOLF MENZEL, German (1815-1905)
Head of a Man, 1894
Black chalk with gray wash; 30.8 x 22.6 cm.
(12⅛ x 8⅞ in.)
Founders Society Purchase, Miscellaneous Gifts
Fund (69.60)

217
PAUL CEZANNE, French (1839-1906)
Skull and Book (Vanitas), c. 1900
Watercolor over pencil; 23.5 x 31.1 cm. (9¼ x 12¼ in.)
Bequest of John S. Newberry (65.139)
See *Cézanne*, exh. cat., The Phillips Collection, Washington, D.C., etc., 1971: no. 51.

218
KATHE KOLLWITZ, German (1867-1945)
Mother and Dead Child, c. 1903
Charcoal and yellow chalk; 40.6 x 35.6 cm.
(16 x 14 in.)
Bequest of Robert H. Tannahill (70.308)
See *The Robert Hudson Tannahill Bequest*, exh.
cat., DIA, 1970: 74-75.

219
HENRI MATISSE, French (1869-1954)
The Plumed Hat, 1919
Pencil; 53 x 36.5 cm. (20⅞ x 14⅜ in.)
Bequest of John S. Newberry (65.162)
See *Henri Matisse, Dessins et Sculpture,* exh. cat.,
Musée National d'Art Moderne, Paris, 1975:
no. 57.

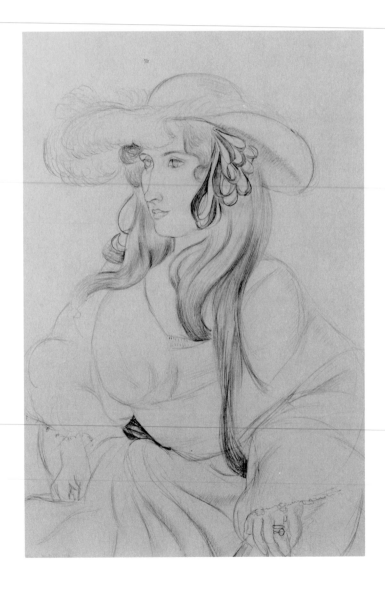

220
PABLO PICASSO, Spanish (1881-1973)
Bather by the Sea (Dora Maar), 1939
Gouache; 64.1 x 47 cm. (25¼ x 18½ in.)
Bequest of Robert H. Tannahill (70.339)
See C. Zervos, *Pablo Picasso, oeuvres de 1937 à 1939*, Paris, 1958, 9: no. 318.

221
JACOB LAWRENCE, American (b. 1917)
No. 2 from the *John Brown Series*, 1941
Gouache; 50.8 x 35.6 cm. (20 x 14 in.)
Gift of Mr. and Mrs. Milton Lowenthal (55.354b)
See E. Sharp, *The Legend of John Brown*, exh. cat., DIA, 1978: 12.

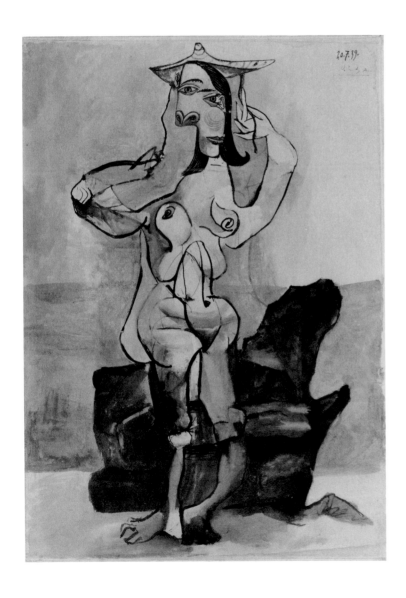

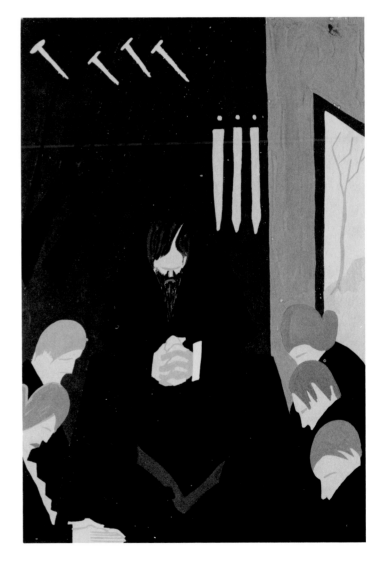

222
ALBRECHT DURER, German (1471-1528)
Adam and Eve, 1504
Engraving; 25.1 x 19.5 cm. (9⅞ x 7¹¹/₁₆ in.)
Founders Society Purchase, New Endowment
Fund (F76.14)

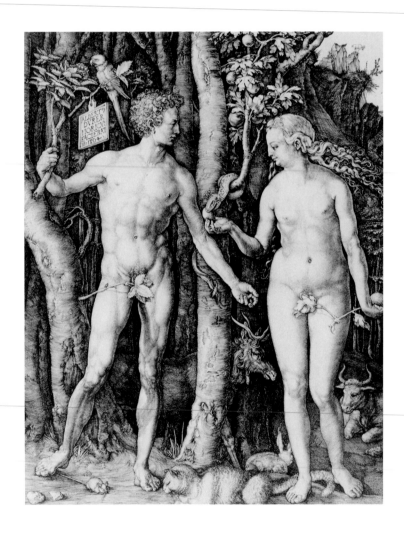

223
UGO DA CARPI, Italian (c. 1480-1532)
Diogenes (after Parmigianino, 1503-1540)
Chiaroscuro woodcut; 46.7 x 34.6 cm. (18⅜ x
13⅝ in.)
Gift of Mrs. James E. Scripps (09.1-S 242)
See A. Klein, "Chiaroscuros: Highlight of a Gift,"
DIA *Bull.* 46, 3 (1967): 48-49.

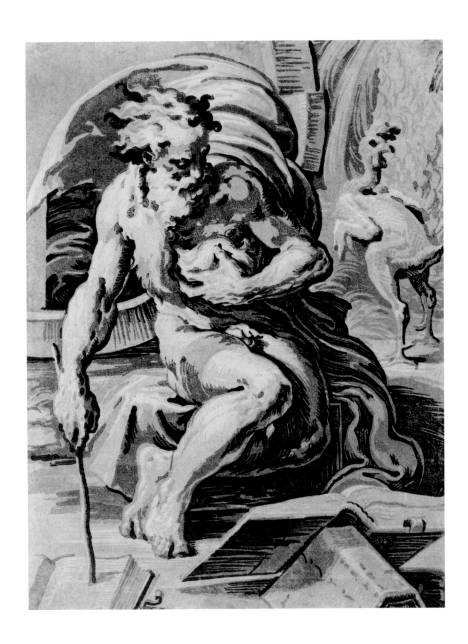

224
REMBRANDT VAN RIJN, Dutch (1606-1669)
The Descent from the Cross by Torchlight, 1654
Etching and dry point; 21 x 15.9 cm. (8¼ x 6¼ in.)
Founders Society Purchase, Charles L. Freer
Fund (38.33)
See I. Weadock, "Rembrandt's 'Descent from the
Cross by Torchlight,' " DIA *Bull.* 18, 1 (1938): 2.

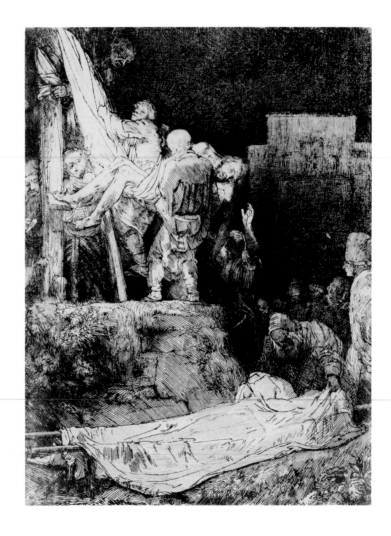

225

GIOVANNI BATTISTA PIRANESI, Italian (1720-1778)

"An Immense Interior, with Numerous Wooden Galleries, and a Drawbridge in the Center,"
Pl. 7 from *The Prisons (Carceri)*, 1745-51

Etching; 55.2 x 41.3 cm. (21¾ x 16¼ in.)

Founders Society Purchase, Elizabeth P. Kirby and Hal H. Smith Funds (42.67)

See I. Weadock, "The Prisons of Piranesi," DIA *Bull.* 22, 8 (1943): 81-84.

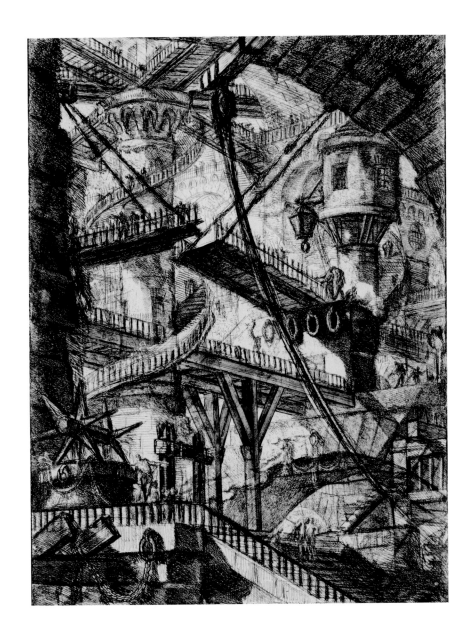

226
HONORE DAUMIER, French (1808-1879)
Rue Transnonain, April 15, 1834, 1834
Lithograph; 28.6 x 44.3 cm. (11¼ x 17⁷⁄₁₆ in.)
Gift of Mr. and Mrs. Bernard F. Walker in
memory of Kurt Michel (72.841)
See E. Sharp, "Some Notable Additions to the
Print Collection," DIA *Bull.* 51, 2-3 (1972): 81-83.

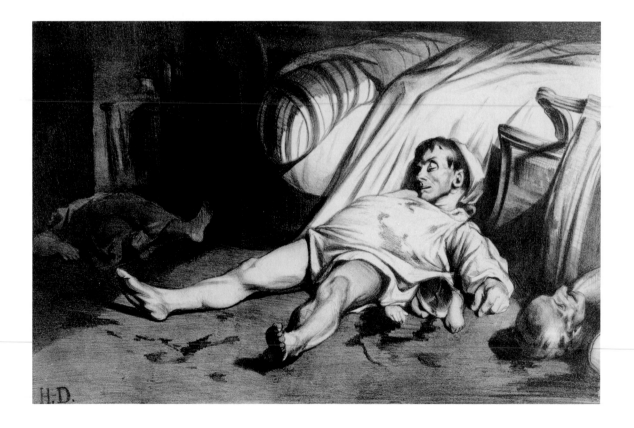

227
RODOLPHE BRESDIN, French (1822-1885)
The Good Samaritan, 1861
Lithograph; 57.5 x 44.5 cm. (22$\frac{1}{16}$ x 17$\frac{1}{2}$ in.)
Gift of Mr. and Mrs. Bernard F. Walker (74.269)

228
EDOUARD MANET, French (1832-1883)
Dead Christ with Angels, c. 1866/67
Etching and aquatint; 39.4 x 31.8 cm. (15$\frac{1}{2}$ x 12$\frac{1}{2}$ in.)
Founders Society Purchase, General Funds (70.588)
See J. C. Harris, "Prints by Manet," DIA *Bull.* 49, 3-4 (1970): 47.

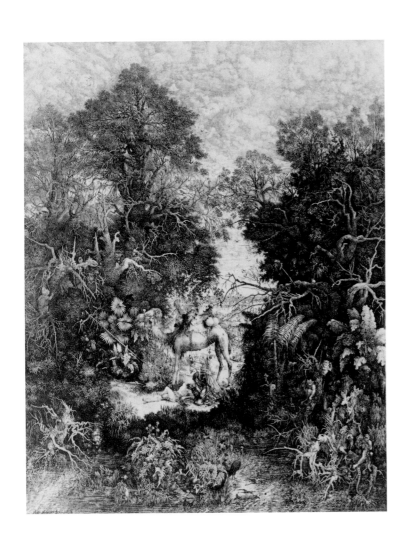

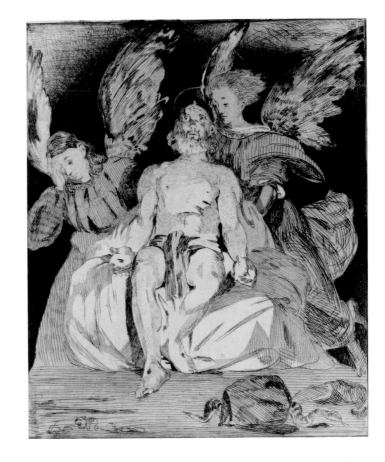

229
ERICH HECKEL, German (1883-1970)
Poster for Die Brücke Exhibition, 1908
Color woodcut; 85.3 x 59.7 cm. (33 1/16 x 23 1/2 in.)
Gift of the Drawing and Print Club (69.298)
See DIA *Handbook*, 1971: 204.

230
GEORGES BRAQUE, French (1882-1963)
Fox, 1911/12
Etching with drypoint; 54.6 x 37.2 cm.
(21 1/2 x 14 5/8 in.)
Gift of Lydia Winston Malbin (70.908)
See E. Sharp, "Some Notable Additions to the
Print Collection," DIA *Bull.* 51, 2-3 (1972): 85.

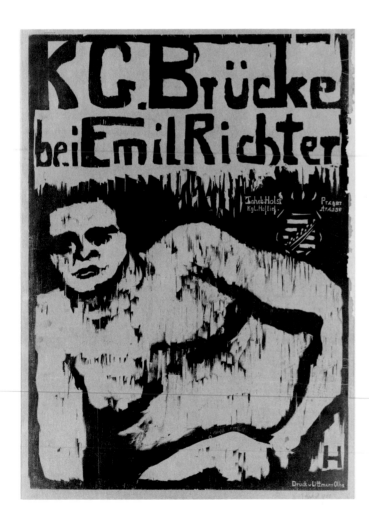

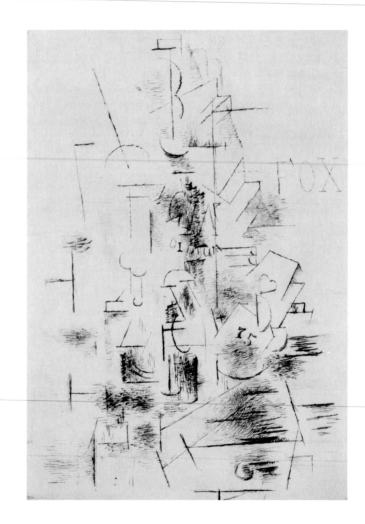

231
HENRI MATISSE, French (1869-1954)
Nude with Raised Arms Seated before Fireplace,
1925
Lithograph; 75.9 x 56.4 cm. (29⅞ x 22³⁄₁₆ in.)
Founders Society Purchase, Robert H. Tannahill
Foundation Fund (F78.27)

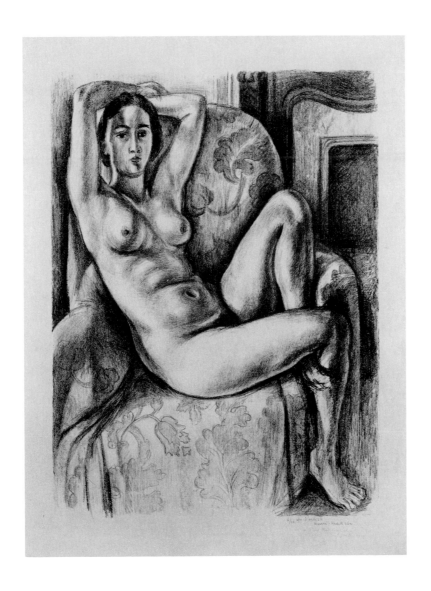

232
ROBERT MOTHERWELL, American (b. 1915)
Red 4-7, from *A la pintura*, 1972
Color aquatint; 36.8 x 66 cm. (14½ x 26 in.)
Founders Society Purchase, Dr. and Mrs. George
Kamperman Fund (73.24)

233
JULIA MARGARET CAMERON, English (1815-1879)
Sir John Herschel, 1867
Albumen-silver print from collodion-on-glass
negative; 35.3 x 26.2 cm. (13 ⅞ x 10 ⁵⁄₁₆ in.)
Founders Society Purchase (73.37)
See M. F. Symmes, "Important Photographs by
Women," DIA *Bull.* 56, 2 (1978): 141-44.

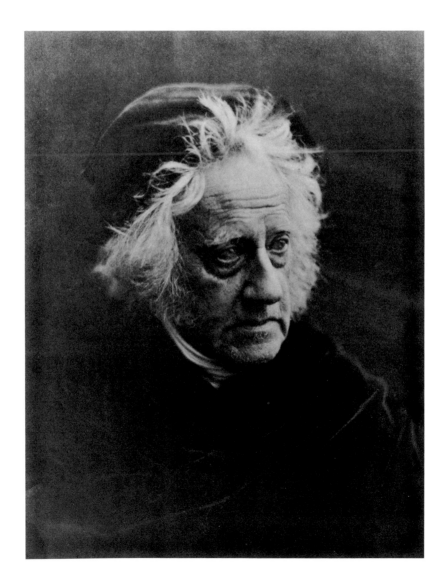

234
THOMAS EAKINS, American (1844-1916)
Three Female Nudes, c. 1883
Albumen contact print; 14.3 x 9.9 cm.
(5⅟₁₆ x 3⅞ in.)
Founders Society Purchase, Robert H. Tannahill
Foundation Fund (F77.104)
See F. J. Onorato, "Photography and Teaching:
Eakins at the Academy," *American Art Review*
3, 4 (1976): no. 9.

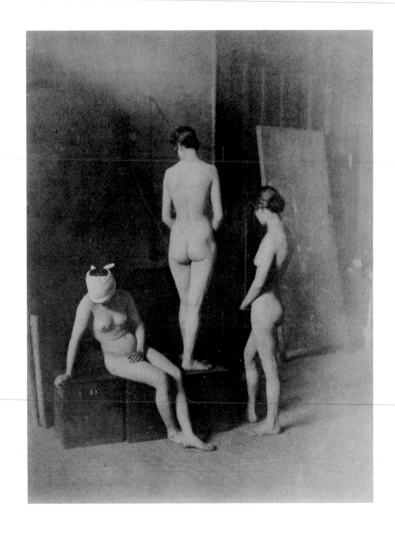

235
CHARLES SHEELER, American (1883-1965)
Still Life, Zebra Plant Leaves, c. 1938
Silver print; 19.7 x 24.5 cm. (7¾ x 9⅝ in.)
Founders Society Purchase, Beatrice W. Rodgers
and Edward E. Rothman Funds (F77.57)

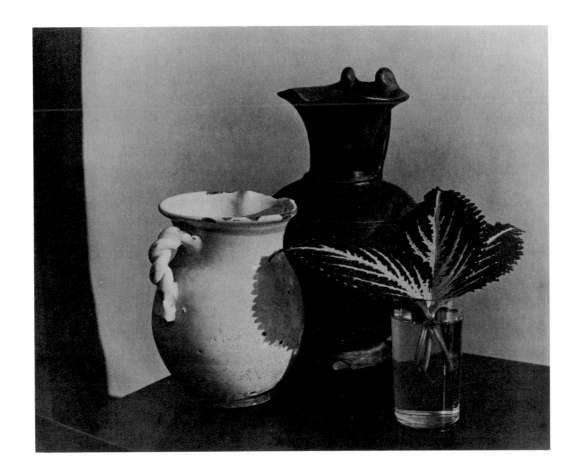

Michael Kan, Curator
William Wierzbowski, Research Assistant

The Department of African, Oceanic, and New World cultures is one of the most recently established curatorial departments in The Detroit Institute of Arts, although its collections date back virtually to the founding of the museum. Its holdings are diverse and comprehensive, covering the visual arts of Africa, Oceania, and Pre-Columbian and native America.

The beginning of the collections can be traced to the end of the 19th century. Housed on the second floor of the old Detroit Museum of Art, the Scientific department included "curiosities" representing all the races of mankind. Among the objects collected and donated to the museum primarily by Frederick Stearns were a few African and Oceanic pieces of quality. A number of souvenirs given to the Scientific department by General George A. Custer from his Indian fighting days in the upper Midwest were also part of the collection. The most important of these souvenirs is an exquisitely painted Cheyenne shield (no. 251) dating from about 1865.

With the appointment of Dr. William R. Valentiner as Director in 1924, a new age began for the museum as a whole and for the collection of ethnographic art in particular. He felt that the regional arts of mankind were important to the history of civilization, and as such each had a place in a museum devoted to the art of the world. Through careful purchasing, Valentiner sought to build the ethnographic art collection. The Benin head and the Kongo knife case from Africa, the ceremonial shield from New Guinea, and the numerous ceramics and textiles from Pre-Columbian America attest to the seriousness of his intent (nos. 240, 244, 256). When the new building of The Detroit Institute of Arts opened its doors in 1927, it was one of the first American art museums to exhibit ethnographic art.

The 1930s saw little in the way of additions to the collections except for two large bequests of North American Indian material: the Henry Glover Stevens collection of Navajo blankets in 1934 and the Mrs. Sidney Corbett (Miss Kate Mabley) collection of California basketry in 1937. During this time Valentiner nurtured collectors and patrons such as the Edsel B. Fords, Robert H. Tannahill, and Lillian Henkel Haass, all of whom would become important figures in the continuing development of the ethnographic art collections, donating gifts throughout the next three decades. Mrs. Haass gave many pieces of African, North American Indian, and Pre-Columbian art to the museum, including the Jalisco figure (no. 257). Tannahill, in addition to the many gifts given during his lifetime, bequeathed his entire collection of African and Pre-Columbian art to the museum in 1970. The African Bembe figure (no. 239) was part of that bequest.

The 1960s was an especially important period for the African art collections. In addition to the Tannahill bequest, the museum received a sizable gift of African art collected by Justice and Mrs. G. Mennen Williams during his residency in West Africa as Under Secretary-in-Charge-of African Affairs. The Senufo mask was included in the gift (no. 247). It was also during this decade that the African Art Gallery Committee was formed to aid in the enrichment of the African art collections. The Yoruba mask by a known African sculptor, Bangboye of Odo-Owa, is evidence of their continued support (pl. XLVI).

In 1976, the ethnographic collections were consolidated into the Department of African, Oceanic, and New World Cultures, under the curatorship of Michael Kan. The Eleanor Clay Ford Fund for African Art was secured for the continued development of the African collections. This fund, one of the last bequests of Mrs. Ford, has enabled the museum to purchase many outstanding pieces (pl. XLV). The other areas of the collection have also received renewed attention under the present curator. Important objects have been added to the Oceanic, North American Indian, and Pre-Columbian collections by purchase as well as by gift. Construction of a series of new galleries which will ring the North Court is planned for the near future. Thus, what began as a collection of curiosities has grown into a major Midwestern collection of ethnographic art.

236
Female Figure, African, Akan, Ghana/Ivory
Coast, 1800/1900
Wood; h. 61 cm. (24 in.)
Founders Society Purchase, Eleanor Clay Ford
Fund for African Art (76.94)
See *The Art of Black Africa, Collection of Jay C.
Leff,* exh. cat., Carnegie Institute Museum of
Art, Pittsburgh, 1970: no. 117.

237
Ornament, African, Akan, Ghana/Ivory Coast
Gold; 6 x 5 cm. (2⅜ x 2 in.)
Founders Society Purchase, Eleanor Clay Ford
Fund for African Art (76.26)

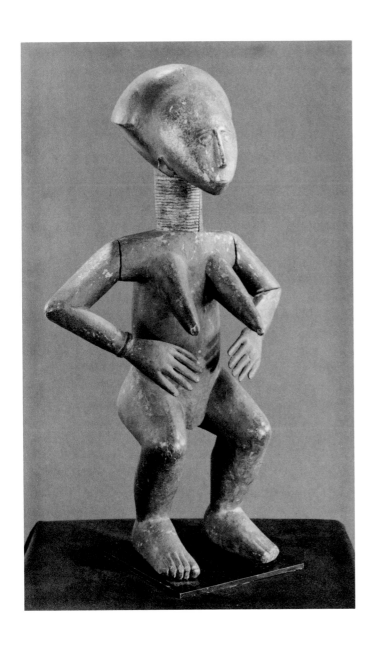

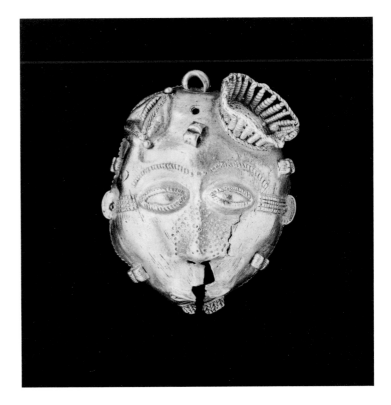

238
Night Society Mask (Bacham), African,
Bamileke, Cameroon, 1800/1900
Wood; h. 87.6 cm. (34½ in.)
Founders Society Purchase, Eleanor Clay Ford
Fund for African Art (78.9)
See P. Harter, "Les Masques dits 'Batcham,' "
Arts d'Afrique Noire 3 (1972): 24.

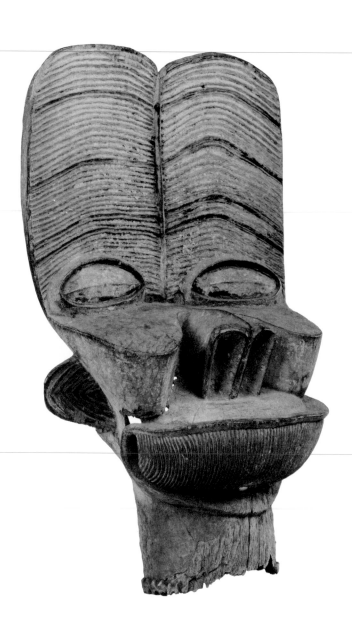

239
Male Figure, African, Bembe, Congo (Brazzaville)
Wood, shell; h. 13.7 cm. (5⅜ in.)
Bequest of Robert H. Tannahill (70.17)

240
Female Head, African, Benin, Nigeria, late 18th/
early 19th century
Bronze; h. 53.3 cm. (21 in.)
City Purchase (26.180)
See *Masterpieces of Art,* exh. cat., North Carolina
Museum of Art, Raleigh, 1959: no. 217.

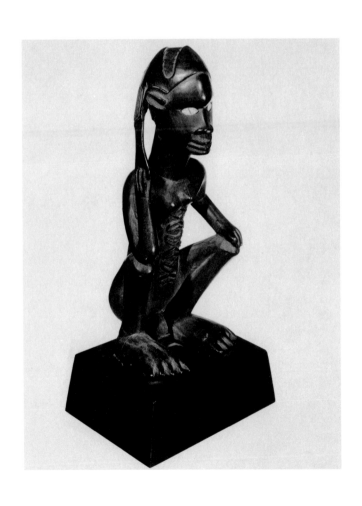

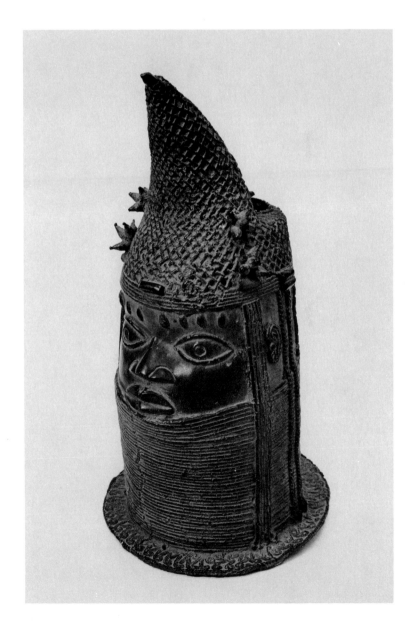

241
Bearded Male Figure, African, Djenne, Mali,
1300/1400
Terracotta; h. 38.1 cm. (15 in.)
Founders Society Purchase, Eleanor Clay Ford
Fund for African Art (78.32)

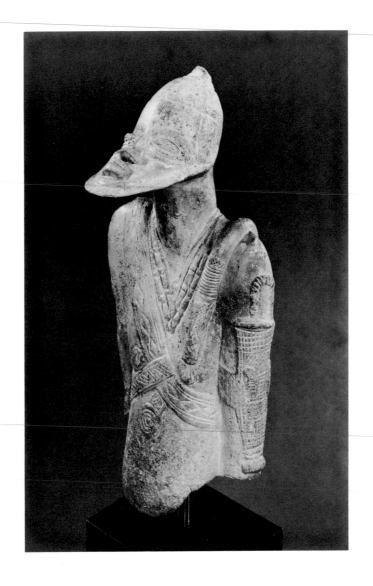

242
Head (Bieri), African, Fang, Gabon
Wood; h. 30.5 cm. (12 in.)
Founders Society Purchase, Eleanor Clay Ford
Fund for African Art (77.29)

243
Vigangu Figure, African, Kambe, Kenya, c. 1850
Wood; h. 113 cm. (44½ in.)
Founders Society Purchase, Eleanor Clay Ford
Fund for African Art (78.14)

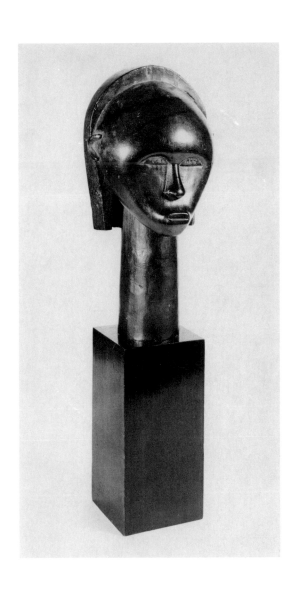

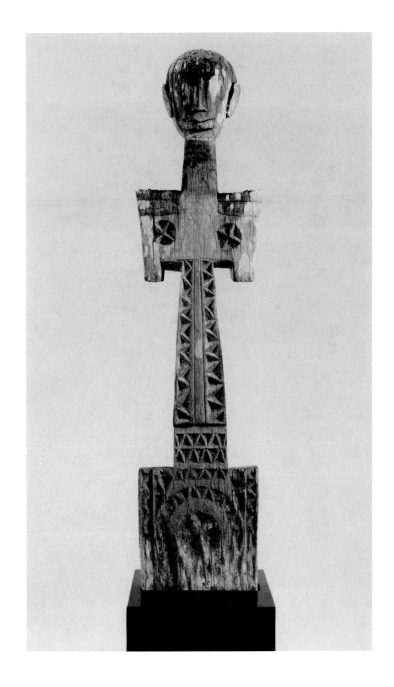

244
Knife Case, African, Kongo, Zaïre, 1500/1800
Ivory; l. 32.4 cm. (12¾ in.)
City Purchase (25.183)
See W. Fagg and M. Plass, *African Sculpture,*
An Anthology, London, 1964: 118.

245
Helmet Mask, African, Makonde, Mozambique
Wood, wax, fiber; h. 22.9 cm. (9 in.)
Founders Society Purchase, Eleanor Clay Ford
Fund for African Art (76.25)

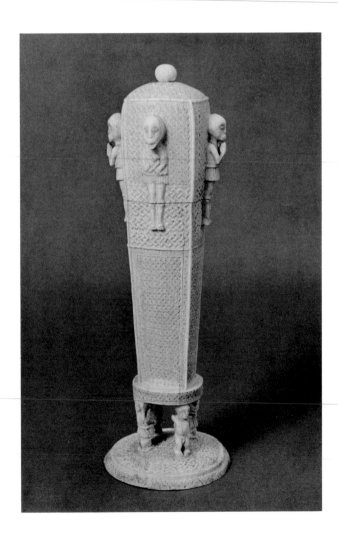

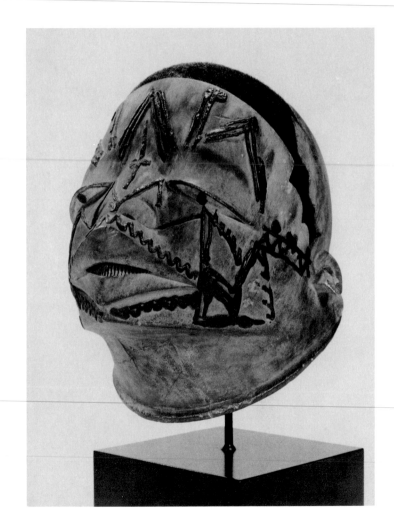

246
Container, African, Mangbetu, Zaïre, late 19th century
Wood; h. 55.9 cm. (22 in.)
Founders Society Purchase, Eleanor Clay Ford Fund for African Art (77.70)

247
Helmet Mask (Firespitter), African, Senufo, Ivory Coast
Wood; l. 96.5 cm. (38 in.)
Gift of Governor and Mrs. G. Mennen Williams (66.485)

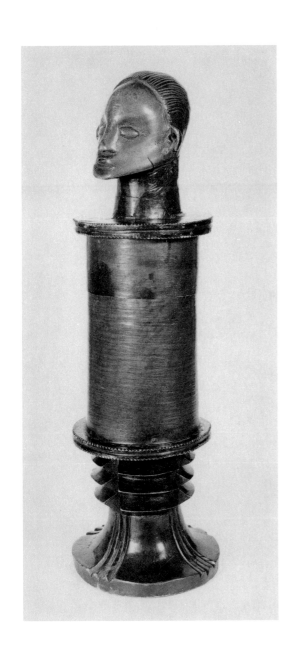

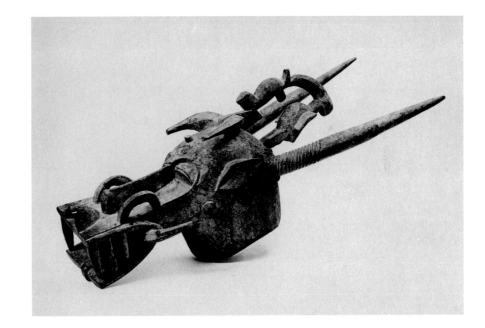

248
Stool, African, Songye, Zaïre
Wood; h. 52.7 cm. (20¾ in.)
Founders Society Purchase, Robert H. Tannahill
Foundation Fund (75.1)

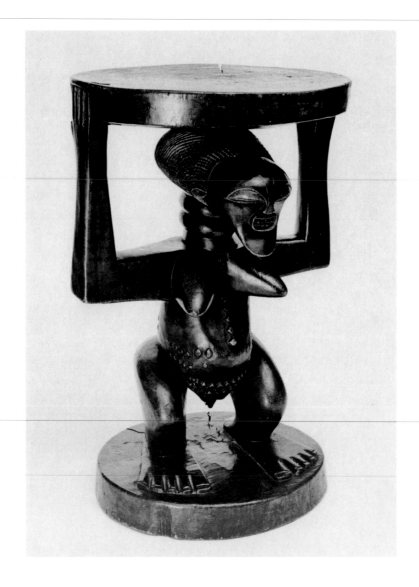

249
Bowl, North American Indian, Mimbres, Arizona
1000/1400
Terracotta, pigments; diam. 26.7 cm. (10½ in.)
Founders Society Purchase (76.87)
See E. M. Maurer, *The Native American Heritage: A Survey of North American Indian Art,* exh. cat., The Art Institute of Chicago, 1977: no. 284.

250
Spoon, North American Indian, Northeastern Woodland, early 19th century
Wood; l. 24.5 cm. (9⅝ in.)
City Purchase (51.10)

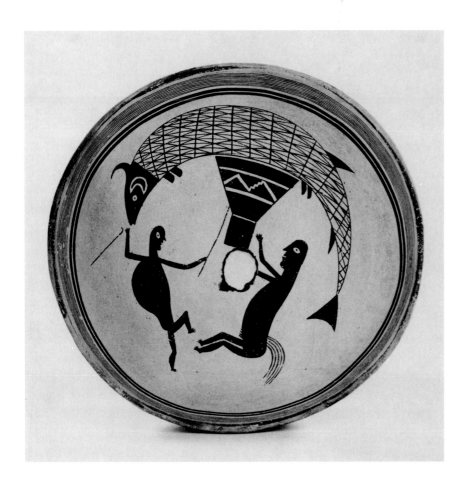

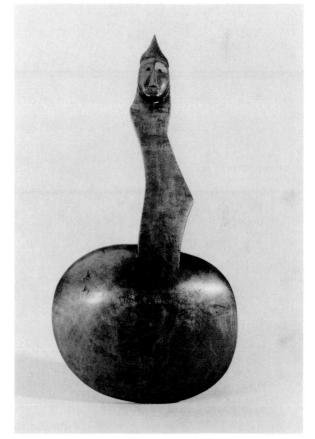

251

Shield, North American Indian, Cheyenne,
c. 1865

Buffalo hide, feathers, brass bells, pigments;
diam. 49.5 cm. (19½ in.)

Gift of Gen. George A. Custer through the
Detroit Scientific Association (76.144)

See E. M. Maurer, *The Native American Heri-tage: A Survey of North American Indian Art,*
exh. cat., The Art Institute of Chicago, 1977:
no. 206.

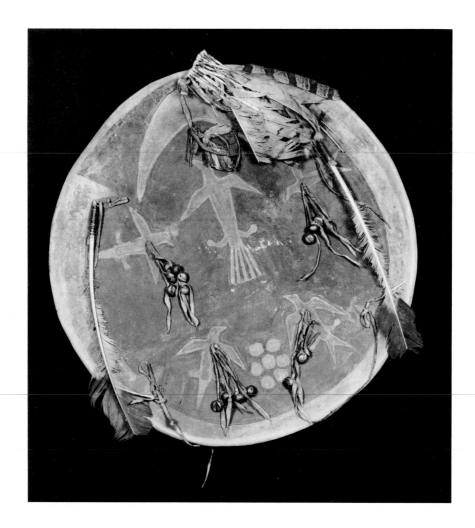

252
Ceremonial Robe, North American Indian,
Kwakiutl, late 19th/early 20th century
Wool, beads, abalone shell; 143.5 x 184.2 cm.
(56½ x 72½ in.)
Founders Society Purchase, Various Funds and
Gifts (63.151)

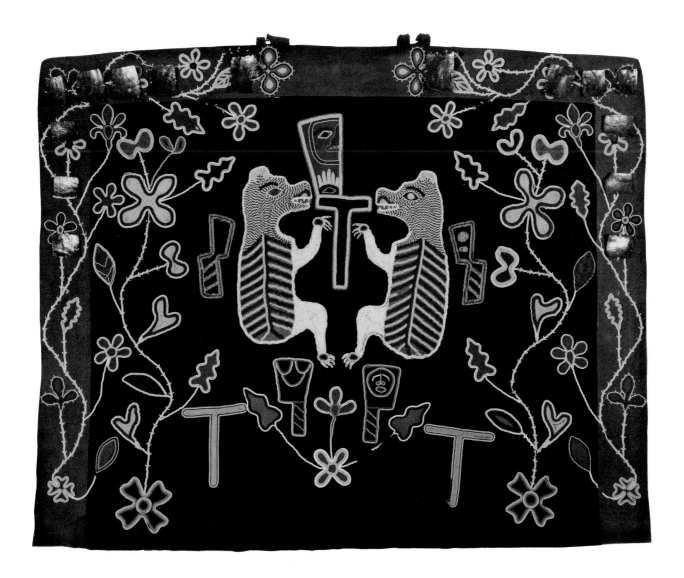

253
Neckrest, Polynesian, Tonga Islands, 1700/1800
Wood, ivory inlay; l. 59.1 cm. (23¼ in.)
Founders Society Purchase, L. A. Young Fund
(77.62)

254
Calabash, Polynesian, Hawaiian Islands, c. 1800
Calabash; h. 31.8 cm. (12½ in.)
Gift of Walter Randel (77.26)

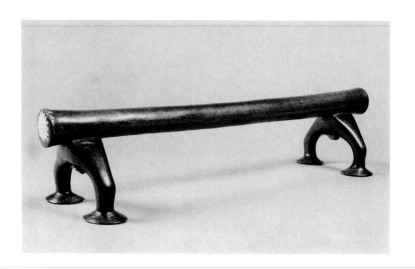

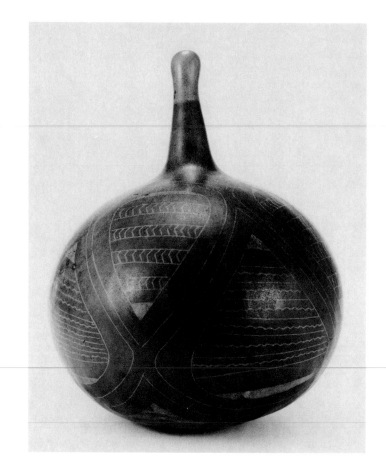

255
Canoe Prow Ornament, Melanesian, Solomon
Islands
Wood, mother of pearl; h. 58.4 cm. (23 in.)
Anonymous Gift (52.233)

256
Ceremonial Shield, Melanesian, Middle Sepik
River area, New Guinea
Wood, pigment; h. 167.6 cm. (66 in.)
City Purchase (26.370)
See *The Art of the Sepik River,* exh. cat., The
Art Institute of Chicago, 1971: no. 177.

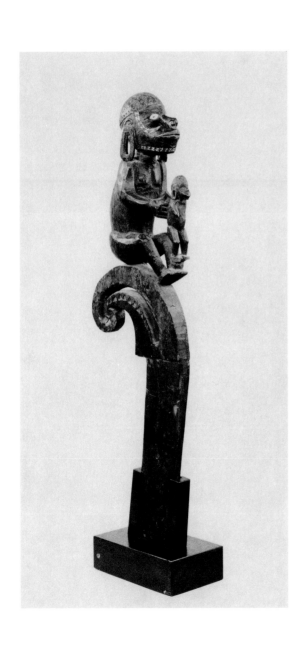

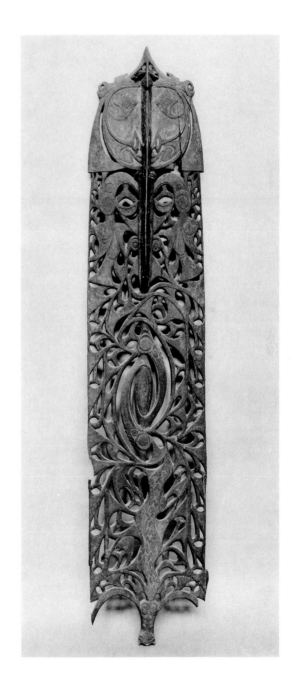

257
Male Figure, Mexican, Jalisco,
c. 200 B.C./A.D. 200
Terracotta; h. 22.9 cm. (9 in.)
Gift of Mrs. Lillian Henkel Haass (56.227)

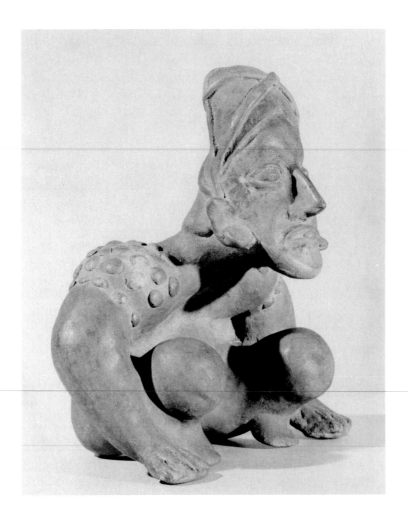

258
Embracing Couple, Mexican, Maya, Jaina Island,
c. 700
Terracotta, pigment; h. 24.8 cm. (9¾ in.)
Founders Society Purchase, Katherine Margaret
Kay Bequest and New Endowment Funds (77.49)

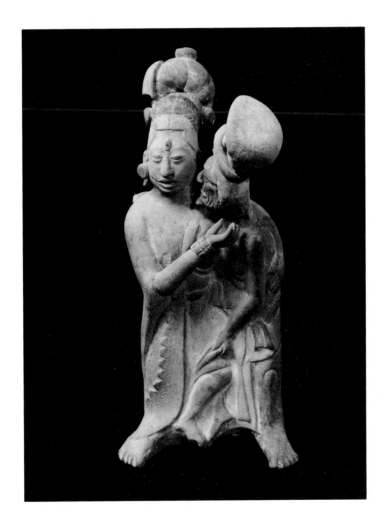

259
Palma, Mexican, Vera Cruz, c. 1200
Gray basalt; h. 48.3 cm. (19 in.)
City Purchase (47.180)
See A. S. Cavallo, "A Totonac Palmate Stone,"
DIA *Bull.* 29, 3 (1949-50): 56-58.

260
Eagle Pendant, Panamanian, Veraguas Style,
c. 1200
Cast gold; h. 10.2 cm. (4 in.)
Gift of Mr. and Mrs. Theodore O. Yntema
in memory of Eleanor Clay Ford and Robert H.
Tannahill (77.45)

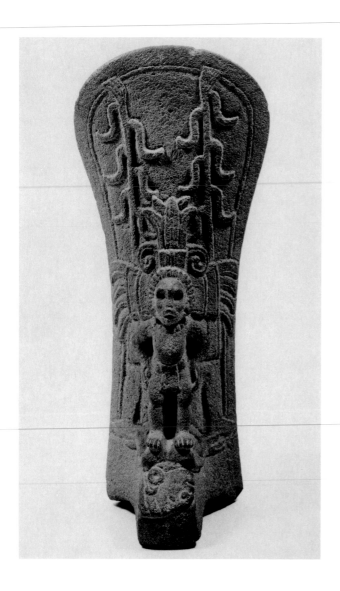